KU-739-020

ANGELICA KAUFFMAN

A Continental Artist in Georgian England

edited by

WENDY WASSYNG ROWORTH

with essays by

DAVID ALEXANDER

MALISE FORBES ADAM & MARY MAUCHLINE

ANGELA ROSENTHAL

WENDY WASSYNG ROWORTH

~~CROFT~~ COLLEGE
LIBRARY
SOUTH BANK
SURBITON
~~SU~~RREY KT6 6DF

published in association with

THE ROYAL PAVILION · ART GALLERY & MUSEUMS

BRIGHTON

BY REAKTION BOOKS · LONDON

Published by Reaktion Books Ltd
in association with the Royal Pavilion,
Art Gallery & Museums, Brighton

Distributed to the booktrade
by Reaktion Books Ltd
1–5 Midford Place, Tottenham Court Road
London W1P 9HH, UK

First published 1992, reprinted 1993
Copyright © 1992 the Royal Pavilion,
Art Gallery & Museums, Brighton
and the authors

Distributed in USA and Canada
by the University of Washington Press
PO Box 50096, Seattle, WA 98145-5096, USA

All rights reserved

Designed by Humphrey Stone
Cover design by Ron Costley

Photoset by Rowland Phototypesetting Ltd,
Bury St Edmunds, Suffolk
Printed and bound in Great Britain
by BAS Printers Ltd,
Over Wallop, Stockbridge, Hampshire

British Library Cataloguing in Publication Data
Angelica Kauffman: Continental Artist in
Georgian England
I. Roworth, Wendy Wassyng
759.9494

ISBN 0-948462-41-8

Contents

Foreword

This book has been published to coincide with the first exhibition to be held in this country since the 1950s on Angelica Kauffman's work and her influence in England as seen through paintings and prints produced for British clients both here and abroad. It also considers the wide range of media and decorative arts which have been used to reproduce Kauffman's compositions.

Considerable research has been necessary for the realization of both the exhibition and the book. It has been a lengthy process, and we are indebted to a large number of people for their assistance and support over several years. We would particularly like to thank Wendy Wassyng Roworth, Professor of Art History at the University of Rhode Island, USA. As the guest curator of the exhibition and editor of this publication she has worked unceasingly to bring the project to fruition. We would also like to thank the contributors to this book: David Alexander, Malise Forbes Adam, Mary Mauchline and Angela Rosenthal. Their generosity and willingness to share their expertise is greatly appreciated.

Special thanks are due to numerous individuals and institutions and they are fully acknowledged in the Summary Checklist for the Exhibition. All have generously lent items from their collections and provided valuable assistance and information; without their co-operation the exhibition would not have taken place.

Many staff in the Museum and Art Gallery have contributed to the exhibition, but particular credit is due to Sarah Carthew, who initiated the project, and Caroline Collier and Susan Fasquelle who were responsible for its development. The exhibition was brought together in its final stages by Shelley Tobin, with assistance from Sarah Sutton and Sorrel Hershberg.

Finally, we would like to express special gratitude to the sponsors of the exhibition, in particular the Museums and Galleries Commission, Pro Helvetia Arts Council of Switzerland, the Arts Council of Great Britain, the University of Rhode Island Council for Research, Sotheby's, South East Arts and the European Arts Festival (July–December 1992). The publication was produced with financial

assistance from the Paul Mellon Centre for Studies in British Art. Without generous support from the sponsors this project could not have been realised.

JESSICA RUTHERFORD
Head of Museums and
Director of the Royal Pavilion

BRIGHTON
BOROUGH COUNCIL

Acknowledgements

Through their generous support and encouragement, many people have assisted with the development of this book, and with the exhibition it accompanies. Sarah Carthew originated the idea for an exhibition, and brought together the group of contributors to the final project. A video programme, 'Angelica Kauffman R.A., and the Choice of Painting', co-produced by the BBC and the Brighton Museum and Art Gallery for the exhibition and the Open University, was directed by Charles Cooper with the participation of Gill Perry. Others to whom we owe thanks for assistance with research, advice or photography are Brian Allen, the American Council of Learned Societies, Maureen Attrill, Geoffrey Beard, David Bindman, Frances Collard, Caroline Collier, Tim Clayton, Mr and Mrs Robin Compton, Belinda Cousens, John Culverhouse, Mabel Davis, Ian Dejardin, Rob Dixon, David Edmond, Susan Fasquelle, Christine Fell, Sir Brinsley Ford, James Gladstone, Antony Griffiths, John Hardy, Andreas Haus, Helena Hayward, Jeremy Howard, Michael Kitson, Alastair Laing, Lady Victoria Leatham, Christopher Lloyd, Clare Lloyd-Jacob, Nigel Llewellyn, Elizabeth McGrath, James Miller, Lady Monson, Helena Moore, Evelyn Newby, Barbara Peters, John Philpin, Adrian Randolph, John Roworth, Vanessa Roworth, Gudrun Schubert, Dorothy Sherwood, Wendy Sheridan, Kim Sloan, John Somerville, Hubert von Sonnenburg, Shelley Tobin, Freda Jowsey, Peter Walch, and Lucy Wood.

Kauffman and the Art of
Painting in England

WENDY WASSYNG ROWORTH

Angelica Kauffman,[1] one of the most successful women artists in the history of art before the end of the nineteenth century, established herself as a leading figure in the art world of late eighteenth-century London, following her arrival in 1766. Fifteen years later, on the eve of her departure in 1781, her friend the poet George Keate published his *Epistle to Angelica Kauffman*, in which he describes how 'The Historic Muse unfurls her Scroll', a reference both to Kauffman's source of inspiration and the mark of her achievement. Keate lamented the impending loss of such an accomplished artist, and described grief-stricken Britain sighing to reckon Kauffman one of its own. For although she was born in Switzerland and had trained in Italy, Kauffman became closely involved with art and taste in England in the Neoclassical period. She was a founder member of the Royal Academy of Arts in 1768, and sent paintings to its annual exhibitions for much of her career. She spent less than one quarter of her life in England, but her presence and influence at a critical moment in the development of its painting, and her continued popularity among its people after her departure, has ensured her a significant place in the history of British art.

Kauffman was, in fact, celebrated throughout Europe for her creative talents, which she demonstrated in a variety of artistic productions, from portraits and history paintings to etchings, engravings and designs for decorative paintings. The diversity of subjects and themes in her art ranges from Classical and medieval history and mythology, through the Renaissance to the contemporary literature of England, France, Germany and Italy, a reflection of the broad spectrum of taste in the art market in the second half of the eighteenth century.

During the nineteenth and twentieth centuries the multiplicity of views on

Kauffman and her art were such that we still have a fragmented, in some ways confusing, idea of this female artist. Her image has been framed and reframed in many different contexts, and a reappraisal of her art and life, especially her role in England, illuminates a number of larger issues, such as the position of women as professional artists, the popularity of certain themes in eighteenth-century painting, and the dissemination of these images through reproductive means.

In 1905 William Shaw Sparrow wrote in *Women Painters of the World*:

> Angelica Kauffman, R.A., though born at Coire, the capital of the Grisons, belongs to the British School . . . [Her art] is quite artificial in spirit, with a strong bias towards the sentimental; but it has for all that considerable charm and ability, qualities let us remember, that won the admiration of Reynolds and Goethe . . . But in recent times Angelica Kauffman has been remembered for the romance of her personal life and treated with cool contempt in all that appertains to her work. Critics have searched in her pictures for manly qualities, and finding there the temperament of a sentimental woman, their judgment has failed them.[2]

This 'failure of judgement' by critics has been problematic in much that has been written about Kauffman, for, as a woman, she does not fit the expectations or criteria of the 'norm' – the male artist. The 'romance' of Kauffman's life, her sentimentality, charm and the search for 'manly qualities' in her work has indeed been the subject of much criticism and discussion since the eighteenth century. In an age when women artists were still rare, she was very much in the public eye as an attractive, gracious, talented and, apparently, quite sociable person. As Sparrow noted, she was admired and befriended by numerous well-known and influential artists, writers and intellectuals, such as Joshua Reynolds, Goethe, J. J. Winckelmann, J. G. von Herder, Benjamin West, Nathaniel Dance, Anne Damer, and members of the aristocracies of Europe. She received an unending stream of commissions for portraits, subject pictures and designs that kept her constantly busy. The extent of her earnings is impressive by any standard, over £14,000 by the time she left England, an enormous sum for the time, but especially so for a woman artist.

There is much information about Kauffman in contemporary biographies, commentaries, letters and documents. Her husband Antonio Zucchi, whom she married in 1781, kept a *Memorandum of Paintings*, in which are recorded the commissions she executed in Italy after her return from England in December of

that year.[3] It includes a wealth of useful information about her work during this period – the names of patrons, descriptions of pictures and their literary sources, their dimensions, prices, dates of delivery and payments. Unfortunately, no such memorandum exists for the work she completed in her early years on the Continent or during her stay in England between 1766 and 1781, or during the brief visit she made to Ireland in 1771. Information about her career before 1782 must be assembled from a variety of sources and records. Kauffman kept up an extensive correspondence with a large international circle of friends, and those letters that have survived reveal a woman of warmth, intelligence, wit and compassion, and one with an excellent head for business.

The story of Kauffman's life contains the elements of drama and romance, honours and scandal, as well as a cast of famous characters from the Neoclassical period. The information supplied by her earliest biographer, Giovanni Gherardo De Rossi, an Italian with whom she became quite close during her later years in Rome,[4] and by contemporary commentators, such as Joseph Farington,[5] as well as from letters, contemporary reviews and documentary sources, provides enough material to put together a picture of a woman's life worthy of a nineteenth-century novel, if not a Hollywood biography. In fact, Anne Thackeray did cast her as the heroine of her novel *Miss Angel*, which appeared in 1875.[6]

KAUFFMAN'S SUCCESS

How was Kauffman able to succeed as an artist in a professional world that, for practical, and ideological, reasons, had excluded women? Some of her success can be attributed to her ability to produce a variety of different types of art, which gave her a flexibility not all artists possessed. Although she had high ambitions, she was not averse to creating whatever might be popular and would sell, and to this end she worked closely with several printmakers and dealers. She was an excellent portraitist, the genre most appreciated and demanded by the British, but she could also produce decorative mythological and allegorical scenes suitable for reproduction on painted furniture, textiles and ceramics, or which could be incorporated into wall decorations. One major reason for her success in England was, as we shall see, her particular ability as a painter of Classical and historical subjects.

Another factor that may account for Kauffman's success was her single status, although she did marry twice – once in a nearly disastrous scandal. Most of her years in England were spent as a single woman, protected by her father with whom she lived. A young female artist was bound to attract some unwelcome attention, yet she was at least spared the responsibility of caring for a family and the burden of various traditional female obligations. Both Kauffman's English and German biographers have tended to highlight her physical charms and feminine wiles, and to speculate on various supposed relationships with men, which included an engagement to Nathaniel Dance in Italy, a suspected marriage proposal from Reynolds, the passionate attentions of J. H. Fuseli, a flirtation with the printmaker William Ryland, and her seduction by the French Revolutionary Jean-Paul Marat. Undoubtedly she was a young woman who was clearly at ease in the company of men, with whom she shared many interests, but a clearer image of her emotional attachments and sexuality has yet to emerge.

One of the most difficult moments of her life must have been the brief four-month marriage in which she became entangled at the end of 1767, not long after her arrival in London. The man in question, 'Count Frederic de Horn', turned out to be an imposter, having tricked her into marriage in order to remain in England. This illegal union (he already had at least one wife) was dissolved as soon as she and her father paid him off, and he then fled the country. It is remarkable and surprising that such a scandal did not seem to have affected her relationship with patrons, including the royal family, or her professional friends.[7]

Ironically, it may have been this disastrous, and illegal, marriage that allowed her to maintain her freedom. Whether through poor judgement, naivety or rash action. Kauffman in effect exempted herself from the traditional expectations of love followed by marriage and family, a situation that would likely have curtailed the high aspirations and heavy workload she maintained. After this disruption in her life, she retained a peculiar status: neither spinster nor virgin, nor widow nor wife, a situation that seems to have kept further suitors at bay until 1781, when at the age of forty she married the decorative painter Antonio Zucchi (died 1795), an older man who had long been a close friend to her and her father. The notorious 'Count de Horn' had recently been declared dead, so Kauffman was at last released from the limbo of her not-quite-single status. By then she had accomplished all she could hope for in England in terms of professional respect, admiration, financial reward

and fame, and left for the Continent with Zucchi and her elderly father, who wished to spend his last years in his native land.

EARLY LIFE AND TRAINING

According to De Rossi, Kauffman was recognized relatively early as a prodigy by her father, a provincial painter in Bregenz, a story that is typical of many artist's biographies.[8] As is the case with the majority of women artists, it was her father who first trained her in the basics of drawing and painting, allowing the girl to work beside him, drawing copies of plaster-casts and other objects. Soon she began to paint quite seriously, and by the time she was thirteen produced a more than competent self-portrait (illus. 8).

As a female prodigy, a very talented musician as well as painter, she became quite widely known. Still under the guidance of her father, she received numerous requests for portraits, and assisted him with his own commissions. In 1760, while still in her teens, she felt, according to De Rossi, that she must choose which career to pursue.[9] As De Rossi explained, this was a difficult decision to make, so she and her father consulted the local priest. He advised her that, while early success in a musical career would be comparatively easy and initially more lucrative, the life of a performer might present dangers for a young Catholic lady, as it would not allow time for proper religious observance. On the other hand, he argued, a career in painting required more training and would probably not bring immediate success, yet this more intellectual and arduous profession could ultimately bring greater reward. Thus, Kauffman chose to become a painter. This anecdote may be based on some truth; however, the fact that De Rossi chose to tell it is rather extraordinary, for one would not have thought a young woman of her circumstances in the eighteenth century would have concerned herself with any career at all. Furthermore, De Rossi reveals his own prejudice in favour of painting, and, as a supportive biographer, his characterization of Kauffman assured that not only would she be remembered as intelligent, hard-working and ambitious, but she would also be acknowledged as a 'proper' young woman of high moral standards.

Thirty years later, in the 1790s, at the time that she was compiling notes for her biography, Kauffman memorialized this choice in an allegorical self-portrait (illus. 36).[10] She portrayed herself standing between two female figures, who represent

the arts of Painting and Music. Such personifications had become a standard means of representation in allegory since the Renaissance. Based largely on images and attributes from Antiquity, these abstractions were identified by dress, pose, attributes and gender (most were female), and they were explained for artists, poets and others in dictionary-like guides, such as the well-known *Iconologia* by Cesare Ripa, first published in 1593 in Rome and reprinted in many editions and translations until the end of the eighteenth century.

Kauffman's composition is based on a well-known story, 'The Choice, or Judgement, of Hercules' (Xenophon, *Memorabilia*. II, i. 22), in which Hercules is confronted with the moral choice between Pleasure, represented as a beautiful, sensuous, reclining woman, and Virtue, personified as a powerful, upstanding and armed woman who points the way to the Temple of Glory. Many great artists since the Renaissance, such as Albrecht Dürer, Annibale Carracci and Nicolas Poussin, had invoked this moralizing tale, and Kauffman's contemporaries Pompeo Batoni (1708–1787) and Benjamin West (1738–1820) had both painted the subject.[11] Joshua Reynolds (1723–1792) had also employed a parody of the motif in the witty portrait of the actor David Garrick he painted in 1762: *Garrick Choosing between Comedy and Tragedy*, in which Comedy takes the place of Pleasure and Tragedy that of Virtue.[12]

In Kauffman's version her own image is substituted for that of Hercules and Music for sensual Pleasure, while she depicted Painting with the stern, heroic posture of Virtue. Kauffman's posture and glance indicate that, not without regret, she will follow the more difficult profession of painting up the steep path to her reward in the Temple of Glory, seen high on the mountain-top.

An important factor that distinguishes Kauffman's interpretation of this subject from any other version is her abandonment of Music, an act which for a woman artist held particular significance. There was a tradition among Italian Renaissance women artists, such as Lavinia Fontana, Sofonisba Anguissola and Marietta Robusti, of portraying themselves playing music, an art considered a proper aristocratic feminine accomplishment that expressed more about their class and decorum than their professional status as artists.[13] Kauffman's purposeful rejection of such an image, which parallels De Rossi's stress on her preference for painting and her difference from previous women artists, places her within the tradition of great male artists such as Poussin, who represented Hercules's

Choice for its theme of masculine moral judgement.[14] Thus, despite her position between two females, which gives her the appearance of one of the Graces,[15] Kauffman recorded her decision to choose the difficult path of a traditionally 'male' career, and the self-portrait sums up her sense of the achievements that had followed.

TRAVELS AND TRAINING IN ITALY

While still a young girl, even before she made her 'choice', Kauffman and her father lived and travelled in Italy, which since the Renaissance had been considered the artistic centre of Europe. She spent hours in the galleries of Milan copying paintings by the Old Masters, a privilege not usually granted to women. Later they went south to visit additional regions in order to broaden her knowledge of Renaissance and seventeenth-century painting, and to provide the necessary practice needed to perfect her technical skills. She studied the works of Correggio in Parma and the Carracci in Bologna, and produced copies after their works as drawings, etchings and paintings. She arrived in Florence in 1762 and soon obtained permission to copy in the Uffizi in a separate room where she could enjoy privacy. She was accepted as a member of Florence's prestigious Accademia del Disegno that year, and the next year she was in Rome, followed by several months in Naples fulfilling a commission to copy paintings in the Royal Collection of Capodimonte. She had returned to Rome by April 1764, where she lived until the following July.

During this period in Italy Kauffman became acquainted with several artists, whose works define early Neoclassicism including West (illus. 84), Batoni, Dance (1736–1811; illus. 86) and Gavin Hamilton (1723–1798). Also important for her growing interest in the Classical past was her friendship with the German antiquarian and scholar J. J. Winckelmann, whose book, *The History of Ancient Art* was published in 1764 (illus. 9).[16] Winckelmann, along with his friend Anton Raffael Mengs (1728–1779), whose paintings Kauffman knew, were considered to be authorities on Greek and Roman sculpture, and their works were highly influential in the creation of Neoclassical taste. Winckelmann served in Rome as librarian and antiquary to Cardinal Albani, whose great collection of antiquities Kauffman was familiar with, and he was appointed Prefect of Papal Antiquities in

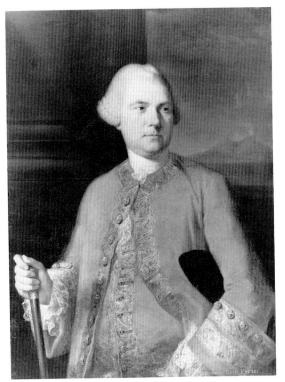
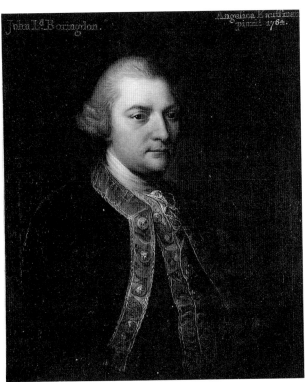

1 *Brownlow Cecil, 9th Earl of Exeter,*
1764, oil on canvas.

2 *John Parker, later Lord Boringdon,*
1764, oil on canvas.

1763. In addition, recent rediscoveries made in the course of excavations at Herculaneum and Pompeii outside Naples fueled a growing interest in Antiquity, and portraits of the British on the Grand Tour, especially those by Batoni, reflect this taste through the inclusion of Antique sculptures or well-known monuments in the backgrounds.[17]

Kauffman's paintings during this period in Italy demonstrate her awareness of and involvement in these developments. In Naples she received commissions for portraits from Englishmen such as David Garrick (illus. 85), whose portrait she sent for exhibition to the Society of Arts in London in 1765, the Anglo-American Dr John Morgan of Philadelphia,[18] Brownlow Cecil, 9th Earl of Exeter (illus. 1) and John Parker of Saltram, Devon (illus. 2), who later became an important patron. Her sketchbook from this period includes numerous portrait drawings as well as studies from the Antique (illus. 3), and copies after paintings, such as Titian's *Pesaro Madonna* in Venice (illus. 5) and Rembrandt's self-portrait in Florence (illus. 6).[19]

3 *Antique head of 'Seneca'(?)*, *c.* 1763, chalk,
from a sketchbook.

4 *Male figure*, *c.* 1763, chalk, from a sketchbook.

5 *After Titian's 'The Pesaro Madonna'*,
chalk, from a sketchbook.

6 *After Rembrandt's 'Self-portrait'*,
c. 1762, chalk, from a sketchbook.

In 1764 John Byng, a young Englishman on tour in Naples, was among the visiting gentlemen who commissioned a portrait from Kauffman. In James Martin's journal of his Grand Tour he noted that on Sunday 8 January 1764 he 'walked with Byng to Angelica's and saw her pictures – Portrait of Lord Exeter remarkably resembling'.[20] The portrait of Byng (illus. 10), completed shortly before his untimely death in Bologna in May of the same year, shows him standing before an open window through which can be seen a view of Naples harbour, with its distinctive lighthouse, and Mt Vesuvius in the distance. Byng gazes out from the picture, his hand on his hip, a pose characteristic of Batoni's portraits of English gentlemen at this time. Byng is shown in the act of turning the page of a book that lies open on a table, one of the volumes of the *Antiquities of Herculaneum*, the official publication of the excavations in which wall paintings and other objects were described and explained with engraved illustrations.[21] The particular page shown is plate IX from the second volume published in 1760, which illustrates an image of Urania, muse of Astronomy, one of a series of the Nine Muses painted on the walls of a villa (illus. 7). This image may have held some special significance for Byng;

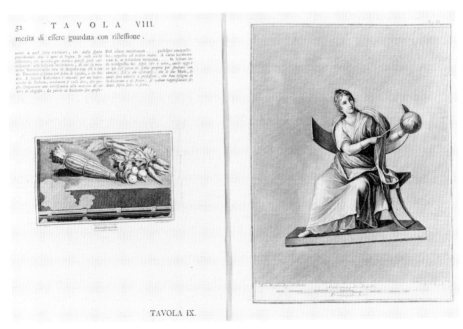

7 Anon., *Urania*, from *Le Pitture Antiche d'Ercolano*, 1760.

however, I suggest it was the phrase ending the sentence at the top of the preceding page that determined the choice. In Italian it reads: 'merita di essere guardata con riflessione' (Worth looking at with reflection).[22] This isolated phrase refers simultaneously, and wittily, to the book, to Antique art, to the heavens (astronomy), and to the fair city of Naples, in addition to Kauffman's representation of Byng, who in turn gazes back at the viewer (and painter) of his portrait. The young artist has cleverly managed to suggest Byng's fashionable worldliness and familiarity with the latest discoveries of Antiquity. This early portrait shows the sophistication and skill that brought her to the attention of British visitors even before she set off to pursue her career in England.

HISTORY PAINTING

Kauffman's sketches and commissions in Italy ranged from portraits to religious subjects, but her studies after Antique art and youthful attempts at Classical subjects prepared her for a career as a history painter, a genre that few women practised. What distinguishes Kauffman from most artists active in England during the eighteenth century, and from virtually all women artists before the twentieth, was her ambition to achieve standing as a history painter. Much of her success in England must also be attributed to this choice to become not just an artist, but specifically a history painter.

One of Kauffman's earliest known history, or subject, pictures is a large *Ariadne Abandoned by Theseus, Discovered by Bacchus*, signed and dated 1764, which also appears to be based on an Antique composition.[23] The God of Wine, with his leopard skin, thyrsus and crown of vine-leaves, looks down at the weeping maiden, who reclines in the erotic pose of a Classical nymph or a Venetian Renaissance beauty. This painting, as others from her early Italian period show, demonstrates a synthesis of Roman seventeenth-century Baroque classicism, as seen in paintings by Guido Reni and Domenichino, with an awareness of the new interest in and ideas about Antiquity shown by her contemporaries.

History painting, according to academic art theory formulated during the Renaissance, was the highest branch of the art, elevated above portraiture, genre scenes of everyday life, landscape and still-life. History painting represented heroic or tragic human actions through narratives based on scripture, mythology, Classi-

cal or modern history and literature. Its purpose was to provide moral instruction through the representation of uplifting scenes of noble deeds, although this lofty goal was often modified by purely visual delectation.

The theory and practice of history painting had been the subject of an influential book by Anthony Ashley Cooper, 3rd Earl of Shaftesbury, *A Notion of the Historical Draught or Tablature of the Judgement of Hercules* (1713). As the title indicates, Lord Shaftesbury utilised this story about the mythical hero Hercules, the subject on which Kauffman also based her allegorical self-portrait, as an example through which to explain the aims and process of history painting, especially in relation to and in contrast with narrative texts. This was part of a larger philosophical debate about the relative merits and methods of pictorial versus literary description of actions and emotions, the ability of artist or writer to portray a story both vividly and accurately.

In a lengthy description and analysis of the Choice of Hercules, Shaftesbury explained how this subject – the virtuous hero choosing between the easy path of pleasure or the hard path of virtue – perfectly embodied the principles of narrative history painting. In one economical scene it represented the reality of human action and passion joined with moral and poetic truth. Kauffman's choice of this particular composition for her self-portrait suggests that not only did she choose painting, but that she wished to identify specifically with its highest genre.

History painting was considered the most difficult and demanding genre, for it required an extensive knowledge of literature and history as well as skills in drawing the human figure, perspective and the technical knowledge of working in fresco or on canvas. Very few women were able to become history painters, for even those who took up the profession of painting often lacked the means to acquire the necessary literary education, and were discouraged from seeking such commissions; hence women more often specialized in the lesser genres of still-life or portraiture. Kauffman stands out as one of the few women, among them the seventeenth-century Italians Elisabetta Sirani and Artemisia Gentileschi, who were able to make a name for themselves as history painters.[24]

Training in anatomy was a particular problem for women, who were not generally allowed to draw from nude models, especially male nudes, and were forced to acquire this essential knowledge through the study of sculpture and painting, or from books.[25] It is for this reason that in the group portrait of 1771 by

Johann Zoffany (1734–1810) of the founder members of the Royal Academy, Kauffman and the other female founder member, the still-life painter Mary Moser, are not depicted in the room but only in the background as portraits hanging on the wall.[26] Their presence in the life-class would have been seen as highly inappropriate.

In his biography De Rossi made a particular point of emphasizing Kauffman's decision to become a history painter, or *pittrice storica*, the most noble field in the profession.[27] He explained that although the young Kauffman was recognized for her talent in portraiture, by the age of sixteen she resolved to become a history painter, and from that time this became her main ambition. He goes so far as to claim that she even denied 'Love' in order to follow this difficult path, and in order to prevent distraction she filled her time reading in Italian, French and German. From this point, says De Rossi, her entire training was based on preparation for her role as a history painter; as he tells it, this was certainly the case.

In Italy Kauffman had selectively studied the works of the most admired artists of the past, and she acquainted herself with Antique sculpture and architecture while developing the basic skills of perspective, chiaroscuro, colour, proportion and elegance of form. In order to establish a foundation for the creation of suitably noble subjects for paintings she read history, and poetry written in various languages. Later, De Rossi adds, on her journey to London from Italy in 1766 she stopped in Paris to study more works of art, in particular Rubens's great series of allegorical paintings in the Luxembourg Palace, which glorified the life and rule of Marie de' Medici. Thus, by the time she arrived in England, Kauffman was thoroughly prepared to take a place in the London art world as a painter of history as well as portraits.

History painting within the academies and among connoisseurs on the Continent commanded the highest respect and prices, but this was not the situation in England.[28] Shaftesbury was the first in a long line of commentators in the eighteenth century who wanted to establish a native school of history painting. The English had traditionally relied on foreign artists, not only portrait painters such as Hans Holbein, Peter Lely and Anthony van Dyck, but also history painters, such as Orazio and Artemisia Gentileschi, Rubens, and Sebastiano and Marco Ricci, to provide history or allegorical paintings.[29] Alternatively, they purchased foreign paintings while abroad. In 1755 Jean-André Rouquet had written that the

English did not often paint historical subjects, for even if they were capable, it would be folly for them to apply themselves to the nobler art of history painting, which was so little esteemed and encouraged in England.[30] British artists also complained of the lack of patronage for history painting, particularly William Hogarth, and by the mid eighteenth century dissatisfaction was rife.

By the 1760s there was a movement afoot to establish an Academy of Arts under royal patronage, which, among other things, could support the development of a public taste in England for modern history painting of heroic subjects, and, as Reynolds hoped, would bring about an enlightened, cultured populace who understood the value of civic virtue and national pride.[31] The Royal Academy of Arts was finally established in 1768, almost two centuries after the first art academies were founded in Italy and France.[32]

Arriving from the Continent at this critical moment, Kauffman came with the background, education, and skills to enable her to succeed as a history painter. In 1775, eight years after its foundation, a reviewer of the Royal Academy exhibition of that year wrote:

> It has long been a matter of *complaint* in this Country, that there is very little Encouragement for Historical Painting; and that most Men extend their Ideas of Painting no farther than to get their own Portrait executed, and perhaps that of their Wife, or favourite Child . . . However well founded the above-mentioned complaint might be some Years ago, yet it is certainly not so at present . . . The *public Exhibitions* have kindled an Emulation among the Artists; and above all, the ROYAL PATRONAGE AND PROTECTION has set an Example of Encouragement to the Rich and Great; so that at present when artists arise in the historical Line (of such acknowledged Merit as Mr *West* and Signora *Angelica*) there can be no doubt of their being fully employed and amply rewarded.[33]

This writer was optimistic, but although history painting found favour among the reviewers, academicians and a few enlightened patrons, it was never as popular in England as portraiture, landscape, or pictures of the houses, horses and dogs of the landed classes.

KAUFFMAN'S EARLIEST HISTORY PAINTINGS

While still in Italy, at about the same time she painted the *Bacchus Discovering the abandoned Ariadne*, Kauffman received a commission from John Byng for a pair of

8 *Self-portrait at Age 13*, 1754, oil on canvas.

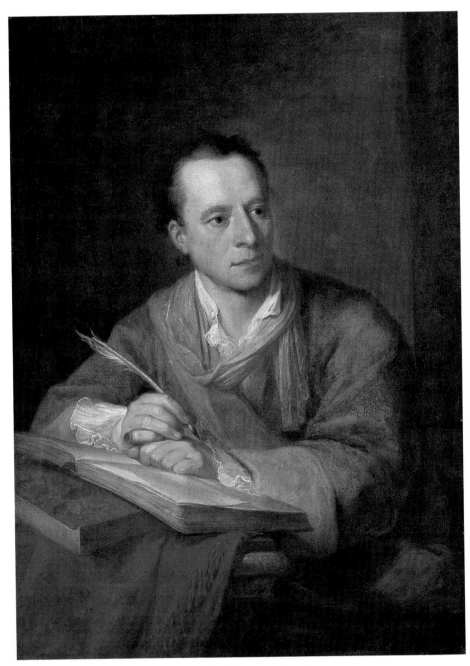

9 *Johann Joachim Winckelmann*, 1764, oil on canvas.

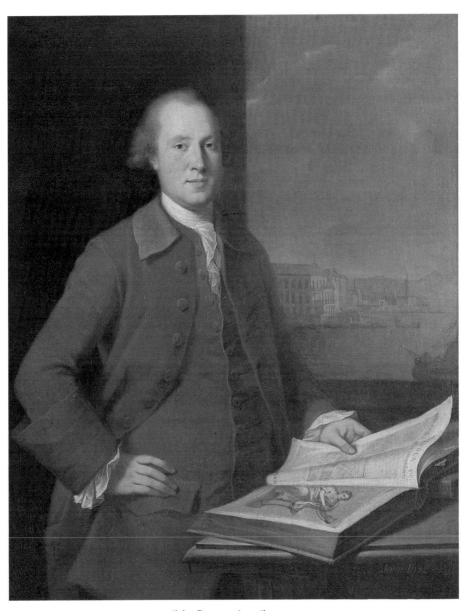

10 *John Byng*, 1764, oil on canvas.

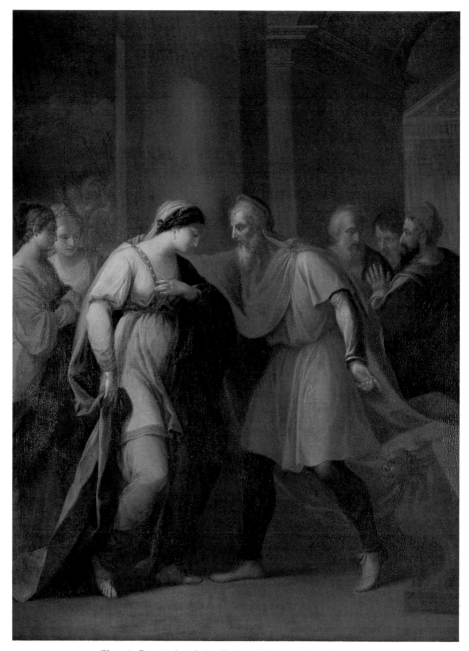

11 *Chryseïs Reunited with her Father, Chryse,* 1764, oil on canvas.

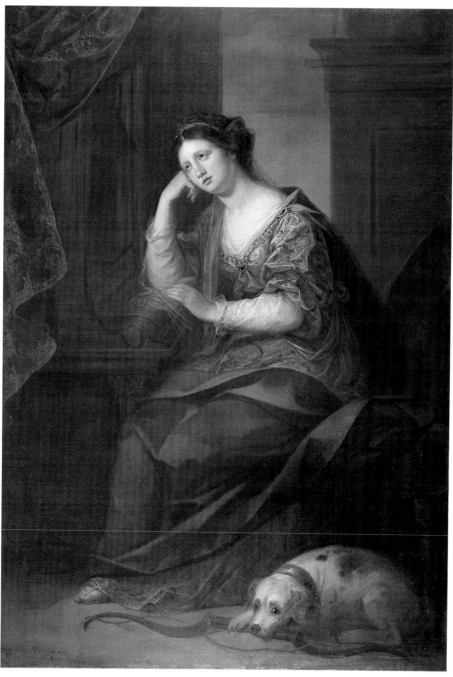

12 *Penelope at her Loom*, 1764, oil on canvas.

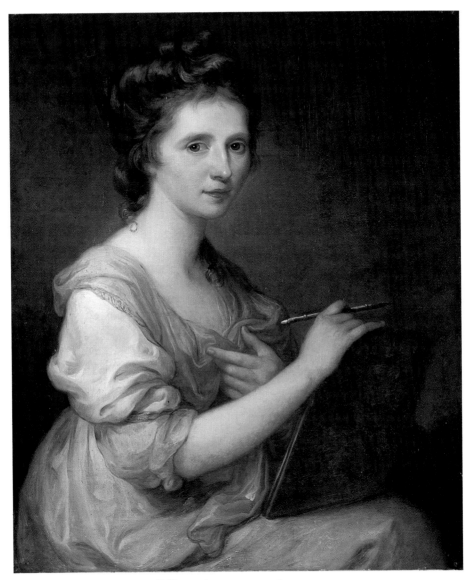

13 *Self-portrait, c.* 1770–5, oil on canvas.

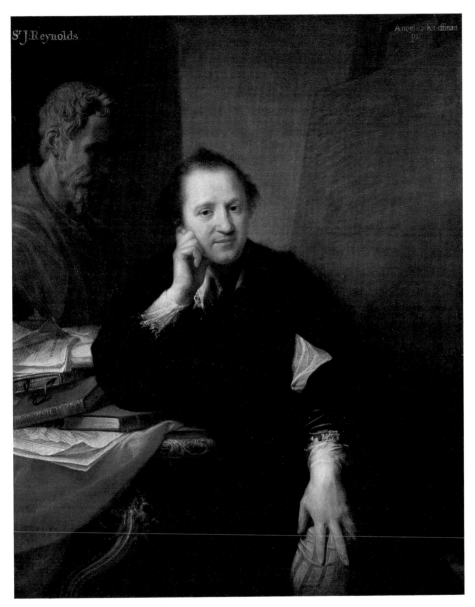

14 *Joshua Reynolds*, 1767, oil on canvas.

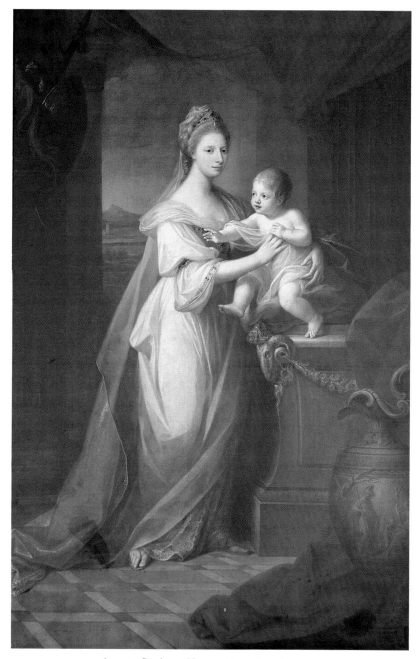

15　*Augusta, Duchess of Brunswick*, 1767, oil on canvas.

paintings that depict scenes from Greek and Roman history (illus. 11, 16). As pendants, they provide an important early example of Kauffman's treatment of Classical themes in her history paintings and demonstrate the way in which she often paired subjects to reinforce their meanings.

The subject of one of the Byng paintings (illus. 16) has long been recognized as a scene from the story of Coriolanus.[34] This Roman hero had been banished by his own people, and in anger he joined their enemies in an attack on Rome. Specifically, the scene is *Coriolanus Entreated by his Mother, Vetturia, and his Wife, Volumnia*, which takes place during a truce, when the women implore Coriolanus not to make war on his native land. In Classical texts it was often cited as an example of patriotism and familial piety overcoming wrath, as shown in an illustration to a 1567 edition of Valerius Maximus (illus. 17).[35]

This subject is unusual, but it had appeared in painting previously, in, for example, a version from the early eighteenth century painted for Sir Gregory Page of Blackheath House in London by the Italian artists Francesco Imperiali and Agostino Masucci (illus. 18).[36] In this painting the two women accompanied by Coriolanus's children stand before him in his camp. Coriolanus steps forward as if to embrace them, but his mother stops him with outstretched arm and appears to speak. Their poses imply the moral strength of the women's plea for peace, family unity and restraint, which ultimately convinced him to withdraw his troops.

As a companion piece to this painting of a moralizing, heroic Roman subject, Masucci and Imperiali, following the pattern of Plutarch's parallel lives, represented a Greek counterpart – a scene from Homer's *Iliad* of *Hector Taking Leave of his Wife, Andromache, and Son, Astyanax*, in which the wife begs her husband to remain with her. The women and children also intervene in an attempt to restore peace and family stability.

These moralizing, sentimental themes from Classical literature of the personal grief of public figures became quite popular among the British, and by the early 1760s, when Kauffman was painting in Rome, Gavin Hamilton, a pupil of Masucci, portrayed *Andromache Weeping Over the Body of Hector* (1761), and *The Oath of Brutus on the Death of Lucretia* (1766). Nathaniel Dance, Kauffman's new friend, had painted a similar oath-taking in the *Death of Virginia* (1761), and Benjamin West produced a *Continence of Scipio* (1766).[37]

Kauffman, in the manner of Imperiali and Masucci, created a companion

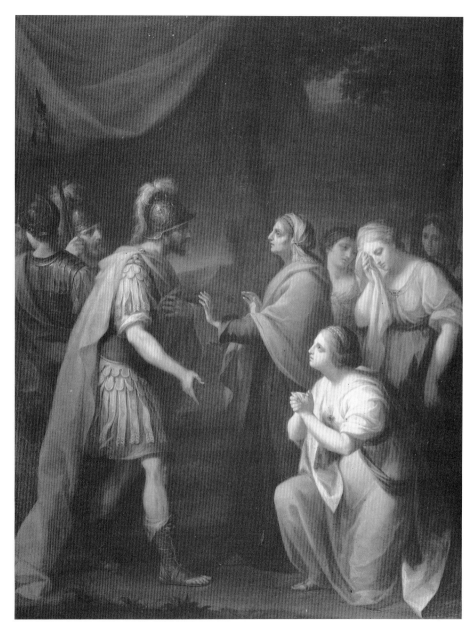

16 *Coriolanus Entreated by his Mother, Vettunia, and his Wife, Volumnia,* 1764,
oil on canvas.

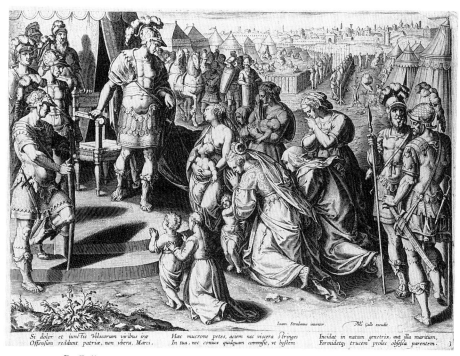

17 P. Galle, engraving after J. Stradanus, *Coriolanus*, from Valerius Maximus, *Facta et dicta*, 1567.

picture for the Roman *Coriolanus* in a Greek subject that echoed and comple-
mented the theme of filial devotion and womanly peacemaking. This subject,
which, since the nineteenth century, has been called the 'Companion to Cor-
iolanus', is *Chryseïs Reunited with her Father, Chryse*, a scene from Book I of the *Iliad*,
in which the young woman who had been Agamemnon's mistress is returned by
Odysseus to her father, the Trojan priest of Apollo whose prayers had prevented
the sailing of the Greek fleet (illus. 11). The pair appear in the centre of the
composition, Chryseïs with sad, downcast expression gently guided by her father to
a seat. At the far left behind the women, Greek soldiers can be seen departing, and
on the right a group of Trojan men wearing, as Chryse does, the distinctive
Phrygian cap react to the implications of this reunion. A father and daughter are
brought back together during a truce, and, as with the companion painting of
Coriolanus, we can see the tension and divided loyalties of parted families in time of
war. Kauffman has emphasised the similarity and balance between the two through

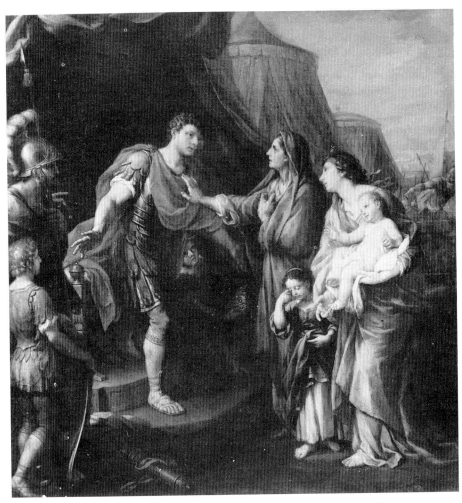

18 Francesco Imperiali and Agostino Masucci, *Coriolanus Entreated by Vettunia and Volumnia, c.* 1765, oil on canvas.

the centralized placement and confrontations between mother and son, father and daughter. Her rich colours, solid figures, dark backgrounds and clear rhetorical gestures and expressions recall the Roman Baroque classicism of Guercino, as in his *The Intervention of the Sabine Women* (1645), Domenichino or Guido Reni.

Another painting Kauffman made in Rome in 1764 exhibits many of the same influences and introduces a theme that became important and popular in her work later in England: Penelope, the heroine of the *Odyssey*. The painting *Penelope at her*

Loom (illus. 12) is slightly larger than the Byng paintings. It represents Odysseus's faithful and patient wife as the ideal embodiment of devotion. She sits in the classic pose of melancholic reverie beside the loom on which she alternately wove and unraveled her father-in-law's shroud in an attempt to deceive and delay the numerous suitors who intended to compete for her hand (Odysseus they presumed dead) as soon as the weaving was complete. In sympathy with her mood, Odysseus's faithful dog lies at her feet resting on his master's great bow, the weapon with which Odysseus would eventually slay the impatient suitors.

Kauffman's choice of Penelope for a large history painting is significant, as this subject was extremely rare in painting. Unlike the more frequently portrayed classical heroines, such as Lucretia, Virginia, Iphigenia, Polyxena, Ariadne, Cleopatra or Andromache, Penelope is not a passive victim, an abandoned maiden or a grief-stricken suicide. Nor is the subject suitable for the rather erotic representations of bare-breasted female victims so popular in the seventeenth century. Penelope is the ideal married woman and mother: patient and faithful, gifted by Athena herself with a talent for womanly handicraft and a clever, crafty mind. It is not surprising that a young female painter with artistic skills, intelligence and wit would exploit the image of Penelope, who was so rarely depicted in art. Penelope, like so many other females in Classical literature, may weep and mourn, yet her perseverance and cunning allowed a more positive interpretation of female virtue and strength. Protected by Athena, the chaste warrior goddess of wisdom and the arts, Penelope provided a suitable character through which Kauffman could advertise her talents.

ARRIVAL IN ENGLAND

While Kauffman was steadily enlarging her clientele among the British visitors in Italy, she did not receive many commissions from the Italians, so that when, in 1766, Bridget, Lady Wentworth, wife of John Murray, the British Consul, invited her to England, Kauffman seized the opportunity to further her career where she was more likely to succeed. Even before her arrival in London in June of that year, Kauffman had made influential contacts and patrons in Lord and Lady Spencer and Brownlow Cecil, 9th Earl of Exeter, who soon introduced her to Reynolds. She set up a studio in London complete with separate rooms for painting and for

displaying finished works for view by clients, so she could maintain a lifestyle appropriate to a painter of fashion.

Kauffman had arrived at an important turning-point in the history of British art, on the eve of the foundation of the Royal Academy. Reynolds must have been intrigued by this young, attractive female painter who had already proven her ability in history painting, the type of painting he hoped to promote in England. Her Continental background and training in history painting, which Reynolds himself lacked, and her talent for pleasing British taste put her in a position to play an important role.

Her friend Nathaniel Dance, to whom she may have once been engaged, painted her portrait at about this time. She appears as an enchantingly pretty and fashionable young woman holding her portfolio and crayon as if ready to launch her career (illus. 19). In a self-portrait painted a few years later (illus. 13), she represented herself in nearly the same pose, but in a less constraining, Neoclassical, gown, with loosely piled hair and otherwise unadorned. With slightly parted lips she points to herself, an image of self-possession, the mirror of her own ambitions.

While a jealous Nathaniel Dance may have mocked her relationship with the older, hard-of-hearing Reynolds in an amusing drawing in which abandoned Music turns her back upon them (illus. 20), there is no doubt that she and Reynolds became mutual admirers as both artists and friends. This relationship provoked much speculation and gossip. In 1775, for example, the Irish painter Nathaniel Hone (1718–1784) submitted *The Conjuror* to the Royal Academy's annual exhibition, in which he mocked Reynolds's method of painting. In the background of Hone's painting were several naked revellers (since overpainted, but see his sketch: illus. 21), one of which was taken to be Kauffman. Following her letter of protest to the Academy, *The Conjuror* was withdrawn.[38] One of her early critical successes in England was her portrait of Reynolds of 1767 (illus. 14), which was acquired by his boyhood friend John Parker, later Lord Boringdon, the same individual that Kauffman had portrayed a few years earlier in Naples. She depicted Reynolds attired in van Dyck-style finery, leaning his head on his hand in a characteristic pose. He sits beside a table covered with works by British authors who were also his friends, Johnson's *Idler* essays, Oliver Goldsmith's *The Traveller* and Edmund Burke's *Philosophical Enquiry into . . . the Sublime and Beautiful*, and a bust of Michelangelo, the artist Reynolds admired above all others, positioned as if to

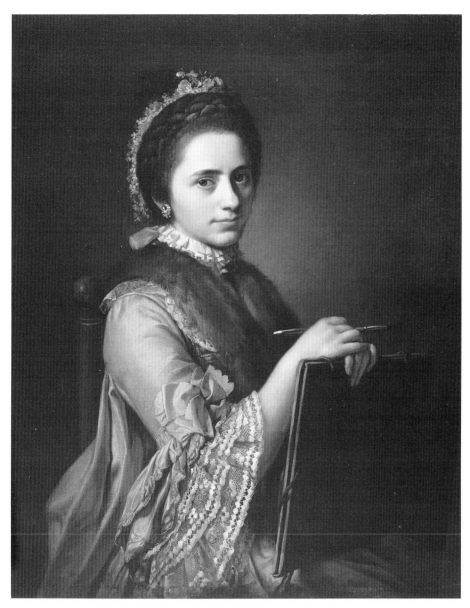

19 Nathaniel Dance, *Angelica Kauffman*, *c.* 1765, oil on canvas.

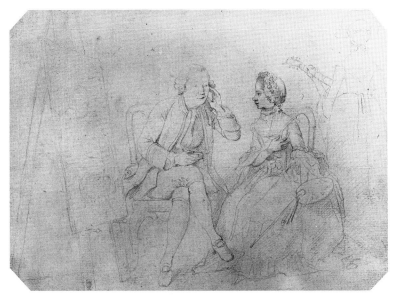

20　Nathaniel Dance, *Angelica Kauffman and Joshua Reynolds*,
c. 1766, pencil on paper.

21　Nathaniel Hone, *Sketch for 'The Conjuror'*, 1775, oil on wood.

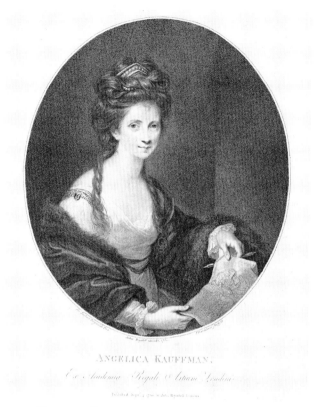

22 Francesco Bartolozzi after Joshua Reynolds, *Angelica Kauffman*, 1780, stipple engraving.

whisper inspiration into Reynolds's cupped ear. At his side a blank canvas stands on an easel, which along with his thoughtful pose, alludes to the first part of artistic creation, the invention that takes place within the mind.[39] One of Kauffman's most appealing works, this portrait seems to capture the warmth and respect shared by artist and sitter, as well as the patron, Reynolds's friend John Parker. Reynolds may have undertaken to paint her portrait that year, although no picture has ever been securely identified. The Bartolozzi print of 1780 after a painting in the Spencer collection, and formerly at Althorp, is probably after a later painting of 1777 (illus. 22).[40]

Another notable achievement during her first year in London was a commission for a large state portrait of Augusta, Duchess of Brunswick, George III's sister

(illus. 15). The Duchess stands against a distant view, gracefully attired in a flowing white garment of pseudo-Antique style, with her infant son Charles George Augustus. To enhance the timeless elegance of her stance, she delicately poises the child on a pedestal. The pose of mother and child demonstrates Kauffman's familiarity with both the meaning and forms of Antique art, for it is based on a Greek statue known through Roman copies. The original represented Peace holding the infant Wealth, an allegorical subject eminently suitable for portraying the Princess and her child.[41] This interpretation is confirmed by the image and inscription on the urn beside her, which alludes to Augusta's husband, the Duke of Brunswick, to his military victory at Emsdorff in 1760, and to Love's victory over him when he married her in 1764.[42] The relief on the urn depicts Mars and Venus with Cupid between them, a Classical image readily recognizable as Love conquering War, which results in peace and prosperity. Perhaps Kauffman was inspired by the flattering allegorical portrayals of Marie de' Medici by Rubens that she had recently seen in Paris, but in any event her success was assured when the Princess of Wales, mother of the Duchess and the King, visited her studio to see the picture, an event that Kauffman wrote about to her father, telling him that no other artist had ever received such an honour.[43]

The careful thought and effort Kauffman put into this allegorical portrait seems to have been calculated to attract the attention of the King, who was already involved in plans to found the Royal Academy. Impressive and grand, the portrait was much more than a simple likeness, for it embodied the idea of historical or allegorical portraiture that Reynolds was later to extol in his annual presidential Discourse at the Royal Academy.

HISTORY PAINTINGS FOR SALTRAM

In 1768 a special private exhibition was held in London by the Society of Artists in honour of the visiting Christian VII of Denmark. At the same time plans were under way for the Royal Academy's foundation, so it was agreed that artists who participated in this exhibition could show the same works the following spring in the first of the new Academy's exhibitions.[44] The showing was notable for the inclusion of several history paintings of Classical subjects, such as West's *Agrippina Landing at Brundisium with the Ashes of Germanicus*, which was composed in a

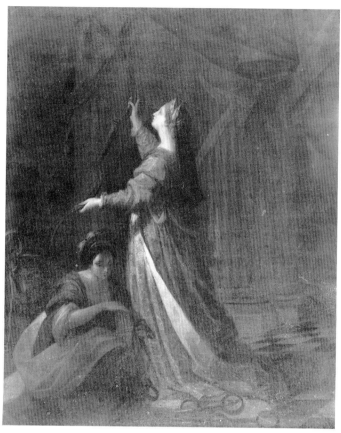

23 *Penelope Taking Down the Bow of Ulysses for the Trial of her Wooers*, 1768, oil on canvas.

Neoclassical style based on the work of Poussin and Roman relief sculpture.[45] Kauffman showed three paintings of subjects from the Trojan legend (illus. 23, 24, 25), and the following year she exhibited them along with one other (illus. 26) in the Royal Academy show. All four were acquired by Reynolds's friend, John Parker, who had recently married Theresa, daughter of Thomas Robinson, 1st Baron Grantham.

Parker had also just inherited the estate of Saltram Park in Devon, and commissioned the architect Robert Adam (1728–1792) to design a Grand Saloon.[46] After several years in Italy studying Classical architecture, Adam had become much sought after by the aristocracy, for whom he provided Neoclassical

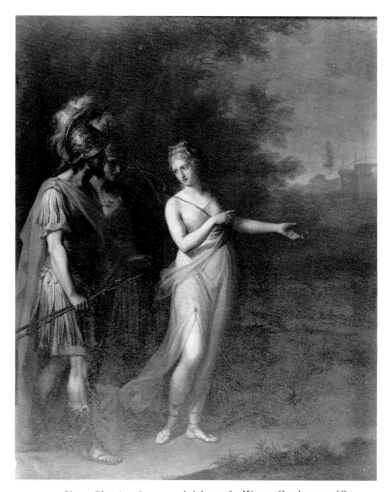

24 *Venus Showing Aeneas and Achates the Way to Carthage*, 1768,
oil on canvas.

designs for houses and interior furnishings, such as those at Kenwood and
Osterley, two houses on the edge of London. It seems likely that Kauffman's four
paintings were specifically commissioned as part of the decorative scheme for this
room, no doubt under Reynolds's guidance. The critical success of these pictures
firmly established her presence in England as a history painter of the highest
quality. A review of the Royal Academy exhibition in 1769 noted 'Hector and
Andromache, Venus Directing Aeneas and Achates, by Mrs Angelica, an Italian
young lady of uncommon genius and merit'.[47]

All four paintings are limited to a few key figures arranged near the foreground plane. Two are composed in a vertical format and are identical in size, while the remainder are horizontal and somewhat larger, suggesting two pairs. The first painting represents a scene from the *Iliad* (VI, 394–496) – *The Interview of Hector and Andromache* (also known as *Hector Taking Leave of Andromache*) – in which the hero, bidding farewell to his wife, and to his young son held in the nurse's arms, departs for the battlefield (illus. 25). Kauffman limited the scene to its essential figures, and minimised all extraneous ornamentation.

The other pictures first shown in 1768 represent *Penelope Taking Down the Bow of Ulysses* (illus. 23), a scene from the *Odyssey* (XXI, 40ff.), and *Venus Showing Aeneas and Achates the Way to Carthage* (illus. 24), another episode in the Trojan legend, from Vergil's Latin epic, the *Aeneid* (I, 314–71). The fourth painting she added to the group in 1769 was *Achilles Discovered by Ulysses amongst the Attendants of Deidamia* (illus. 26), which Kauffman took from the less well known *Achilleid*, a fourth-century Latin epic by Statius.

Kauffman must have been influenced in her choice of subjects at least in part by an important recently published source, the Comte de Caylus's *Tableaux tirés de l'Iliade, de l'Odyssée d'Homère et de l'Enéide de Vergile*.[48] This book was a helpful and instructive guide for history painters to the most suitable pictorial compositions from the great Classical epics. Caylus has selected particular narrative moments for their powerful ideas, grand images and continuous narratives, which could be broken down into easily understood, separately rendered, actions. This was a practical text, one that belonged to the continuing theoretical debate that had concerned Shaftesbury on the comparison of verbal and visual means of describing narrative action.

Kauffman had already painted at least one subject recommended by Caylus, the return of Chryseïs to her father by Odysseus (illus. 11), one of the pictures for Byng.[49] Three of the subjects portrayed in Kauffman's Saltram pictures – Penelope taking down the bow, Hector and Andromache, and Venus and Aeneas – are recommended in this book as well, although Kauffman seems also, as Caylus recommended, to have directly consulted the original texts, for she reproduced the actions with remarkable fidelity.

Hector Taking Leave of Andromache follows Caylus's advice to emphasise the relationship between husband and wife, and to differentiate the emotions by

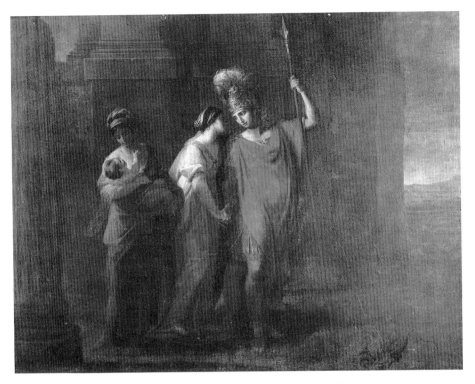

25 *The Interview of Hector and Andromache*, 1768,
oil on canvas.

character and sex.[50] She renders this moment with economy and grace in a simple, frieze-like arrangement, in which we can see Andromache's intense love and anxiety as she attempts to persuade Hector to stay, as well as Hector's painful decision as he wavers between remaining with his family and leaving for the field of battle. Each character expresses conflicting emotions, and the viewer, knowing the tragic outcome, can well understand the poignancy. Hector, of course, makes the only choice a virtuous hero can make and, like a Hercules, he takes the more difficult path, that of separation from his wife.

The scene from the *Odyssey* is especially notable, for it does not appear to have been depicted by any other artist prior to Kauffman (illus. 23).[51] Penelope, the faithful wife whom Kauffman had already depicted at her loom, was also left by her husband when he went off to the Siege of Troy. Caylus gave a brief description of Penelope's actions as she removes the bow, but Kauffman also followed Homer's

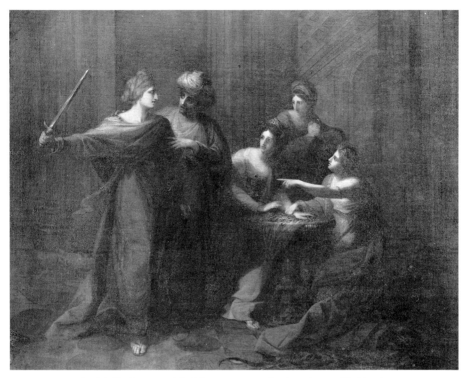

26 *Achilles Discovered by Ulysses amongst the Attendants of Deidamia*,
1769, oil on canvas.

description quite closely. The significance of Penelope's action lies in our anticipa-
tion of the dramatic revelations of Odysseus, who has returned in disguise and with
whom she will soon be reunited. *Venus Showing Aeneas* (illus. 24) represents a
moment that immediately precedes the meeting of the lovers Aeneas and Dido.
This picture forms a visual pendant to the vertically formatted *Penelope*, and all
three of Kauffman's paintings share the theme of heroes of the Trojan War who
must leave their women behind.

Kauffman followed Vergil's descriptive text closely, depicting Aeneas accom-
panied by his friend Achates and carrying two broad-tipped spears at the moment
he meets his mother, who, disguised as a hunting maiden, hopes that Dido will
enable her son to reach Italy. This subject forms a counterpart to the situation of
Penelope and Odysseus, for both stories involve disguises, and in each painting the
loved one is conspicuously absent, though, as the knowledgeable viewer recog-

nizes, is soon to enter the narrative. The viewer is made aware of the presence of
absent loved ones through symbolic attributes, a device recommended to painters
by Shaftesbury when they cannot include all sequential events in the single scene.[52]
The absent Odysseus is represented by his bow, which in turn forms a connection
with Venus's bow and arrows. Love's weapons, Odysseus' bow, Aeneas's broad-
tipped spears and Hector's upright lance punctuate the mixed emotions of private
and public devotion expressed in poetic imagery.

All three subjects illustrate the conflict between Love and War as experienced by
men and women. Although Caylus's book did not include the fourth scene, from
the *Achilleid* (illus. 26), it was the subject of a supposed ancient painting described
in the *Imagines* of the Greek author Philostratus, which had been a source for many
Renaissance recreations of ancient paintings;[53] the scene had, in fact, been painted
in several versions by Poussin. The inclusion of this subject was probably Kauff-
man's original addition, chosen to complement the other three scenes and to
complete the theme: love between heroes and heroines portrayed at dramatic
moments of meeting or parting. Achilles appears disguised as a maiden, for the
young hero had been hidden by his mother among the daughters of Lycomedes so
that he might escape the prophecy of his heroic, but early, death in the Trojan War.
In this scene the crafty Odysseus tricks Achilles into revealing his manhood, when
he cannot help but choose the shining sword he holds aloft that had been hidden
among feminine gifts of clothing and jewels. Kauffman depicts the moment of
Achilles's self-betrayal and the women's reaction to the event, especially his
beloved Deidamia, who begins to rise, her face revealing sadness and some fear.
Achilles's sword is the fourth symbolic weapon in this group. Together, Kauffman's
four pictures represent the conflict between love and war, male and female roles,
passion versus good judgement, and the difficult choices these characters must
face. Masculine public virtues of patriotism and courage are contrasted and
balanced by the soft grace of the women.

This unified group of pictures was likely intended to serve as overdoors in
Saltram's Grand Saloon, the large drawing-room designed by Adam (illus. 27):
the two vertical paintings above the doors that flank the fireplace, the horizontal
pictures over the doors at each end. Adam's drawings for Saltram were modified
several times,[54] and characteristically he indicated only the general outlines of the
room, showing the placement of windows, mirrors and pictures, but without

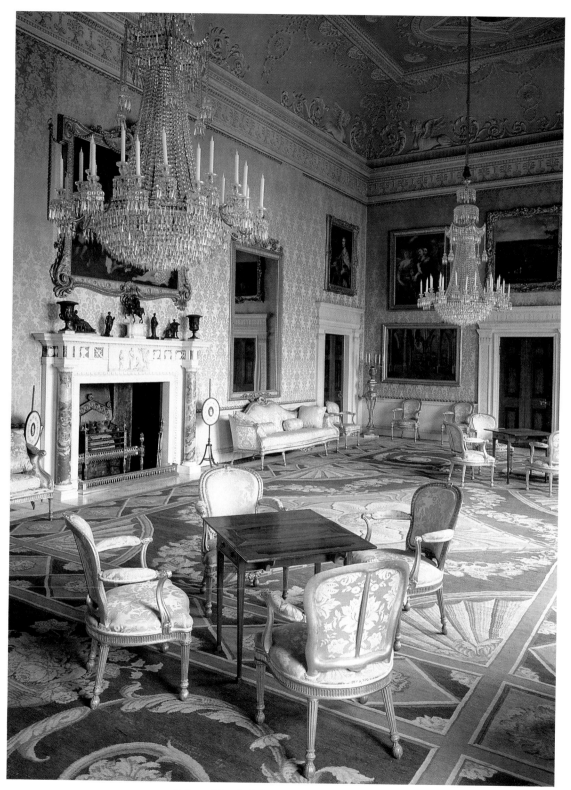

27 Robert Adam's Saloon at Saltram, Devon, 1768.

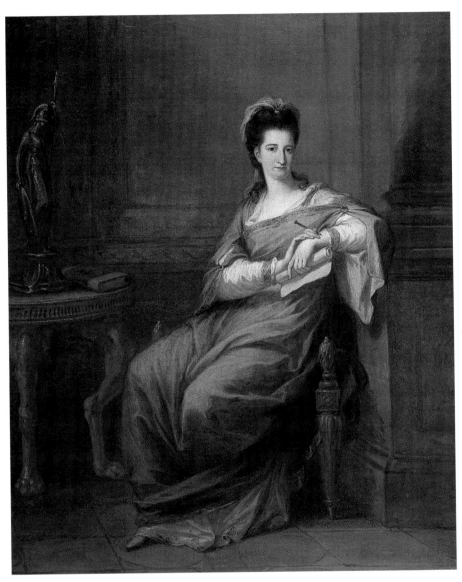

28 *A Lady with a Statue of Minerva, c.* 1775, oil on canvas.

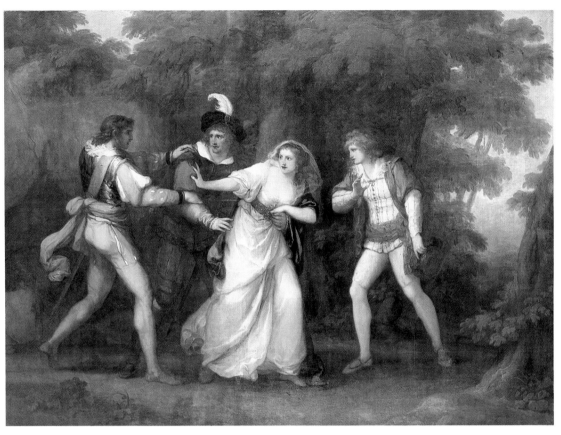

29 *Scene from 'The Two Gentlemen of Verona'*, 1789, oil on canvas.

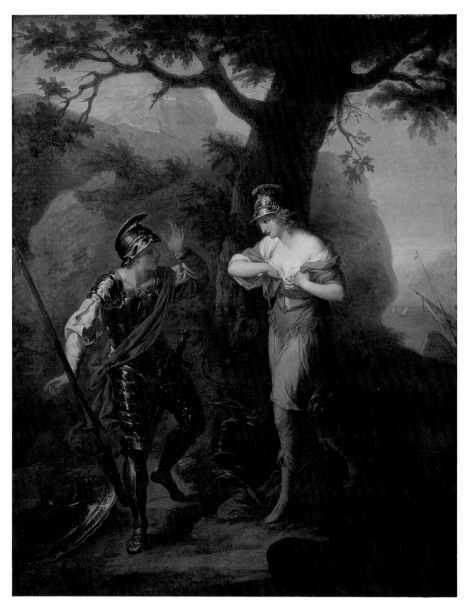

30 *Trenmor and Imbaca, from 'Ossian',* 1773, oil on canvas.

31 *Eloisa and Abelard*
(from Pope's Poem), c. 1778

32 *Abelard presents Hymen to Eloisa*
(from Pope's Poem), c. 1778

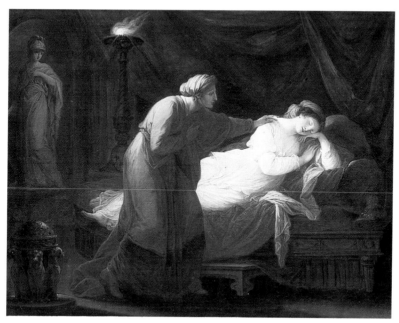

33 *Penelope Awakened by Euryclea with the News of Ulysses's Return,*
1773, oil on canvas.

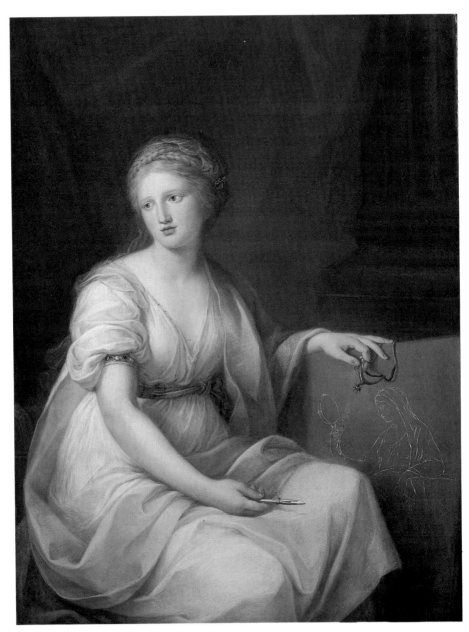

34 *Allegory of Imitation, c.* 1780–81, oil on canvas.

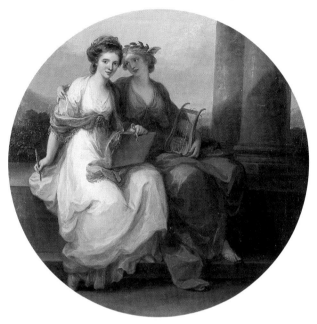

35 *Self-portrait in the Character of Painting Embraced by Poetry*,
1782, oil on canvas.

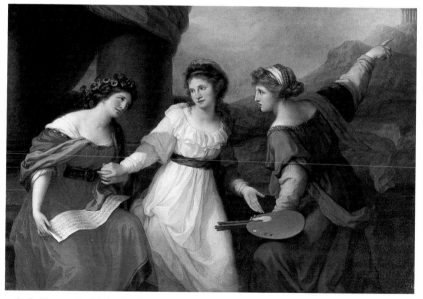

36 *Self-portrait: Hesitating Between the Arts of Music and Painting*, 1791, oil on canvas.

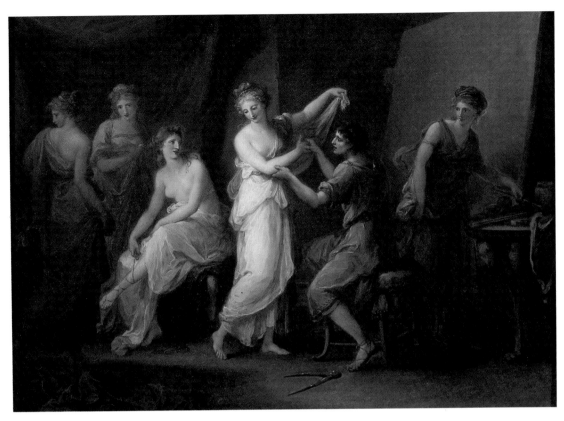

37 *Zeuxis Selecting Models for his Painting of Helen of Troy*, *c.* 1778, oil on canvas.

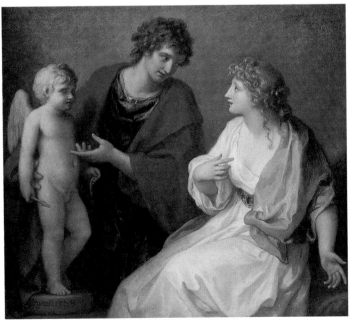

38 *Praxiteles Giving to Phryne his Statue of Cupid*, 1794, oil on canvas.

specifying particular subjects. Kauffman's four paintings would have fitted into the spaces provided, but the strongest evidence for their intended placement in this room is the image carved on the fireplace mantel (illus. 101). In the original sketch the central panel was a decorative scroll motif; however, the finished mantel carved by Thomas Carter represents the Choice of Hercules, the quintessential choice between pleasure and duty, and the subject central to Shaftesbury's discussion of history painting.[55]

It is not entirely clear whether or not Parker had specifically commissioned the paintings from Kauffman before she made them, or if after she had exhibited the first three Reynolds convinced his friend to purchase them as a gesture of enlightened patronage. It was not uncommon for interiors to be designed with specific paintings in mind, although they were usually for Old Master paintings purchased on the Grand Tour. The significance of Kauffman's pictures for Saltram is that they provided a series of history paintings on Classical themes by a modern artist that could be integrated into a decorative scheme by a contemporary British designer. Although the Grand Saloon was intended to display family portraits and other works of art, Kauffman's paintings would have given the space a framework based on a cohesive theme conceived to instruct as well as delight in the Renaissance tradition of allegorical fresco cycles. The balance of male and female roles, both sentimental and moralizing, was ideal for the home of a fashionable young couple.

Soon after the marriage, Theresa Parker, whose surviving letters reveal her lively intelligence and impressive knowledge of art and theory (she discussed Reynolds's ideas about art with him at dinner-parties), appears to have taken over the responsibility of purchasing paintings for the new room.[56] It is quite possible that Kauffman's pictures were never placed where they were originally intended, for by the early nineteenth century, when the Saloon became a ball-room, they were embellishing the main staircase, where they are today. Kauffman's thoughtful interweaving of themes and pictorial compositions was no longer apparent, and Reynolds's desire to promote a taste for modern British art of the most elevated kind continued to be frustrated when the walls were filled with copies after Titian's erotic paintings of the Loves of the Gods: *Bacchus and Ariadne* and *Danaë*. High-minded and literary instruction in civic virtues through pictorial means did not catch on easily in Britain, despite Reynolds's support and encouragement.

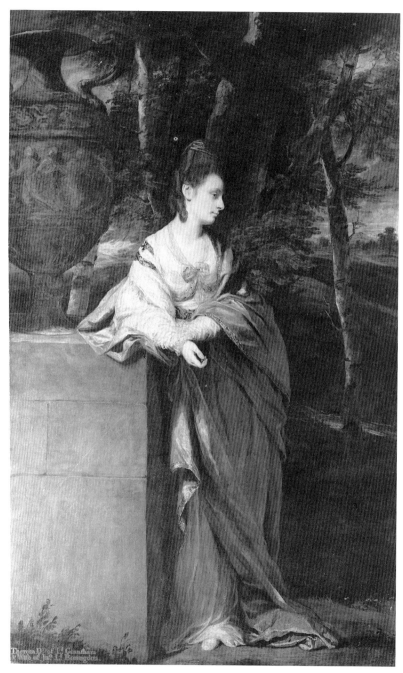

39 Joshua Reynolds, *Theresa Robinson, Mrs Parker*, 1773, oil on canvas.

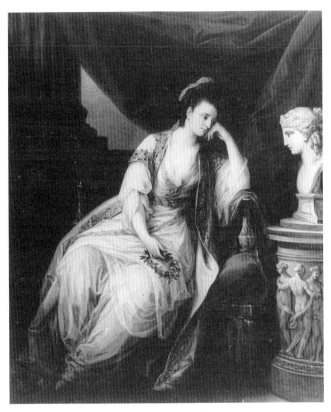

40 *Theresa Parker*, 1773, oil on canvas.

THE PORTRAIT OF THERESA PARKER

In 1773 Reynolds painted a large portrait of Theresa Parker for the Grand Saloon
(illus. 39) to form a pair with a portrait of a Parker ancestor, and a more informal
seated portrait of her to which he later added her son. At the same time that she was
in London, sitting for Reynolds, Kauffman also made a portrait of Theresa
(illus. 40), which seems to have been intended by the sitter as a gift for a close
friend, Lady Anne Pelham. An entry in Parker's account book for 29 May 1773
indicates a payment to 'Miss Angelica' of £50 in cash, a generous sum, for a three-
quarter-length portrait given to Lady Pelham, and on 4 June 1773 Theresa
mentioned in a letter to her brother that her husband had given Lady Pelham her
picture, 'and she was pleased with it'.[57]

The allegorical treatment of the figure also suggests it was intended for a special recipient. A gauzy, white embroidered garment drapes Theresa's body that suggests both an informal and timeless quality. This is the pseudo-Turkish dress in which Kauffman frequently portrayed female sitters in the mid 1770s.[58] Other similar examples are *Margaret, Lady Bingham, later Countess Lucan* (see illus. 125), *Mary, Duchess of Richmond* (illus. 80), *A Lady in a Turkish Dress* (illus. 63), and the picture known as *Morning Amusement* (illus. 119). These women are shown engaged in needlework or as if looking up from reading, writing or some other private activity. Kauffman's portraits of women in Eastern garb in imitation of the garments worn in the Turkish harem suggest an exclusively female setting, or at least the informality of women receiving female visitors in their private rooms, a relaxed intimacy that could perhaps be achieved more easily in a female artist's studio.

Theresa Parker (illus. 40) gazes thoughtfully at an ideal Antique-style bust of a woman, an image that Kauffman took directly from her own drawing made many years earlier in Italy. Carved in relief on the pedestal are the Three Graces with arms entwined, who symbolize, according to Ripa's *Iconologia*, the reciprocity of true friendship, as well as beauty; the evergreen wreath of myrtle Theresa holds represents constancy. Together, these symbols indicate the bonds of friendship, allegorical imagery suitable for the portrait of a lady made for a close female friend. Theresa's contemplative pose recalls Kauffman's earlier painting of Penelope pining for her distant husband, so that Theresa, too, seems lost in reflection on her absent friend.

ROYAL ACADEMY EXHIBITIONS

Once the Royal Academy exhibitions were established on an annual basis, Kauffman became a regular contributor, consistently showing a variety of paintings in order to demonstrate to the public and potential patrons the full range of her talents. For example, in 1770 she showed another Trojan War theme, *Hector Upbraiding Paris for his Retreat from Battle* (illus. 41); a subject from Roman history, *Cleopatra Adorning the Tomb of Mark Antony* (illus. 42); a scene from the religious epic *Messias* by the German poet Friedrich Klopstock; and one of the first pictures of British history, *Vortigern, King of the Britons, Enamoured with Rowena, at the Banquet of Hengist, the Saxon General. Vortigern* was acquired by the Parkers for

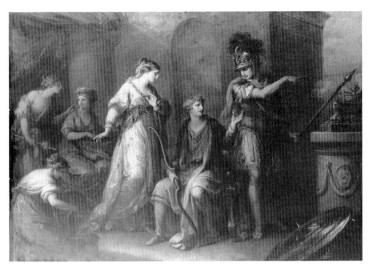

41 *Hector Upbraiding Paris for his Retreat from Battle*, 1770, oil on canvas.

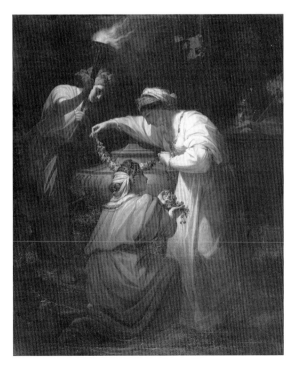

42 *Cleopatra Adorning the Tomb of Mark Antony*
1770, oil on canvas.

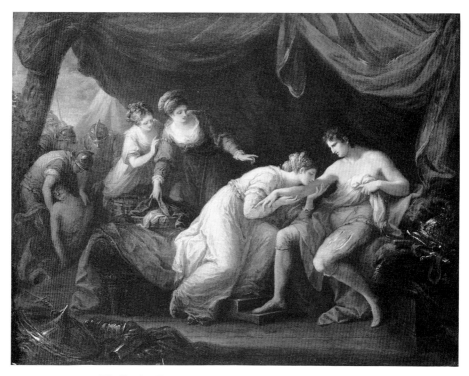

43 *The Tender Eleanora Sucking the Venom out of the Wound . . . ,*
1776, oil on canvas.

Saltram in 1771 together with a second painting of a scene from British history that
Kauffman had shown the same year, *The Interview of King Edgar with Elfrida, after
her Marriage with Athelwold.* These had been left on the artist's hands when an
earlier commission from an unidentified patron, a commission that included
West's *The Death of General Wolfe*, had fallen through.[59] Today, these two large
paintings also hang on the stairs at Saltram.

Ironically, although the Society of Artists had offered premiums since 1760 for
paintings of British history, it was the Swiss Kauffman (in 1771) and the American
artist West who first exhibited such subjects at the Royal Academy.[60] In 1776
Kauffman exhibited two pictures of stories taken from Paul de Rapin-Thoyras's
History of England (1726–31): *The Tender Eleanora Sucking the Venom out of the
Wound which Edward I, her Royal Consort, Received with a Poisoned Dagger from an
Assassin in Palestine* (illus. 43), and *Lady Elizabeth Grey Imploring of Edward IV the*

Restitution of her Deceased Husband's Lands, Forfeited in the Dispute between the Houses of York and Lancaster (see illus. 141). She seems to have made a point of choosing subjects that featured women, perhaps in an attempt, as a woman, to secure the interest and patronage of the Queen, as West had won patronage by the King for his heroic paintings of British history.

Throughout her years in England Kauffman continued to exhibit the same range of works: history paintings of all kinds of subjects, as well as portraits. She selected subjects from a variety of authors, many of them British, including Shakespeare (illus. 29), Alexander Pope and Laurence Sterne, whose character 'Poor Maria' (illus. 107) from his novels *Tristram Shandy* (1759–67) and *A Sentimental Journey* (1768) was particularly well known. One of her most frequently rendered subjects was the romantic story of Rinaldo and Armida from Tasso's *Gerusalemme liberata* (1575), which she painted in several versions in the 1770s. Kauffman also portrayed playfully erotic subjects, such as *Cupid Binding Aglaia* (1774) and *Love Punished* (1777), from the poetry of Pietro Metastasio, who was then court poet at Vienna, and whose works were extremely popular,[61] while James Macpherson's *Ossian* (1765) provided the subject for *Trenmor and Imbaca* (illus. 30). Kauffman's choices seem to have been calculated to attract patrons of almost any taste, whether for serious or frivolous subjects, large or small canvases, or potentially for reproduction in the form of prints.

44 *The Letter – Girl Reading*, c. 1766, black chalk and stump.

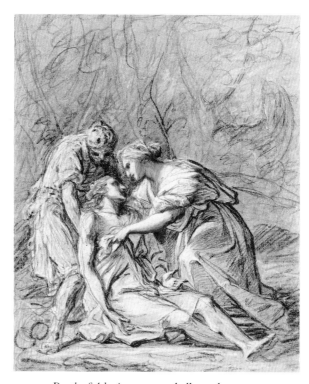

45 *Death of Adonis, c.* 1771, chalks on brown paper.

By far Kauffman's most often exhibited subjects were from the sources of her first serious success in England, the epics of Homer and Vergil. Particular favourites were Kauffman's heroine Penelope and her son Telemachus, portrayed in *Telemachus at the Court of Sparta* (1773) and *The Return of Telemachus* (1775; illus. 93). This latter subject, showing the dutiful son's return from his adventurous travels in search of his father (*Odyssey*, XVII), was one of a pair commissioned by Edward Stanley, 11th Earl of Derby, for his London house, designed by Adam, in Grosvenor Square. This picture and its companion, *Andromache Fainting at the Unexpected Sight of Aeneas on his Arrival in Epirus* (illus. 46), from Vergil's *Aeneid* (III, 301ff.), also exhibited in 1775, were intended as overdoors, as noted in early records, hence their wide, horizontal format, with figures arranged across the picture plane within a shallow space.[62]

As a pair, these pictures create an elegant balance both compositionally and thematically. The subjects had been recommended for history paintings by

Caylus.[63] In one image we witness the tearful embrace of mother and son's reunion, heightened by the joyful reactions of Euryclea, the nurse, who rushes in from the right. Its companion, which has for a long time been misidentified as Penelope and Telemachus, represents a more tragic reunion: Andromache swoons at the tomb of her husband, Hector, which is inscribed clearly with his name – *EKTΩP*. She had been invoking her husband's spirit just at the moment when Aeneas, whom she believes might be a messenger from the dead, appears. While Penelope's son brings hope of happiness, Aeneas only confirms the reason for Andromache's grief. There is a parallel to the themes in the paintings at Saltram and the even earlier Byng pictures, for here again wives grieve for husbands lost in war.[64]

Kauffman appears to have initiated, or invented, several other paintings centered on Penelope. These include *Penelope Invoking Minerva's Aid for the Safe Return of Telemachus* (1774; illus. 71), *Penelope Weeping over the Bow of Ulysses* (illus. 47), which is another subject in Caylus, *Penelope Awakened by Euryclea with the News of Ulysses's Return* (engraved by Burke in 1773, and by Ryland in 1785; illus. 33), and the engraving (by Ryland in 1777) of *Perseverance (Penelope at her Loom)* (illus. 132), an allegory based on Kauffman's *Penelope at her Loom* of 1764 (illus. 12).

Penelope Invoking Minerva's Aid (illus. 71) is typical of Kauffman's style in the mid 1770s, when she developed a lighter, more fluid and delicate treatment than was used in the earlier dark, heavily Baroque paintings sent from Italy. Shown in classic

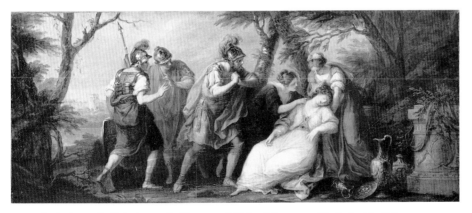

46 *Andromache Fainting at the Unexpected Sight of Aeneas on his Arrival in Epirus,* 1775, oil on canvas.

47 *Penelope Weeping over the Bow of Ulysses, c.* 1775–8, oil on metal.

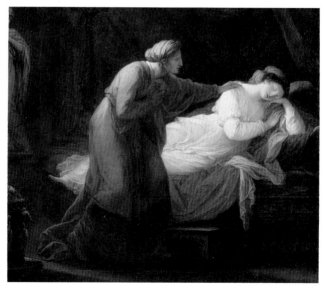

48 W. W. Ryland (finished by Michel) after Kauffman, *Penelope Awakened by Euryclea,* 1785, stipple engraving.

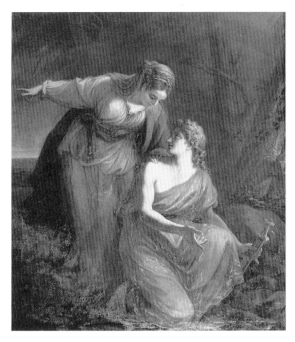

49 *Aethra and Theseus*, 1771, oil on canvas.

profile, Penelope gracefully raises one arm towards the statue of the goddess standing on a pedestal, while the other points downwards in opposition. Although this picture has been described as being a portrait of Frances Anne Hoare as Penelope, the figure's idealized features do not resemble those in Kauffman's known portrait of Frances Hoare at Stourhead (illus. 88), in which she is portrayed with a bust of Clio (the muse of History) and a book. Perhaps Frances Hoare had a particular interest in history; at the very least she wished to be characterized as a serious, scholarly woman.

Kauffman continued to receive commissions for portraits and subject pictures from many patrons. Among her most devoted clients were George Bowles of Wanstead, Essex, who at one time owned fifty of her works, and Lord Exeter, whose collection included numerous etchings, engravings and drawings, as well as paintings, many still at Burghley House in Lincolnshire, such as *Aethra and Theseus* (illus. 49) exhibited in 1771, *Cleopatra Adorning the Tomb of Mark Antony* (illus. 42), two scenes from Pope's *Eloisa to Abelard* (illus. 31, 32), and the early portrait of Garrick (illus. 85).

THE ROYAL ACADEMY AND ART THEORY

In 1779 the Academy moved to new quarters in Somerset House in the Strand, and plans were developed for it to have a programme of allegorical ceiling paintings to represent the theoretical basis of the fine arts. Kauffman, who was included in this important scheme, was assigned four oval paintings of allegorical images to represent the four parts of painting – Invention, Composition, Design and Colour (illus. 51, 52, 53, 54). They were set into the ceiling of the Council Chamber around paintings by West that represented Nature, the Graces and the Elements (illus. 50) and portraits by Biagio Rebecca of the great artists of Antiquity. The paintings by Kauffman and West are today set in the ceiling of the entrance hall of Burlington House in Piccadilly, the current home of the Royal Academy.[65]

Kauffman used allegorical personifications to characterize the theory of art as expressed in Reynold's Discourses, which were originally delivered in the Council Chamber and then published.[66] Reynolds encouraged aspiring artists to aim high, to pursue the Grand Style in the tradition of the great Renaissance artists and to privilege history painting, with its moralizing purpose, above portraiture, landscape or still-life. Thus, Kauffman's *Invention* (illus. 51) has wings on her head and looks upward to suggest inspiration and intellectual activity. *Composition* (illus. 52) sits in serious contemplation before a chessboard, and has a pair of compasses to indicate careful judgement and reason. The more practical parts of painting are illustrated in *Design* (illus. 53), which shows a female drawing from the *Belvedere Torso* (of which a plaster-cast was present in the Council Chamber), and in *Colour* (illus. 54), in which a sensuous female with a chameleon at her side takes colours directly from the rainbow. The grisaille drawings for these compositions (illus. 55, 56, 57) were probably presented as working studies, for some of their features appear in modified form in the finished paintings.

Kauffman produced an allegorical image of another aspect of art, in a person-ification of Imitation, probably painted *c.* 1780–81 soon after completing the Royal Academy paintings and shortly before she left England (illus. 34). This idealized figure wears classic white, girt with a turquoise sash and yellow and lilac drape. Her head, wrapped in braids, is crowned by a band bearing her name in Latin, similar to Kauffman's engraved self-portrait of 1781 as Painting (illus. 145), in which she

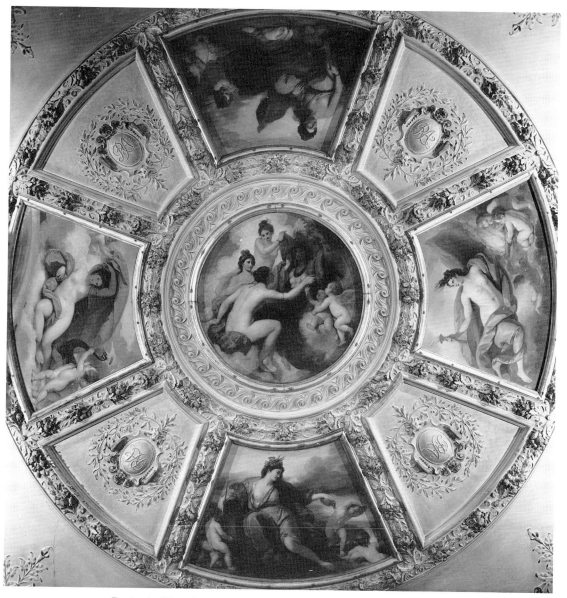

50 Benjamin West, *Nature Attired by the Graces*, with the *Four Elements*, 1780, ceiling tondo at Burlington House, oil on paper.

51 *Invention*, 1780, oil on canvas.

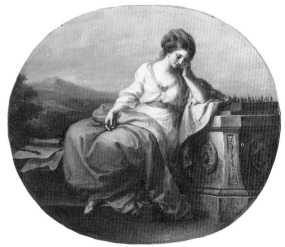

52 *Composition*, 1780, oil on canvas.

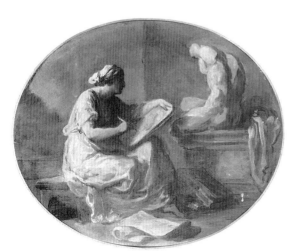

53 *Design*, 1780, oil on canvas.

54 *Colour*, 1780, oil on canvas.

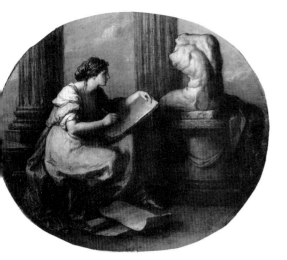

55 *Design*, 1779, grisaille.

56 *Invention*, 1779, grisaille.

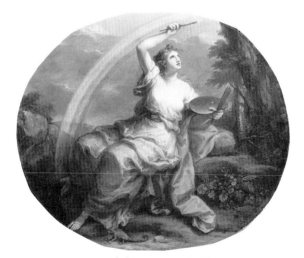

57 *Colour*, 1779, grisaille.

wears the same head-band, but inscribed in English. Although a *pentimento* shows a ribbon with the word 'Imitatio', this figure does not resemble the usual personification of Imitation, who traditionally holds a mask and brushes.[67] Kauffman's figure holds a *porte-crayon* and a tablet, on which she has sketched the allegorical image of Prudence, which can be identified by the standard attributes of mirror (self-knowledge) and snake (wisdom). The spur in Imitation's hand represents the 'spur' of Ripa's *capriccio*, or fancy, which must be judiciously controlled by Prudence in order to produce art of the highest quality. Kauffman has broadened the meaning of imitation to encompass qualities of the noblest aspects of painting – imagination tempered by careful judgement – as well as the ability to render what is seen in Nature.

Her important self-portrait (see illus. 66) painted in 1787 for the prestigious Medici collection of artists' self-portraits in the Uffizi in Florence shows her seated in Imitation's pose.[68] Wearing the familiar white dress, belted, with an Antique cameo, she sits beside a column against the blue sky. She appears younger than her forty-six years, palette and brushes laid by her side, immortalized among the greatest 'masters' of painting.

Kauffman used female figures to represent the arts in another allegorical self-portrait, painted in 1782 after her return to Italy as a gift for her loyal patron George Bowles (illus. 35). She portrayed herself with portfolio and brush as the personification of Painting embraced by Poetry, her Sister Art, who is identified by the standard attributes of laurel wreath, winged temples and lyre. This image expresses Kauffman's allegiance to the ideal of *ut pictura poesis* (As is painting, so is poetry) expressed in Horace's *Ars Poetica*, and long a staple of art theory.[69] Both noble arts require learning in order to create images in words or pictures that will instruct as well as delight the mind and eye. As Sister Arts they work in harmony, and Poetry's lyre, although a musical instrument, is here equivalent to Painting's pencil. Significantly, unlike Kauffman's abandonment of Music in her later allegorical self-portrait (illus. 36), Painting welcomes Poetry's embrace.

CRITICAL RECEPTION IN ENGLAND

In 1771 the botanical artist Mary Delany recorded that 'This morning we have been to see Mr West's and Mrs Angelica's paintings . . . My partiality leans to my

58 *Cornelia Knight*, 1793, oil on canvas.

59 *Lady Elizabeth Foster, later Duchess of Devonshire,* 1785, oil on canvas.

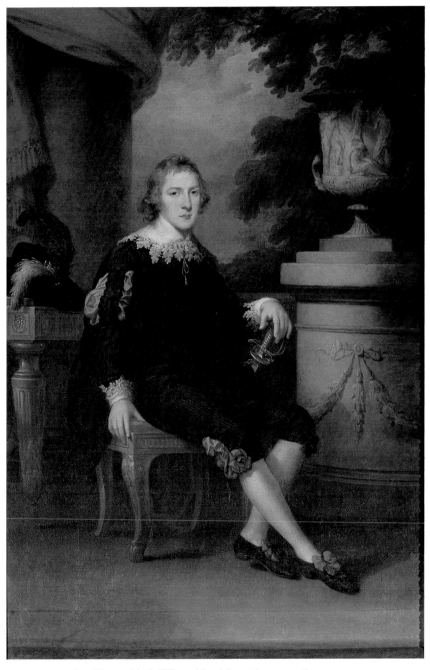

60 *Thomas Noel-Hill, 2nd Lord Berwick*, 1793, oil on canvas.

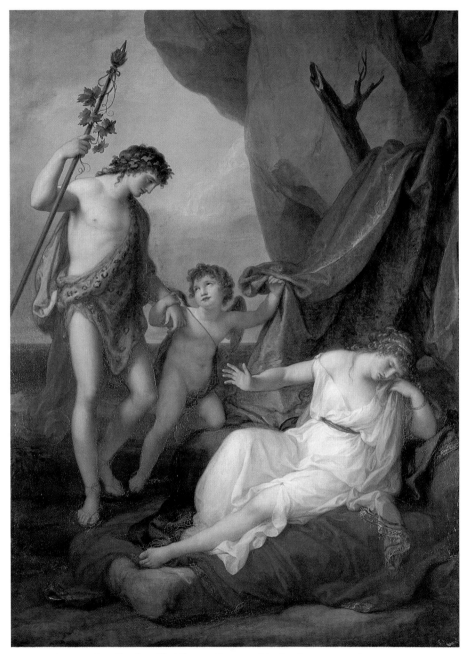

61 *Ariadne Abandoned by Theseus, Discovered by Bacchus*, 1794, oil on canvas.

62 *Euphrosyne Wounded by Cupid, Complaining to Venus,* 1793, oil on canvas.

63 *A Lady in a Turkish Dress*, *c.* 1775, oil on canvas.

64 *Bacchus Teaching the Nymphs to make Verses*, 1788, oil on canvas.

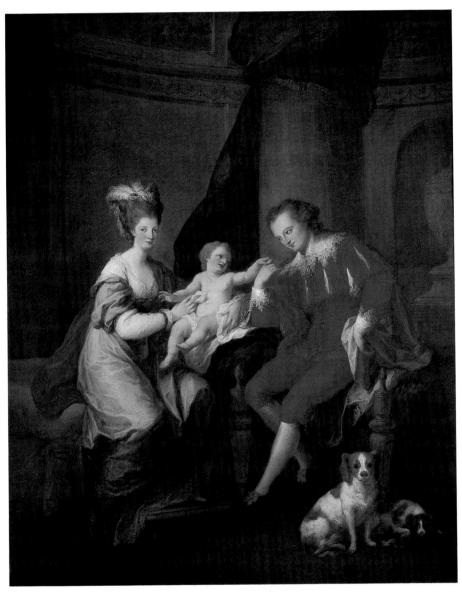

65 *Edward Stanley, 11th Earl of Derby, with his Wife and Son*, oil on canvas.

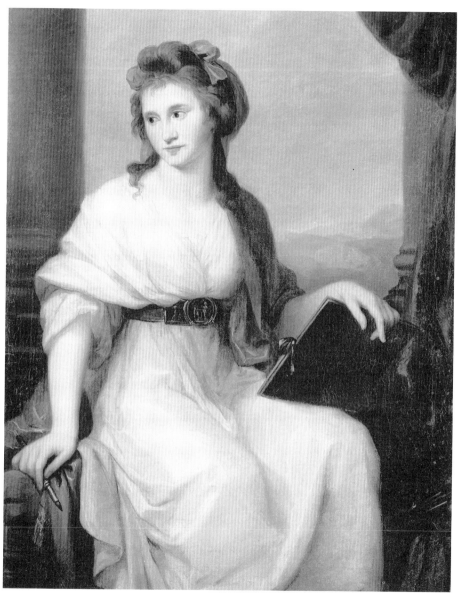

66 *Self-portrait*, 1787, oil on canvas.

67, 68 Anon., *Apollo Belvedere* and *Antinous*,
plates from Winckelmann's *Histoire de l'Art chez les Anciens*, 1802.

69 *Study of a Young Man*, 1771, black chalk heightened with white.

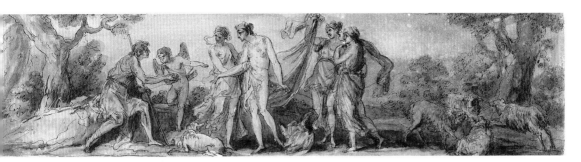

70 *Judgement of Paris*, *c.* 1770, pen and ink with sepia wash, heightened with white.

sister painter. She certainly has a great deal of merit, but I like her history still better than her portraits'.[70] Kauffman generally received favourable notices for her exhibited works, especially her history paintings. In 1772 a reviewer in *The Middlesex Journal*, discussing Kauffman's *Andromache and Hecuba Weeping over the Ashes of Hector*, remarked that, 'This lady seems to have a peculiar turn for history painting, in which branch of the art she has long since acquired a very eminent character'.[71]

Such praise was often moderated by criticism of certain weaknesses, especially the 'effeminacy' of the male characters.[72] While some English critics may not have appreciated her graceful, smooth-limbed men, they conformed to the taste and preference of the antiquarian Winckelmann, from whom she had first learned about Classical art. Winckelmann praised the androgynous qualities of Greek sculptures, such as the graceful form of the *Apollo Belvedere* (see illus. 67) and other, rather effeminate, softly-contoured male figures.[73] Kauffman's Classical men, for example, the painter Zeuxis in *Zeuxis Selecting Models for his Painting of Helen of Troy* (*c.* 1778; illus. 37), the *Judgement of Paris* (illus. 70) and *Praxiteles Giving to Phryne his Statue of Cupid* (1794; illus. 38),[74] all exhibit these characteristics. The male figures, with their curling hair, smooth contours and draped limbs may simply reflect her lack of study of male anatomy; however, they also resemble the Roman relief sculptures of beautiful young men, the *Antinous* in the Albani Collection (see illus. 68), for example, which Winckelmann believed represented the greatest perfection of Roman art,[75] and the relief of the sleeping *Endymion*.

In 1774 a reviewer in *The London Chronicle* commented on Kauffman's *Penelope Invoking Minerva's Aid* (illus. 71) and another painting exhibited by her that year

71 *Penelope Invoking Minerva's Aid for the Safe Return of Telemachus,*
1774, oil on canvas.

of a subject from the *Odyssey,* the *Calypso Calling to Heaven and Earth to Witness her Sincere Affection to Ulysses*:

This Artist, considering her sex, is certainly possessed of very great merit. She is endued with that bold and daring genius which leads her to employ her pencil upon historical paintings which are as much superior to portraits and landscapes as an epic poem is to a pastoral, or a tragedy to a farce . . . [76]

This emphasis on history painting represents a common theme in much of the criticism of Kauffman's work. These comments can be interpreted as a statement

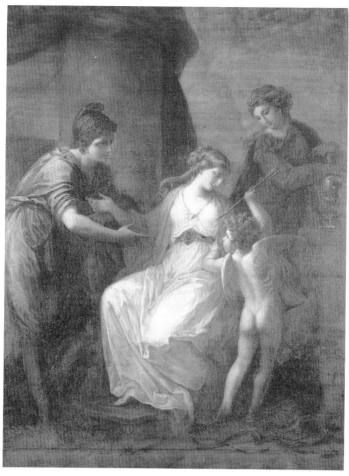

72 *Paris and Helen Directing Cupid to Inflame each other's Hearts with Love*,
1774, oil on canvas.

of the importance of the genre as much as they can be understood as praise for
Kauffman. Her gender was almost always an issue when history painting was
discussed. 'A Friend to the Arts', writing in *The Morning Chronicle* about the same
exhibition in which Kauffman had shown – in addition to the Penelope and Calypso
paintings – an *Ariadne Abandoned by Theseus*, as well as *Paris and Helen Directing
Cupid to Inflame each other's Hearts with Love* (illus. 72) and *Cupid Binding Aglaia*,
emphatically praised Kauffman's choice to work in the most difficult and noble
branch of the art; nevertheless, the comments imply a disparaging view of her style:

This lady has, for years, stood deservedly high in the most difficult, yet most liberal line of her profession – History Painting. She has not, in general, receded from this character in the above pictures, though we would beg leave to observe there is too great a monotony of beauty in all her principal figures . . . [77]

In 1777 a reviewer for *The London Chronicle* wrote (emphases mine throughout):

It is surely somewhat singular, that while so many of our *male artists* are employed upon portraits, landscapes, and other inferior species of painting, this *lady* should be almost uniformly carried, by the boldness and sublimity of her genius, to venture upon historical pieces; which is as great a phenomenon in the painting as it would be if our *poets* dealt in nothing but sonnets and epigrams, while our *poetesses* aspired to the highest and most difficult department of their art, the producing of epic and heroic compositions. But though Miss Kauffman possesses this *masculine and daring spirit*, she still retains so much of the *softness natural to her sex*, that she always pitches upon such historical subjects as have in them a strong mixture of the tender and pathetic . . . [78]

This comment mixes praise with resentment that such a remarkable but uncharacteristically 'masculine' woman could manage what the British male painters could not or would not do. The critic implies she could not reach the highest levels of history painting because her natural female tendencies were for 'tender and pathetic' subjects, although such sentimentality was hardly exclusive to Kauffman's paintings. This is typical of the ambivalence of those who wished to promote heroic history painting, yet had to explain why a woman was among the few that were doing it at all.

Two years later, in 1779, Kauffman exhibited seven paintings with her characteristic variety, among them *The Death of Procris* (illus. 73) from Ovid's *Metamorphoses*, a *Magdalen*, an allegory of *Conjugal Peace*, and *A Group of Children Representing Autumn*. The *London Chronicle* reported: 'This lady deserves amazing praise for her frequent employment of her pencil on historical subjects.'[79] But once again, the point of the reviewer's comment was the issue of history painting in conjunction with Kauffman's gender.

Kauffman was appreciated as one of the few history painters working in England who could stimulate native artists to take up this branch of the art. Yet while that other significant foreign artist at work in England, Benjamin West, was able to gain royal patronage for history paintings of British and Classical subjects, Kauffman never achieved that goal. Except for a few devoted patrons, most buyers tended to

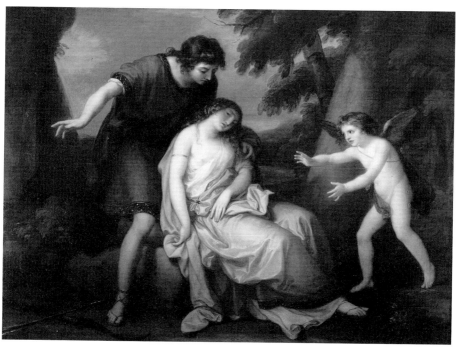

73 *The Death of Procris*, 1779, oil on canvas.

prefer portraits, and history paintings were more often commissioned in order to be reproduced as prints. Groups of large history paintings, such as those executed for Saltram, were not repeated by Kauffman in England. Despite support from the art establishment, history painting was never fully appreciated in Britain. Although within these limitations Kauffman was certainly quite successful, she was not able to fulfil her highest ambitions on the scale that she wished.

RETURN TO ITALY

In 1781 Kauffman married the painter Antonio Zucchi and, together with her father, they returned to Italy. In Naples and Rome her career flourished among a growing clientele of Continental aristocrats, most of whom were eager to commission history paintings as well as portraits. She painted the royal family of Naples in 1784, instructed the royal princesses in drawing, and was invited by the Queen to remain as court painter. Kauffman, however, wished to retain her independence,

and continued to receive commissions for large-scale history paintings through the 1780s and '90s from noble patrons, such as the Emperor Josef of Austria, Catherine the Great of Russia, Count Youssoupov, Prince Poniatowsky, and many others.

According to the *Memorandum of Paintings*, within a few months of her arrival in Venice in October 1781, the Grand Duke of Russia purchased three history paintings. Two were of English history subjects, *Eleanor on the Point of Death from the Poison she had Sucked in the Wound that Edward I had Received in Palestine* and *Queen Eleanor Recovered from the Poison*. The third, *The Death of Leonardo da Vinci When Francis I Came to Visit him*, was an original subject that had been exhibited by her in London in 1778.[80] Presumably these had not sold, so Kauffman must have been pleased to find an enthusiastic buyer.

Within the international community in Rome, Kauffman formed new friendships with several Germans, among them Goethe and J. D. von Herder and the painter Wilhelm Tischbein. She continued to paint for British tourists in Italy, and until the French presence in the Mediterranean made normal trade and communication difficult, Kauffman sent paintings to the Academy's exhibitions in London.

Portraits of the numerous travellers who came to see her in Rome include that of her old friend the art dealer Thomas Jenkins,[81] who is shown within a landscape before the Colosseum (illus. 74). The famous beauty Elizabeth Foster, who later became the Duchess of Devonshire, appears in one of Kauffman's most attractive portraits (illus. 59),[82] and she twice painted the notorious Earl-Bishop Frederick Augustus Hervey, 4th Earl of Bristol.[83] The poet and novelist Cornelia Knight, who lived for a while with her mother in Rome, was portrayed by Kauffman in Neoclassical garb seated in a suitably thoughtful pose (illus. 58). Kauffman had intended to include an image of Minerva in a cameo at her sitter's waist, but Lady Knight, the subject's mother, persuaded the artist to include her self-portrait instead.[84]

Kauffman also continued to produce history paintings for British clients, many of which were intended to be reproduced as engravings. In 1788 she exhibited *Bacchus Teaching the Nymphs to make Verses* (illus. 64) at the Royal Academy, a subject taken from Horace.[85] This picture, with its lovely nymphs and a handsome Bacchus set within a lush landscape, was exactly the type of subject and style Kauffman's British clients had come to expect from her.

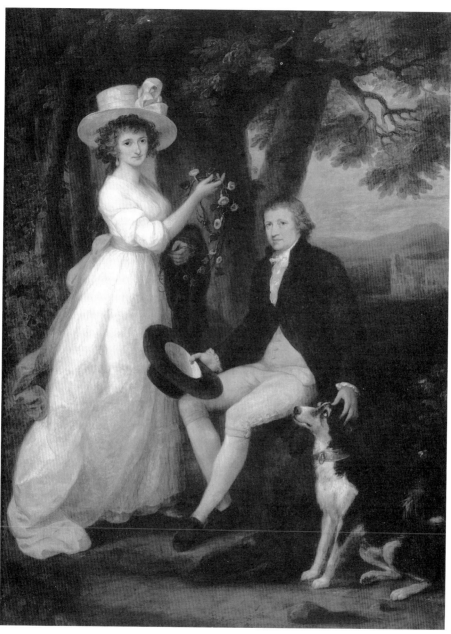

74 *Thomas Jenkins and his niece Anna Maria*, 1790, oil on canvas.

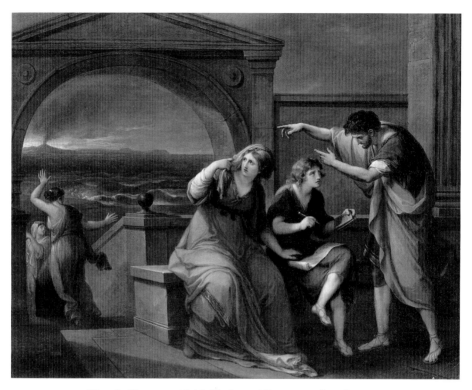

75 *Pliny the Younger, with his Mother at Misænum*, 1785, oil on canvas.

76 Thomas Burke after Kauffman, *Vergil Writing his own
Epitaph at Brundisium*, stipple engraving.

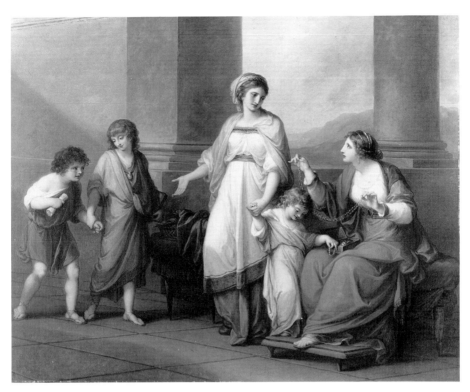

77 *Cornelia, the Mother of the Gracchi, Pointing to her Children as her Treasures,*
1785, oil on canvas.

PAINTINGS FROM NAPLES

Among the most noteworthy of her later paintings was a group for George Bowles
shown at the Royal Academy in 1786. These represented three moralizing scenes
from Roman history that were associated with Naples.[86] They are *Vergil Writing his
own Epitaph at Brundisium* (illus. 76), *Pliny the Younger, with his Mother at Misænum*
(illus. 75) from Pliny's letter to Tacitus describing the eruption of Vesuvius in 79
AD, and *Cornelia, the Mother of the Gracchi, Pointing to her Children as her Treasures*
(illus. 77). The last subject is of particular interest – Kauffman repeated it in a
version for Prince Poniatowsky, nephew of the King of Poland, and for Queen
Caroline of Naples – for it represents a famous Roman matron who demonstrated
feminine virtue through the exemplary upbringing of her two sons. In this image
Cornelia gestures modestly to her sons, in contrast with the seated woman who

demonstrates thoughtless pride and luxury by showing off her jewels.[87] Kauffman heightens the moral issue by positioning the upstanding Cornelia in the centre, with her young daughter placed between the two women. The little girl longingly fingers the jewels while clutching her mother's hands; she is not yet mature enough to make the appropriate (i.e. virtuous) choice. Cornelia's devotion to her sons is counterbalanced by the young Pliny's devotion to his mother, whose side he will not leave, even during Vesuvius's devastating eruption.

All three compositions exhibit a simple, almost severe, austerity, and they are among Kauffman's most classicizing paintings. Their relatively shallow space, warm colour and simple figure arrangements reflect her knowledge of Pompeiian painting. It is worth noting that they were produced in Rome at exactly the same time that Jacques-Louis David was working in Paris on the *Oath of the Horatii*, that great monument of masculine, stoic Neoclassicism. In fact, in 1785 De Rossi, Kauffman's biographer, published, in Rome, laudatory reviews of these works by each artist.[88]

The elegant restraint and severity of Kauffman's late classicism can be appreciated within the context of Continental Neoclassicism as it developed in the work of David and his French followers. However, when her three paintings for Bowles were exhibited at the Royal Academy in 1786 the London critics received them with mixed reviews. Although the *General Evening Post* reviewer reckoned that

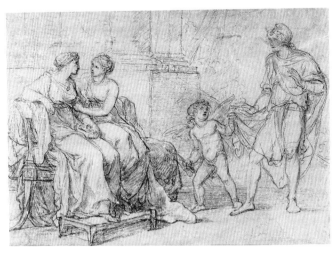

78 *Venus Persuading Helen to love Paris*,
study for a 1790 painting, black chalk on grey paper.

'Angelica Kauffman has hazarded and enriched the Exhibition by three beautiful productions of her pencil, in which she has maintained her accustomed elegance and classical taste', the critic of *The Morning Chronicle* thought she had 'lost perhaps something and has got nothing by her trip to Italy – The Cornelia and the younger Pliny, are neither warm nor delicate . . .'.[89] Another reviewer thought her works were not unlike 'a Cast from one of the poorest antique statues, made after the mold is worn out', and drawn 'in a shambling and affected manner'.[90] The *Public Advertiser* may have best summed up the underlying issue of resentment of her departure from England:

These pictures possess that character which usually constitutes her works, but they do not appear to be either so beautifully conceived, or so tasty in their execution, as to drawing, characters, or colour, as those which she painted in England. They seem to be done from memory of her former works, and no new beauties have been added to her style by her late tour to Italy. Here perhaps it may be proper to remark that there is now established in this country a school of art much superior to what is to be found on any part of the Continent, there being at this moment in England a greater number of living artists, excelling in different branches, envious of each other, and striving with a spirit of enthusiasm, which has left our neighbours far behind. Amongst other foreign artists this country is certainly much indebted to *Signora Angelica*. She has enriched the cabinets of the curious with many elegant performances, composed and executed in her best time; and though she has withdrawn herself from us, her best works and her taste remain with us.[91]

PICTURES FOR LORD BERWICK

By the mid 1790s the political situation in Europe had made the dispatch of works to England precarious, and Kauffman sent fewer pictures. During these years one of her major commissions from a visiting Englishman in Italy was for three pictures – a portrait and two history paintings – ordered in 1793 by Thomas Noel-Hill, 2nd Lord Berwick.[92] As a group they provide an interesting comparison with the three pictures – two history paintings and a portrait (illus. 10, 11, 16) – that she made for John Byng in Italy in 1764, nearly thirty years before.

The life-size portrait of Lord Berwick shows him wearing fancy van Dyck attire and seated by an Antique urn in a traditional Grand Tour pose (illus. 60). The other two pictures are a pair of large mythological scenes, *Ariadne Deserted by Theseus, Discovered by Bacchus* (illus. 61), the same subject of love lost and love found

from Ovid's *Metamorphoses* that she had painted in 1764, and *Euphrosyne Wounded by Cupid, Complaining to Venus* (illus. 62), a subject from Metastasio's poem 'Le grazie vendicate'.[93] Euphrosyne, one of the Graces, shows Venus, Cupid's mother, what her naughty child has done. To Euphrosyne's annoyance, Venus defends Cupid, thus prolonging the humorous and teasing battle between this mischievous boy and the Three Graces. This painting was exhibited at the Royal Academy in 1796, almost the last picture Kauffman sent from Italy.[94]

As pendants, they represent the painful pleasure that love can inflict, a more light-hearted, lyrical theme than the serious moralizing on filial piety and civic duty represented through Classical history and epic seen in her paintings of the 1760s and '70s. In addition, the choice of Classical and modern lyric poetry as sources provided an example of the lively debates of the time between the supporters of the Ancients and the Moderns for supremacy in the arts. The slender, graceful figures and ornamental treatment – like Lord Berwick's elegant attire – suited their subjects, and they characterize the lighter decorativeness that was popular in England, in contrast to the weighty, serious treatment of her early history paintings.

Even during the French occupation of Rome in 1798 Kauffman kept up a busy work schedule for Italian patrons and those of other nationalities who remained in Italy. She painted for free the portrait of 'Citizen-General' Espinasse of the French forces of occupation in response to the courteous treatment she had received. Nevertheless, the paintings in her studio that belonged to Austrians, Russians or the British were confiscated.[95]

For the last ten years of her life, Kauffman's surviving notes and records are sketchy, but De Rossi's biography, comments by contemporaries and the paintings and prints themselves are evidence of her continued, though diminishing, output, and her letters attest to a lively social life. She continued to correspond with friends in England, writing with enthusiasm to Captain Robert Dalrymple in 1805 about the Queen of Naples's excavations at Pompeii, Canova's recent statues of Napoleon and Paulina Borghese, and the latest news of the current market for antiquities.[96] Two years later she wrote to another friend, a Mr Forbes, who had commissioned her painting of *Religion* (1780), of a trip she took to Tivoli to see the Villa of Maecenas, adding that she wished he could see it, 'or that I could once more have the happiness to see you in dear England, to which my heart is so much attached . . . '.[97]

Kauffman died at the age of 66, on 5 November 1807, and was mourned by the entire Roman community, within which she had been such a notable celebrity. Her funeral procession, one of the longest the city had seen, was attended by members of the Academy of St Luke, her family, and the numerous friends she had left behind. She was buried in the same tomb as Zucchi in the church of San Andrea della Fratte.[98]

ANGELICA KAUFFMAN AND ENGLAND

Angelica Kauffman's career in England and her professional contacts and friendships with British patrons throughout her life were essential to her success. It was the circle of British artists and travellers she met in the 1760s in Italy who reinforced and encouraged her talent for history painting, and her contributions to the development of Neoclassical history painting in England were significant. She was in the right place at the right time to take advantage of renewed interest in this genre under the encouragement of Reynolds during the early years of her maturity. It is not surprising, however, that she is still best remembered in England for her portraits, engravings and decorative interiors, which better represented the prevailing taste and market in late eighteenth-century England.

Kauffman was both England's gain and England's loss, for her ambitions eventually drove her back to the Continent, where patrons were more willing to commission large-scale history paintings that could assure her a steady income as well as prestige, and where she could work surrounded by the inspiration of Antiquity and Rome's lively international social and artistic community. Nevertheless, her years in England as a welcomed outsider had been productive ones, for they had permitted her to develop in ways that might have been more restricted elsewhere. As a female artist working very much in a man's world, she managed to negotiate a place for herself, and at times to use her difference to some advantage. A woman of talent, intellect and taste, her high aspirations and independence allowed her to achieve international success and to fulfil the promise of her earliest years.

Kauffman and Portraiture

ANGELA ROSENTHAL

PORTRAITS IN ROME AND LONDON

Despite the relegation of portraiture to a lesser rung of the hierarchy of genres in art theory in eighteenth-century Britain, it commanded a superior position in the art market. In *The Present State of the Arts in England* (1755), the painter Jean-André Rouquet noted with some amazement the extraordinary fondness of the English for portraiture. However, British travellers in Italy were surprised to find that Italians 'very seldom take the trouble of sitting for their pictures', so that peripatetic artists remained frustrated by the lack of indigenous patronage.[1] It is for this reason that Pompeo Batoni, the leading Italian portrait painter working in Rome when Kauffman was there in the early 1760s, had a predominantly British clientele.[2] The importance of British sitters to Kauffman in the course of her career became as great: of her 400 or so documented single and group portraits, at least half depict Britons. Kauffman's dealings while in Italy with Grand Tourists brought her into contact with many members of the British upper classes. Among the connections she forged there were those with Lord and Lady Spencer, the Duke of Gordon, the Earl of Exeter and John Parker, later 1st Lord Boringdon. It was her success with this itinerant society that led to her being persuaded to move to London, for as we learn from a letter of August 1765 addressed to Dr John Morgan in Philadelphia by the Scot Peter Grant, who was then living in Rome, that, excepting London, 'no city in Europe can be more proper for her than this, where she has from our British travellers constant employment'.[3]

In the course of Kauffman's Italian sojourn in the early 1760s, she executed around twenty-five portraits in oils, and the stylistic breadth she mastered in her

79 *Miss Georgiana Keate as a Young Girl*, 1779, oil on canvas.

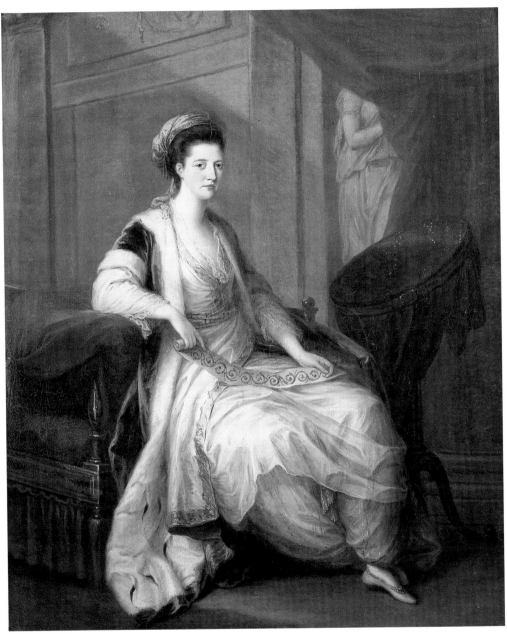

80 *Mary, 3rd Duchess of Richmond, in Turkish Dress,* 1775, oil on canvas.

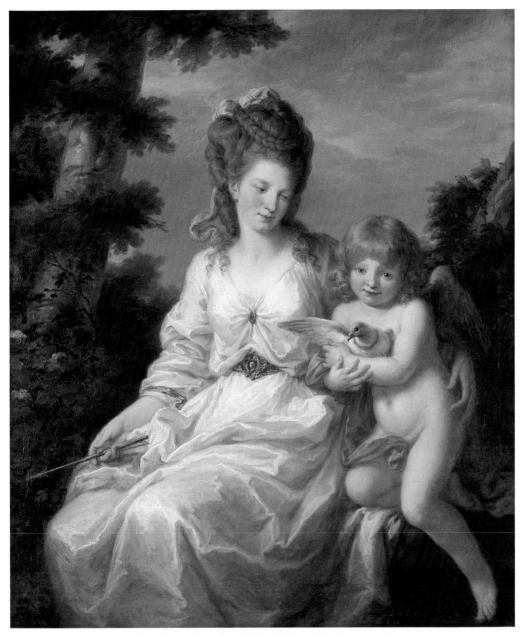

81 *Anne, Marchioness Townshend with a Child as Cupid,* 1771, oil on canvas.

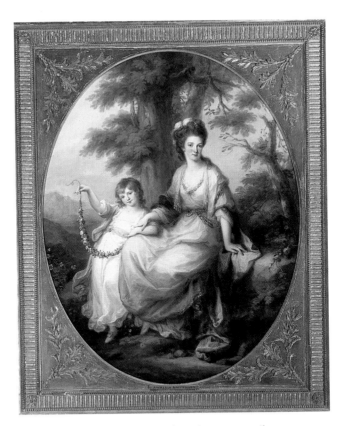

82 *Lady Rushout and her Daughter, Anne*, 1773, oil on canvas.

83 *Mrs Marriot*, *c.* 1773, oil on canvas.

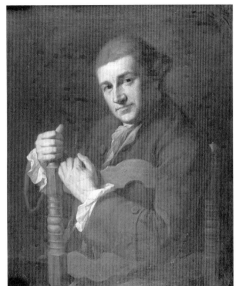

84 *Benjamin West*, 1763, pencil drawing. 85 *David Garrick*, 1764, oil on canvas.

emulation of popular manners of representation is of particular note. According to Anthony Clark, Kauffman's detailed drawing of *Benjamin West* (illus. 84) is an exercise in the manner of Mengs and L. G. Blanchet,[4] while in her portraits of *John Morgan* and *Brownlow Cecil, 9th Earl of Exeter* of 1764 (illus. 1), for example, she demonstrated her ability in the proven, dynamic style of Batoni.[5] The latter work, in which the sitter is viewed from a slight *di sotto in su* and nonchalantly posed before Mt Vesuvius, could not be in greater contrast to her startlingly private and intimate view of the famed actor David Garrick (illus. 85), despite the fact that these two works were painted within three months of one another. Her portrayal of Garrick can be singled out as of special importance, since it heralded her arrival in London, having been sent for exhibition with the Free Society of Artists in 1765; it certainly appears to have made an impression on Joshua Reynolds, who later borrowed its tight composition for his portrait of *Mrs Abingdon as 'Miss Prue'*.[6] In addition to the oil portraits she was commissioned to make in Italy, Kauffman executed a number of portrait drawings, which were private studies intended for her own use. These drawings are mainly of tourists and various friends and acquaintances in Rome's art and antiquarian circles, and include James Byres, Gavin Hamilton, Peter Grant, J. J. Winckelmann, Benjamin West, Piranesi and Nathaniel Dance (illus. 86).[7]

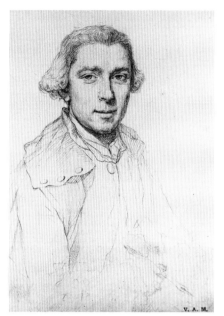

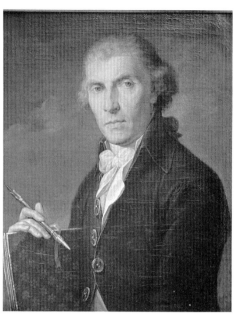

86 *Nathaniel Dance, c.* 1764,
chalk, from a sketchbook.

87 *Johann Josef Kauffman,*
c. 1767, oil on canvas.

Upon arriving in England in 1766, in order to maintain and extend her connections with patrons and potential patrons, Kauffman had to adapt quickly to the assumptions and conventions of the London art market.[8] 'I cannot sustain my character with my work alone. Everything has to be arranged', she informed her father that October.[9] Two months earlier she had set up her first studio at superior premises in Suffolk Street. 'I have four rooms, one in which I paint, the other where I set up my finished paintings as is here the custom, [so that] the people [can] come into the house to sit – to visit me – or to see my work; I could not possibly receive people in a poorly furnished house. My present situation is in order – and at the same time as closely [in accordance with current taste] as one can have'.[10] Rouquet assures us that the show-room of a portrait painter in eighteenth-century London was indeed a public place, for 'people who have nothing to do make it one of their morning amusements to go and see these collections'.[11] Like auction houses, which became increasingly popular in the eighteenth century, a studio was able to draw 'people of different sex and conditions', who – 'introduced by a footman' –

judged and disputed the 'portraits, finished or unfinished' in the picture room, to the extent that they would 'applaud loudly, or condemn softly'. These judges, of course, often commissioned their own portraits after such visits.[12]

With few exceptions, Kauffman's sitters in Italy were men, either Grand Tourists or members of Rome's art community. Nevertheless, on her arrival in England (in the company of Lady Wentworth), she was very soon caught up in a network of female patronage. Indeed, the majority of portraits she undertook in the next fifteen years are of women, such as the half-length, life-size portrait of *Henrietta Williams Wynn as Pandora* (1769), now in Bregenz, *Mary, 3rd Duchess of Richmond* (illus. 80), *Theresa Parker* (illus. 40), *Frances Anne Hoare* (illus. 88) and *Dorcas Bagwell*, daughter of the MP for Clonmel. There are also depictions of

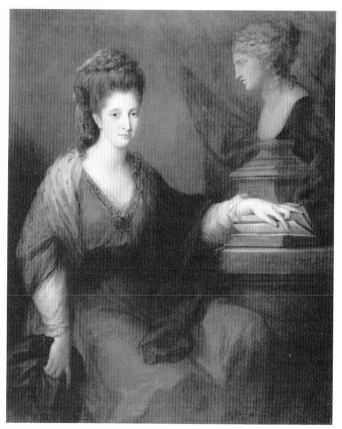

88 *Frances Anne Hoare with a Bust of Clio, c.* 1770–75, oil on canvas.

famous singers, such as *Miss Harrop, later Mrs Bates, with a Lyre*. The most eminent visitor to her studio was undoubtedly the Princess of Wales, mother of George III, who commissioned Kauffman to portray her eldest daughter, *Augusta, Duchess of Brunswick* (illus. 15), and who also introduced her to the Queen. This full-length portrait of the Princess and her son (Kauffman's largest portrait of this kind) appears to have hung, along with Frances Cotes's *Princess Louisa and Princess Caroline* (of the same year) and Allan Ramsay's portrait of the King and Queen, at Carlton House, the London home of the Princess of Wales.[13] Kauffman also made a portrait of Queen Charlotte, a representation best known through the mezzotint of 1772 by Thomas Burke (illus. 117), which pays homage to Charlotte's encouragement of the arts. The Queen was, moreover, supportive of a number of female artists, including Catherine Read and Mary Moser, and lobbied for the admittance of Kauffman and Moser as founder members of the Royal Academy, a gesture that was certainly, in part, the result of the activities at Court of these two artists.

MODES OF PORTRAYAL

Though an exhaustive survey of the many different types of portraits Kauffman produced is not possible here, a sketch of the most prominent and individualistic of her modes of portrayal must be set out. Within her *oeuvre*, the portraits of women that figure so prominently include a large number of mother and child groups. The first of these, possibly painted in Rome in 1764, is the small portrait of the Marchioness of Lothian with her son, later Lord Ancrum, seated in an interior. Such representations offered the opportunity for allegorical treatment, which is why Queen Charlotte (illus. 117) is represented in the act of touching the winged 'Genius of the Arts', which Kauffman's first biographer, G. C. Zucchi, assures us is a portrayal of the Prince of Wales as a 'sleeping Amor'.[14] The large, three-quarter-length portrait of *Anne, Marchioness Townshend* (illus. 81), shows the sitter holding an arrow belonging to her 'son as Cupid', who embraces a large dove. The Antique reference presents the Marchioness, celebrated for her beauty, in the flattering role of Venus. Indeed, such role-playing is a distinctive characteristic of Kauffman's portraiture, especially where it concerned women sitters.[15] But although she was to some degree influenced by Reynolds's concept of historical portraiture, Kauffman shared little of the theatrical dialogue such renditions led many portrait painters to

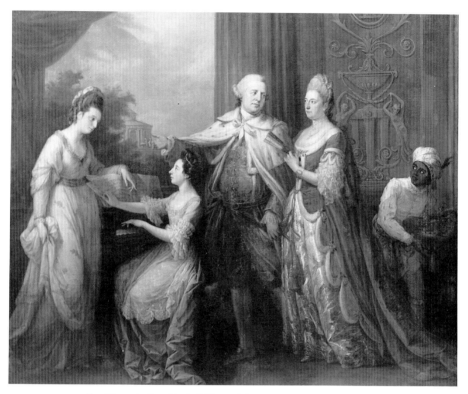

89 *Henry Loftus, Earl of Ely, and Family*, 1771, oil on canvas.

place their sitters in. Cast as Hebe, or as a sibyl, or set in a Classical landscape or attired in the fashionable Turquerie of contemporary masquerade, Kauffman's sitters inhabit a zone of tranquility. She invited the beholder to enter and contemplate this other world of natural constancy, bringing private values to the public discourse on morality.[16]

Kauffman also produced a limited number of group portraits. Three such works the Tisdall, the Townshend and the Ely families (illus. 89) – were begun during her trip to Ireland in 1771, and finished in her London studio, where they were subsequently exhibited.[17] Common to these portraits are Kauffman's attempts to fuse in one pictorial field the forms of public presentation traditionally reserved for representations of men, and the more private manner she had developed mainly for depictions of women, though it was selectively employed in her male portraiture. A good example of this is shown in the way Kauffman managed to unite the group that

comprises the Spencer children (illus. 90). By showing John, Lord Althorp, in a contemplative mood, Kauffman manages to draw him into a sympathetic exchange with his sisters Georgiana and Henrietta. John's cross-legged pose was by this date the archetypal one for portraits of country gentlemen.

The problem of unifying disparate social and gendered spheres is diminished in companion portraits, where the fact that two separate canvases are required permits a more gender-specific treatment of each of the two sitters. The two three-quarter-lengths of *c.* 1769 of the Earl and Countess of Home, or the pair comprising *Henrietta Hill, Daughter of Lord Berwick* (1792) and her husband *Charles Bruce, 1st Marquis of Aylesbury* (1795) can serve as examples. Nevertheless, a dynamic relationship between the pairs of sitters in these canvases is discernible, as is the case in the portraits of *Alexander, 4th Duke of Gordon* and his wife *Jean Maxwell*, both 1774, in the National Gallery of Scotland. The sitters turn towards one another: the Duchess, as Diana, with a bow and arrow in her hand, wears a cameo portrait profile, possibly an image of the Duke himself; her husband, in return, holds a miniature of his wife in his left hand, while resting his right on a sword.

PRICES AND SIZES

In choosing how, and in what dimensions, they wished to be represented, sitters could select from different size canvases, according to the amount they wished to spend and their notions of how the image should function. Regarding the prices and sizes of Kauffman's portraits, four sources are available: the 1788 list of regulations (contained in G. C. Zucchi's biography of Kauffman – last page of the first, handwritten, volume; and in a report to a French journalist said to have been given by Kauffman herself); the *Memorandum* of her Italian paintings kept by Antonio Zucchi; Kauffman's letter to Daulby concerning pricing; and scattered references in correspondence and other documents. The 1788 list provides a general guide to her pricing in that decade, though it is clear from the other sources that she often deviated from it. The following is a summary of the 1788 list:

A portrait painting of a person at full-length and size was costed at 120 zecchini (a zecchini was worth slightly less than one guinea).

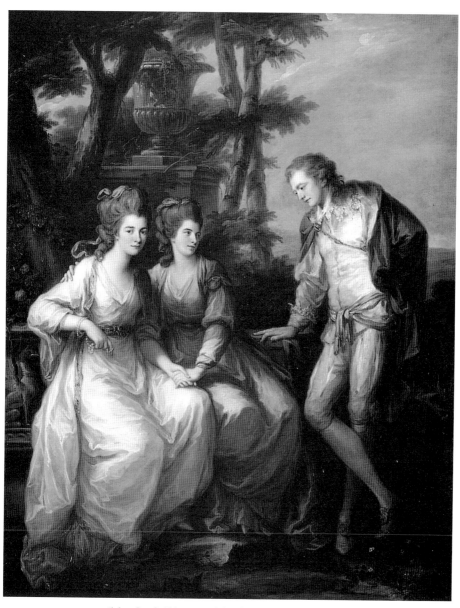

90 *John, Lord Althorp, with his Sisters*, 1774, oil on canvas.

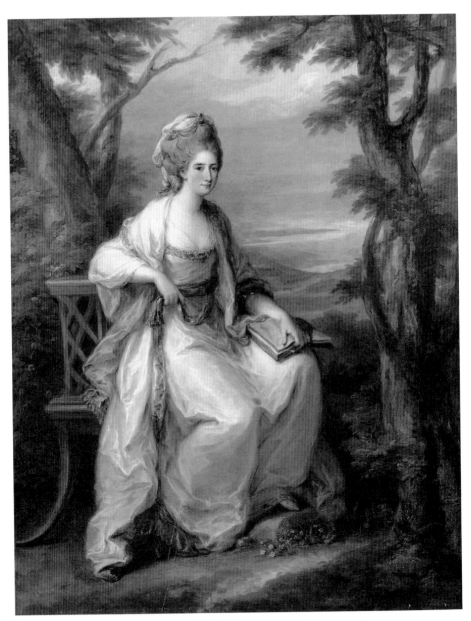

91 *Portrait of Anne Loudoun, Lady Henderson of Fordall,*
1771, oil on canvas.

92 *Dorothea (Dolly) Munro*, 1771, oil on canvas.

A portrait, natural size, on a canvas of 4 ¼ feet (French) was costed at 120 zecchini. This
measurement approximates a three-quarter-length portrait.
A portrait of a head, natural size, but without hands, was costed at 40 zecchini.
Historical and allegorical pictures with half-figures were costed in relation to the price of
portraits, as listed above, and in accordance to their size.

Furthermore, the sitter had to pay half the price agreed on at the first sitting, and
the other half when the portrait was finished. For the most part, Kauffman's prices
during her years in London were in line with the practices of her peers. Reynolds,
in fact, assisted her in fixing them, starting off at 20 guineas a head. According to
standardized canvases, the price for a half-length would thus be 40 guineas, with 60
guineas for a full-length, life-size portrait.[18] Later, in 1769, attesting to her
success, the German poet Friedrich Klopstock wrote to a friend: 'You will
immediately see how strong this young, black-eyed girl is in the arts when I tell you
that the gentlemen [of] Great Britain pay 50 gn. for a portrait.'[19]

Moreover, Kauffman developed a particular portrait form for herself, the full-length depiction on a small canvas. Examples include *Louisa Henrietta Campbell*, a *Lady with a Statue of Minerva* (illus. 28), *Margaret Bingham, later Countess of Lucan*, the *Duchess of Richmond in Turkish Dress* (illus. 80) and a portrait of *Theresa Parker* (illus. 40). This type commanded a fixed price, as an autograph letter of 1785 from Rome to Daulby in London reveals: 'Angelica Kauffman . . . acquaints him that her fixed prices for a small full-length portrait is 30 guineas, the canvas about 2 feet 6 inches high by two feet wide, which was her smallest size for this type. She went on to explain that she had smaller sizes for historical or for fancy figures, for a single figure on a canvas, or for a copper plate of about one foot, which came to around ten guineas.[20]

SITTING FOR KAUFFMAN

None of Kauffman's sitter-books has survived, and since the list of works executed in Italy does not refer precisely to the number of sittings or hours, little of her working practice there or in London can be known for certain.[21] Antonio Zucchi, for example, did comment on the exceptionally speedy execution in Rome in 1793 of her bust-length portrait of the Russian Count Czernichew: 'painted very daringly in one single sitting of four hours, the likeness is remarkable'.[22] Reynolds, on the other hand, wrote that a portrait would take him 'three sittings about an hour and a half each', and that the 'face could be begun and finished in one day'.[23] Nevertheless, these relatively rapid undertakings were the exception rather than the rule. Batoni, for instance, refused to be moved when put under pressure by his travelling clients: George Lucy reported that Batoni required 'a month or five weeks, and that he would not undertake to do me in less time'.[24] While in the case of Count Czernichew Kauffman might have worked directly on the canvas, more usually she seems to have first executed elaborate preparatory drawings, concentrating on capturing a facial likeness. And although there is no proof, she may, in fact, have relied on a system of stock images similar to those kept by many of her contemporaries: Reynolds, for example, had a collection of prints from which visitors could select a pose, just as Peter Lely in the preceding century had maintained a collection of numbered poses for his clients to quiz. Nor is there, it must be said, any evidence that Kauffman ever employed a drapery painter, as so

many other portraitists did, though her father, who was also an artist, may occasionally have assisted her.

Kauffman's compositional process is documented in her drawings, from brief compositional sketches to more elaborate – sometimes even coloured – *modelli*, for the most part on blue paper with added highlights. Of this type is the preparatory sketch for her portrait of *Lady Rushout and her Daughter, Anne*, which, though smaller in size than the canvas (illus. 82), bears on its edges the marks for transfer to the larger scale. Drawings of this kind were often passed to the client for consideration, and, on a few occasions, sold as works in their own right. Of particular interest to Kauffman's working process are the series of life-size cartoons in Bregenz. These elaborate pencil drawings were the immediate models for portraits, and they were closely followed during work on the canvas. Thus, a portrait could actually be painted after the sitter had departed, as was the case for the second autograph version of the portrait of the philosopher and critic J. G. von Herder, which is now in Frankfurt.[25]

As a woman artist, Kauffman was perceived by her British patrons to be able to render legible in her portraits qualities associated with the 'feminine'. In developing for her predominantly female sitters a set of iconographical 'frames' and particular portrait types, such as the small, full-length canvas, Kauffman explored the means of presenting non-commercial, and positively charged, settings. Although this can be seen to have conflicted with the means used for traditional *male* representations, this feminine space was to become increasingly important in the depiction of men. Relevant to a society engaged in redefining virtue according to social standing, her portraits were able to supply a new form of status, one based not on the material world of consumer exchange, but on a participatory exchange of sympathetic values.

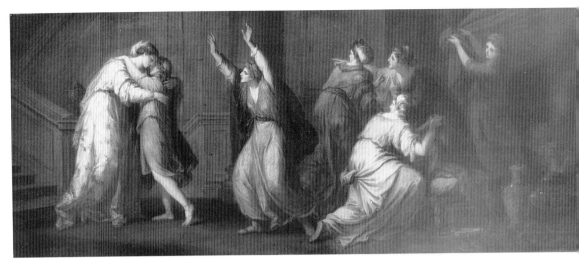

93 *The Return of Telemachus*, 1775, oil on canvas.

94 *Three Graces Dancing*, c. 1775, pen and ink with wash.

Kauffman's Decorative Work

MALISE FORBES ADAM &
MARY MAUCHLINE

Much of Angelica Kauffman's reputation in England rests on her work as a decorative artist. Yet our own examination of her output and achievement in this field has revealed a situation that would have been well known in her own lifetime: almost all the decorative compositions attributed to her are reproductive, and were executed after her designs by copyists. Back in 1805, for example, the inventory drawn up of the contents of Nostell Priory in Yorkshire accurately referred to paintings based on the subject of 'Angelica and Medora' as being 'in the style of Angelica Kauffman'.[1] It is important to realize that at present there are only *two* instances of decorative work by her hand authenticated by documentary evidence: four roundels (illus. 51–54) now in the vestibule of Burlington House, the present home of the Royal Academy, and two overdoors originally painted for Derby House in London's Grosvenor Square (illus. 46, 93).

The decoration of domestic interiors in the Neoclassical style popularized by Robert Adam offered immense scope for Kauffman's inventive and versatile talents, so that she came, in effect, to dominate this rapidly expanding market with her designs for ceilings and walls. She excelled in portraying subjects from the fables and legends of Greece and Rome, executed with rococo delicacy and informed by a considerable knowledge of Antiquity (illus. 94). This latter circumstance ensured the approval of a society nurtured in the Classics and accustomed to the conventions of allegory and symbolism. In 1773 the author and diarist Fanny Burney expressed the sentiments of her generation in 'confessing herself attached . . . to fabulous times!'[2] Kauffman was ideally suited by temperament and training to cater to this fashion for evoking Arcadian unreality, but her astounding success essentially lay in her grasp of the function of such decorative painting: it was there

to serve as a background, reflecting without ostentation or distraction the spirit of Antiquity.

The present misconception regarding the extent of her personal responsibility is due, for the most part, to the frequent occurrence of her name in the revival of the 'style Adam' in interior decoration that began in North America in the late nineteenth century; but the guidebooks published to accompany the opening of certain historic houses in England to the public in the 1920s and '30s also made unwarranted use of her name. In both Britain and the USA Kauffman was mistakenly identified as a member of the group of craftsmen who had worked for Robert Adam. This 'myth' has endured, reinforced by the fact of her marriage to Antonio Zucchi, who did have a long and close association with Robert Adam and his brother James.

The early twentieth-century vogue for the restrained elegance of the Neoclassical period was fashionable on both sides of the Atlantic, a reaction to the crowding of rooms in the late Victorian and Edwardian eras. In North America the renewal of interest in Adam's interpretation of Antiquity inspired a school of young architects. One of them, Charles McKim, produced in 1911 a notable example of Adam's legacy in the creation of the Percy Pyne House at 680 Park Avenue, New York. The ceiling of the first-floor drawing room is an exercise in the fully realized Adam tradition contained within an American interior, recalling the plasterwork of the Rose family, as seen, for instance, in the hall of Osterley House, London. The central panel depicting *Bacchus and Ariadne* – with Bacchus in the pose of the *Apollo Belvedere* – is very much in the style of Zucchi, Rebecca and Cipriani.

The Adam revival had been given impetus and direction by the Bostonian architect, Ogden Codman, who travelled in Europe and was profoundly impressed by certain eighteenth-century European decorative styles. He found his ideal collaborator in Edith Wharton, the American novelist. Together they produced in 1897 the first publication for decades on interior decoration, *The Decoration of Houses*, in which they stressed the value of historical precedent and a liking for, among other styles, English interior decoration of the late eighteenth century. A fine example, from as early as 1894–5, can be seen in a guest bedroom of the

Cornelius Vanderbilt II mansion, The Breakers, Newport, Rhode Island. Codman and Wharton's book caught the imagination and interest of the upper echelons of American society. Mrs Randolph Churchill and her sister, Mrs Moreton Frewen, became absorbed in houses and their presentation.[3] Interior design was recognized as a socially acceptable enthusiasm for a generation of women with the ability, the means and the energy to take advantage of the growing movement for their emancipation. In this climate, Kauffman's career attracted considerable attention, especially her success in providing designs for the decorative arts.

In 1892 Frances Gerard (a pseudonym for Geraldine Fitzgerald) wrote the first biography of Kauffman since the account of 1810 by Giovanni Gherardo De Rossi, the writer and critic who had known Kauffman personally during the later years of her life.[4] Using the source material then available to her, Gerard included a list of houses in which she averred Kauffman's decorative compositions still existed, although none of these has been found to possess authentic painting by her. Gerard's article in the *Art Journal* of 1897 is an apt comment on the position of Kauffman at the close of the nineteenth century, when informed appreciation of her work was clouded by a cult of romanticism, obscuring the possibility of any valid assessment based on stylistic evaluation or historical evidence. This sentimental trend began in 1875 when *Miss Angel*, a novel by Anne Thackeray, drew an exaggerated picture of Kauffman's life as an artist.

The purchase in 1866 for the Victoria and Albert Museum of a dressing-table, dated 1780,[5] gave the accolade both to the Adam revival and to late eighteenth-century furniture design, which included painted furniture in the style of Kauffman. Forty years later, Kauffman's image benefited directly from the scholarly work of Margaret Jourdain, in particular Jourdain's *The Decoration and Furniture of English Mansions in the 17th and 18th Centuries* (1909), which she wrote for the antique dealer Francis Lenygon, who was to do more than most to promote the fashionable neoclassical revival of the 1920s. Gerard's biography and Jourdain's reassessment of the period promoted Adam and Kauffman in the estimation of the public, but led inevitably to a mistaken emphasis on Kauffman's connection with Adam's designs for domestic interiors.

The fashion now launched became a serious branch of the decorative arts. An outstanding example was the involvement of one of the great patrons and philanthropists of the twentieth century, Hesketh Lever, later Viscount Leverhulme,

whose eclectic connoisseurship included late eighteenth-century furniture. In the Lady Lever Art Gallery near Liverpool, which Leverhulme founded, there are several pieces of furniture decorated with designs after Kauffman, which include two commodes, a tray and a cabinet on a stand. Hesketh Lever had part of the Music Room at Harewood House, Edwin Lascelles's palatial seat in Yorkshire, recreated for the Gallery in the form of a model. Coincidentally, the roundels in the Music Room's ceiling were thought to have been painted by Kauffman. It is of interest to note that when the 6th Earl of Harewood and his Countess, the Princess Mary (the Princess Royal), undertook alterations at Harewood around 1929, the style they adopted in Princess Mary's dressing-room was a pastiche in the Adam manner (illus. 95).

At the outbreak of the Great War, Britain and the USA shared the current passion for Neoclassicism; significantly, the impulse to return to the spacious linear form of interior decoration came from women like Mrs Ronald Tree (the interior designer Nancy Lancaster) and Lady Colefax (later a partner in the firm of decorators, Colefax and Fowler). Various scholars added weight to what otherwise might have been deemed a superficial hobby by giving the Adam revival their support and authority. A. T. Bolton, then curator of Sir John Soane's Museum in London, brought out his definitive two-volume study, *The Architecture of Robert and James Adam*, in 1922. Not surprisingly, he attributed to Kauffman two important works that are no longer accepted as autograph.

Bolton affirmed, in the first instance, that the medallions in the back drawing-room on the first floor of Chandos House, London, bore Kauffman's signature, a statement that has become part of the Kauffman 'myth' perpetuated by art historians as received evidence.[6] Recent scrutiny of these paintings and an extensive photographic survey have failed to reveal any trace of Kauffman's signature, although without X-ray examination the possibility of overpainting cannot be ruled out (illus. 96). In addition, these two medallions do not correspond stylistically with Kauffman's known work. One possible candidate for them is Antonio Zucchi. The second instance concerns the painting of classical figures in the Red Drawing-room of Syon House, London. Geoffrey Beard's discovery of the draft of a letter of 1784 and a Receipt and Disbursement Book at Alnwick Castle in Northumberland have substantiated his theory that the decorative artist employed was not Kauffman, but Cipriani.[7]

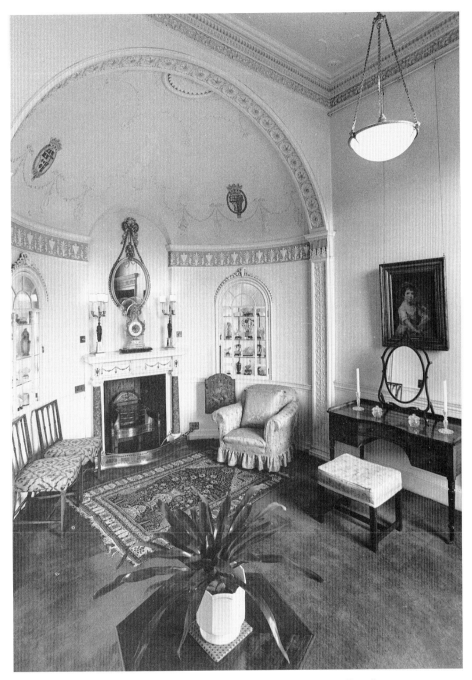

95 Dressing Room of H.R.H. Princess Mary (The Princess Royal), *c.* 1929.
Harewood House, West Yorkshire.

96 Chandos House, London: *Painting*, attrib. Zucchi,
c. 1770s, ceiling tondo, oil on paper applied to canvas.

In 1924 Lady Victoria Manners and Dr G. C. Williamson took a more cautious
view in their biography, *Angelica Kauffman*, casting legitimate doubts on previous
wholesale assignments to Kauffman of Neoclassical painting in the state rooms of
Adam and Adamesque houses. Even so, Manners and Williamson listed seventeen
houses in which it was suggested her decorative work might be seen.[8] However, not
one of these houses exhibits any painting that today can be regarded as definitely by
her hand. In general, such decorative schemes were executed on laid paper, often
in several sections, pasted on to canvas. This obviated the necessity of painting *in
situ*.

Adeline Hartcup's *Angelica: Portrait of an Eighteenth-century Artist*, published in
1954, follows Gerard's biography, but reviews the position of attributions at mid
century. She notes, for instance, that the entrance hall at Kenwood House,
London, is by Biagio Rebecca, not Kauffman, and that a similar misattribution
concerns Osterley Park, with regard to the painted panels in the library. Moreover,
Hartcup correctly describes the four oblong panels in the saloon at Kedleston Hall,
Derbyshire, as merely 'after her designs'. The ceiling of the Red Drawing-room at

Syon is removed from the Kauffman *oeuvre*, yet the Chandos House medallions are said by Hartcup to show her signature. However, this author sensibly concluded by remarking that 'the puzzle of tracking down Angelica's decorative painting is complicated by the common stock of classical subjects which was drawn upon by so many painters at that time'. She also suggests that the copying of engravings of her work by other artists, as well as the habit of painting over engravings in oils, adds to the confusion.[9]

The most authoritative research undertaken in the twentieth century is the doctoral thesis of 1968 by Peter S. Walch.[10] Walch expresses considerable doubt that Kauffman was ever employed by Adam as a decorative artist, pointing out that Manners and Williamson's list of houses in which her work could be seen must be drastically reduced. He cites their argument that contemporary memoirs frequently mention this branch of her art, but that the sources do not stand up to examination. He is on firm ground with her proven authorship of the Royal Academy's roundels, yet one's confidence evaporates when he accepts that her signature is on the Chandos House medallions.

This introduces the whole question of received evidence with regard to Kauffman's decorative work. Take, for example, the statements of Beresford Chancellor and John Swarbrick that Fanny Burney wrote in her diary of Kauffman's direct involvement in the decoration of Elizabeth Montagu's new house, 22 Portman Square, London. So far, no such entry in any printed version of her Diaries, nor in Burney's manuscript, has been located by the present authors.[11] Further, other art historians have written, without mentioning the Burney diaries, that Kauffman was indeed engaged at 22 Portman Square,[12] a statement impossible to prove due to the extensive bomb damage the house suffered during World War II and insufficient photographic records. Belief in her involvement in state rooms designed by Adam and his contemporaries persists nevertheless, although this is a myth now exploded as surely as the Adam–Chippendale connection has been.[13]

Guidebooks and related literature also gave substance to the Kauffman myth. She appears in them as a prominent member of Adam's elite group of artist-craftsmen, with (unproven) responsibility for areas of delightful decorative painting in domestic interiors. Readers were thus encouraged to envisage her travelling around with this 'regiment of artificers' to widely dispersed houses,[14] when, in actual fact, during these years more lucrative commissions for portraits and subject

paintings were occupying Kauffman from dawn to dusk in her London studio. It was a romantic and attractive concept difficult to eradicate. For example, the 1990 guidebook for Stowe House in Buckinghamshire refers to the attribution of 1921 that the overdoors in the state dining-room are the work of Kauffman.[15] A more reasoned approach, which has attended the growth of art-historical scholarship, is responsible for the current revision of Kauffman's work, in conjunction with more advanced techniques of research. (It is now known, for instance, that her name does not occur in connection with the account Adam maintained with Drummond's Bank.[16])

Two Yorkshire houses illustrate the unreliability of received evidence. At Harewood House, the medallions in the Music Room were stated by Ely Hargrove in the 1789 edition of his guidebook, *History of . . . Knaresborough*, to be by Zucchi,[17] but claimed by Jewell in his 1822 guidebook to have been executed by Rebecca. Twentieth-century guidebooks assign them to Kauffman. Those of 1964, 1972 and 1981 are unequivocal on the subject of her authorship, and their successor of 1990 makes the same claim, although the case for Zucchi has been made by several historians.[18] At Newby Hall, about twenty miles north of Harewood, where Adam's decorative craftsmen were also at work, the situation is reversed. One of a pair of painted roundels, *Beauty Directed by Prudence Rejects with Scorn the Solicitations of Folly* (illus. 97) has been noted as 'after a design' by Kauffman, and recorded as such in the 1990 guidebook. The subject of the companion *Design Directed by Beauty to Give her Allegiance to Poetry* (illus. 98) is original and of particular interest. Because of the thematic and stylistic affinities with her known work these have both recently been attributed to Kauffman.[19] Furthermore, the painting by Zucchi over the chimneypiece in the original dining-room, now the library, *Sacrifice to Ceres*, is after a drawing by Kauffman (illus. 99) in the Department of Prints and Drawings in the British Museum.

To deprive Kauffman of her accepted role as a member of the group of decorative artists usually employed by Robert Adam in no way detracts from her influence on the decorative arts in eighteenth-century England. In fact, through the medium of engraving, her designs reached a wider public and were given a greater diversity of use than those of any other decorative painter of her generation. They appear on interior elevations and chimneypieces, on furniture and porcelain, on the exquisite accessories of eighteenth-century social life, such as snuff-boxes

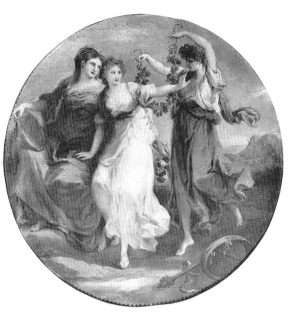

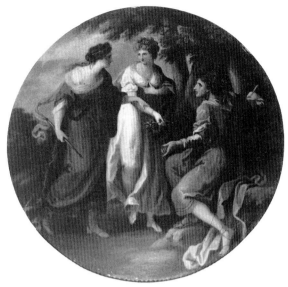

97 *Beauty Directed by Prudence Rejects with Scorn the Solicitations of Folly*, oil on paper applied to canvas, *c.* 1783. Newby Hall, North Yorkshire.

98 *Design Directed by Beauty to Give her Allegiance to Poetry*, oil on paper applied to canvas, *c.* 1783. Newby Hall, North Yorkshire.

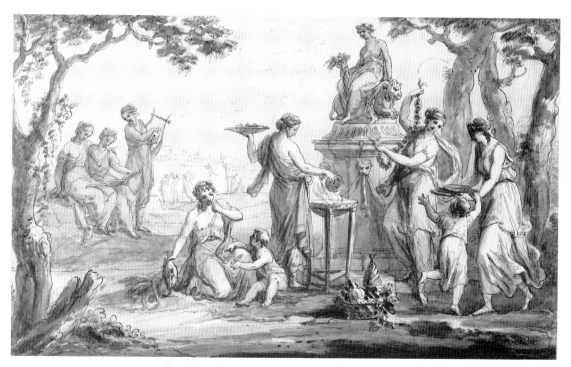

99 *Sacrifice to Ceres, c.* 1770, pen and ink with sepia wash.

100 Anon., *The Muse of Poetry Paying Homage to Shakespeare*, after Kauffman, *Shakespeare's Tomb*, c. 1783, needlework embroidery.

and cameos, as well as book illustrations and needlework pictures (illus. 100). Patrons, architects, cabinet-makers and entrepreneurs could take their choice from an extensive collection of engravings, evidence of Kauffman's remarkable cultural background and her ability to select subjects that would be immediately recognizable and visually appealing. Kauffman came, by virtue of her decorative designs, to personify fashionable good taste.

INTERIORS WITH KAUFFMAN DESIGNS

Three examples of interiors incorporating decoration after her designs are at Attingham Park in Shropshire, Kedleston Hall and Osterley Park; in addition there is the drawing-room (now in the Victoria and Albert Museum) from Northumberland House in London.

In the west wing of Attingham, the suite of rooms for the mistress of the house illustrates the type of conventional Neoclassicism associated with Kauffman. The

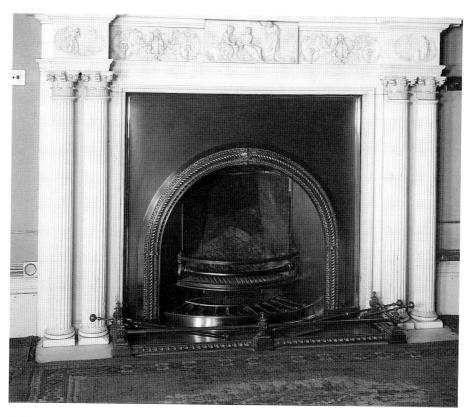

101 Carrara marble chimneypiece in relief attributed to John Devall Jnr, *c.* 1785, in the Drawing Room at Attingham Park, Shropshire, after Kauffman's *Beauty Governed by Reason Rewarded by Merit.*

102 The Boudoir at Attingham Park, Shropshire.

theme of the second drawing-room, the Sultana Room, is Love, symbolized by three of Kauffman's Cupid designs, interpreted in the ceiling roundels by a very competent painter, at present unidentified. In the centre, Cupid is awakened by nymphs, a roundel entitled *Dormio innocuus . . .* (My sleep is harmless, you wake me at your peril), one of her familiar designs engraved by William Wynne Ryland, arguably her favourite engraver, in 1776 (illus. 121). Next door, in the boudoir, the wall panels include one after Ryland's engraving of a herm of Pan adorned by nymphs (illus. 129), and inscribed with the opening line of a satire (I, viii) by Horace: 'Olim truncus eram ficulnus inutile lignum' (Once I was the trunk of a fig-tree, a useless piece of wood). This design also appeared in 1775 as part of the Duke of Northumberland's elaborate 'glass' drawing-room at Northumberland

103 *Fame Decorating Shakespeare's Tomb*, *c.* 1772, oil on metal.

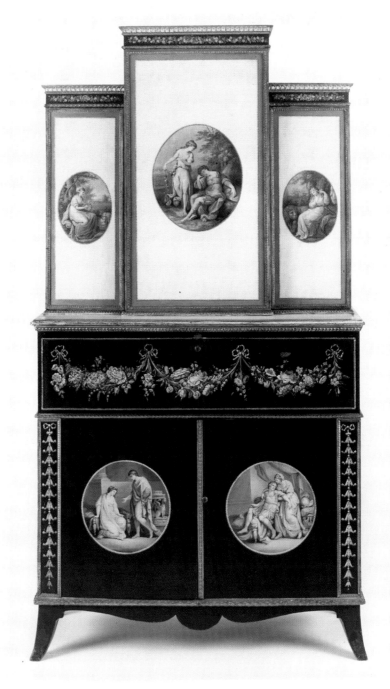

104 Secretaire-bookcase, with five designs derived from compositions by Kauffman, *c.* 1786, oil, grisaille on copper (upper section), oil on panel (lower section).

105 Painted detail from a late-18th-century commode (*see below*),
after Kauffman's *Telemachus at the Court of Sparta*.

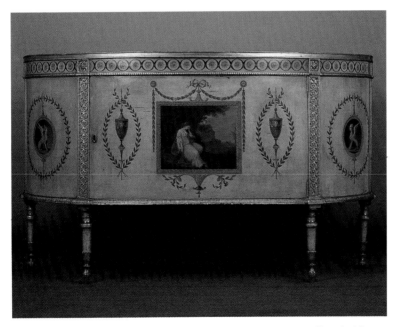

106 Late-18th-century commode with painted detail after Kauffman's *Maria*,
from Sterne's *A Sentimental Journey*.

107 *Maria*, exh. R.A. 1777, oil on metal.

House, which was designed by Robert Adam. Four roundels painted by Cipriani after Kauffman's most advanced Neoclassical designs were incorporated in the exotic scheme.

By contrast, at Kedleston Hall, in Adam's superb and eminently Neoclassical salon, two of the four panels painted in grisaille by Biagio Rebecca are after designs by Kauffman, engraved in colour by Ryland in 1780, which derive from English medieval history: *Lady Elizabeth Grey Imploring of Edward IV* (see illus. 141) and *The Tender Eleanora Sucking the Venom out of the Wound which Edward I, her Royal Consort, Received with a Poisoned Dagger* (see illus. 140). Again, at Osterley Park, one of Adam's most important commissions, Kauffman's depiction of sleeping Aglaia was an appropriate choice for the state bedroom ceiling.

The employment of designs after Kauffman in three of Adam's most prestigious houses – executed in two instances by such accomplished artists as Cipriani and Rebecca – indicates her pre-eminence as a decorative designer.

Chimneypieces were an integral part of the decorative programme of an interior, offering scope for Kauffman's delicate and adaptable compositions. The west wing at Attingham has two splendid examples. In the drawing-room chimneypiece is a tablet in Carrara marble, probably executed by John Devall Jnr, the King's master mason, after Kauffman's design, *Beauty . . . Rewarded by Merit* (illus. 101). In the boudoir (illus. 102), under the painted roundel of *Nymphs adorning Pan*, a large circular tablet depicts another of her cupid designs, the enchanting *Cupid Rebuked by his Mother, Venus* (*Veillez amans si l'amour dort*).

FURNITURE

To achieve this effect of harmony of design and proportion, which Adam regarded as essential for the background to elegant living, furniture, as opposed to furnishings, became of supreme importance. Very little survives that bears Kauffman's designs, since the softer woods used in the construction of painted furniture and the fragility of the decoration made them less durable. Decorations were painted on the wood itself, on copper, canvas or paper, or executed in marquetry. A selection of commodes survives, however, mostly attributed to the painter and cabinet-maker George Brookshaw,[20] where Kauffman's designs beautifully complement Brookshaw's floral decorative painting. One that is attributed to him, now in the

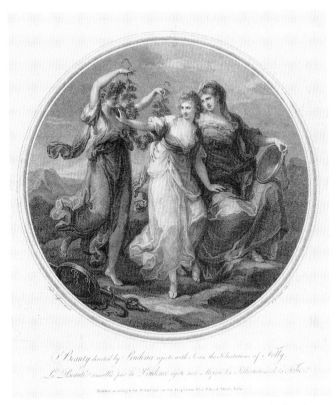

108 J.-M. Delattre after Kauffman, *Beauty Directed by Prudence
Rejects with Scorn the Solicitations of Folly*, 1783, stipple engraving.

Lady Lever Art Gallery (Acc. no. LL 4322), has a particularly interesting design
after Kauffman, an incident from the tale of *Damon and Musidora*, in which
Musidora, about to bathe, is spied on by Damon. The immediate source is
'Summer' (lines 1269–1370) in *The Seasons*, which was first published in 1730 by
the Augustan poet James Thomson, whose emphasis on the theme of human
response to the natural world clearly attracted Kauffman.

Decoration after the prints *Beauty . . . Rejects with Scorn the Solicitations of Folly*,
and its pair, *Beauty . . . Rewarded by Merit*, appears on two semicircular commodes
attributed to the same cabinet-maker. The engravings, by J.-M. Delattre
(illus. 108), were framed to make an attractive pair of Neoclassical shield-shaped
pole-screens (sold by Sotheby's 18 May 1990, lot 202) around 1785 (illus. 109).

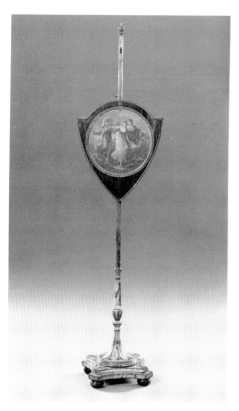

109 Polescreen, *c.* 1785, with engraved
design by J.-M. Delattre after Kauffman's
Beauty Directed by Prudence . . . of 1783.

110 J. K. Sherwin after Kauffman,
Erminia (Writing Tancred's Name on a Tree),
1781, stipple engraving.

Also attributed to Brookshaw are two delicate semicircular tables in the Victoria
and Albert Museum (Acc. no. 349–1871, and 349A–1871). The four ovals painted
on copper, which decorate the tops, are derived from Kauffman designs: *Abra,
Erminia*, the *'Swans of Lethe'* and *Innocence*, from the poetry of Tasso, Ariosto and
William Collins, show the wide range of her literary sources and her illustrations of
the 'moral emblems' for which she was well known. Torquato Tasso's *Gerusalemme
liberata*, a Renaissance epic of the capture of Jerusalem in the First Crusade, was a
constant source of inspiration to numerous artists besides Kauffman. The atten-
tion of the reading public was drawn to it once again in 1771, when this immensely
popular work was republished in Paris in two volumes (in the original Italian text)
with superb engravings after Hubert Gravelot (illus. 111).[21]

C.XIV.

Così l'avvinse, e così preso il tiene.

111 Jean Massard after Hubert Gravelot, *Rinaldo and Armida, c.* 1771, engraving.

Seat furniture with Kauffman designs is very rare. However, in the suite by Brookshaw in the Lady Lever Art Gallery, one sofa has roundels with designs from Tasso's epic: *Rinaldo and Armida* and *The Death of Clorinda* (Acc. no. LL 4161). *Rinaldo and Armida* make up one of five Kauffman designs that decorate a unique secretaire-bookcase in the Philadelphia Museum of Art. It appears with *Abra* (the shepherdess concubine of King Solomon, who makes an appearance in Collins's *Persian Eclogues* of 1742) and *Una* (a virtuous maiden in Edmund Spenser's *The Faerie Queene*) as well as two episodes from Shakespeare depicting *Cleopatra*, illustrating in a most ingenious manner various aspects of love (illus. 104). The

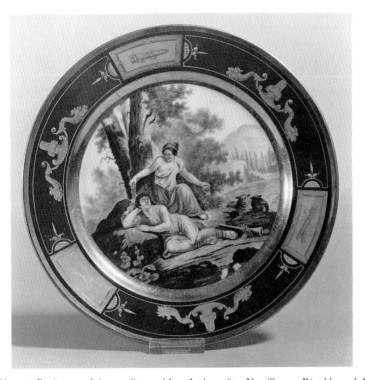

112 Plate in Paris porcelain, *c.* 1810, with a design after Kauffman: *Rinaldo and Armida*.

choice, one surmises, was made by an enlightened and well-read client, perhaps with the help of his cabinet-maker.[22] An interesting footnote in this connection concerns the appearance of *Rinaldo and Armida* on a wardrobe, part of a set of furniture supplied by Charles Jenners (the Edinburgh store whose name was changed to 'Jenners' in 1924). Thus the use of this design coincides with the revival of the popularity of Kauffman's work.

In the Palace of Pavlovsk, near St Petersburg, there are three pieces of furniture decorated with Kauffman designs. The most important piece by far is a firescreen, dated 1796, which was made in the workshop of Heinrich Gambs for Maria Feodorovna, daughter-in-law of Catherine the Great, with a painted oval, possibly executed by the Grand Duchess herself, of *Cupid's Pastime*. The subject was taken from the *Reliques of Ancient Poetry* (1765), an anthology compiled by Thomas Percy, which G. S. Facius and J. G. Facius engraved in 1785 (illus. 113). Percy's collection of ballads, songs and romances dating from the fifteenth century was well received

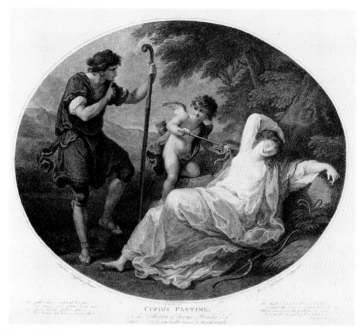

113 G. S. and J. G. Facius after Kauffman, *Cupid's Pastime*, *c.* 1783–5, stipple engraving.

in literary circles; its use by Kauffman indicates that her subjects may actually be derived from English narrative and poetic sources even when they appear entirely Classical in content. The poem 'Cupid's Pastime' was written early in the seventeenth century, and Kauffman followed the text in careful detail.

A further instance of Kauffman's practice of illustrating passages from contemporary literature occurs on a large painted commode now in the Board Room of Coutts' Bank in the Strand (illus. 106). Although the principal decoration, after a design by Kauffman, is *Telemachus at the Court of Sparta* (illus. 105), the secondary decoration is a variation of Kauffman's painting of *Maria* inspired by Laurence Sterne's novel *A Sentimental Journey* (1768). They both depict personal grief. Could the choice of these designs indicate that the patron commissioned this piece during a period of mourning, or were they selected because of the prevailing fashion for the portrayal of sentimental scenes?

Kauffman's painting of *Maria* is at Burghley House, Lincolnshire (illus. 107), and Ryland had engraved it in 1779 (illus. 133). Kauffman's design is completely faithful to Sterne's description of the forsaken simpleton 'Poor Maria', although

the pose refers to the figure in Dürer's engraving, *Melencolia*. The success of Ryland's engraving was immeasurable. 'Poor Maria' appears on a pole-screen, on a tea-tray in the Lady Lever Art Gallery, and on a Wedgwood cameo mounted in a cut-steel frame by Matthew Boulton, for 'In the elegant manufactures of London and Birmingham it was transferred to an incalculable variety of articles of all sorts and sizes from a watch case to a tea waiter'.[23] The only other design of Kauffman's used by Wedgwood is *Veillez amans si l'amour dort*, engraved by Francesco Bartolozzi in 1783 (Acc. no. LL 1733). One might have expected Josiah Wedgwood and his successors to have used Kauffman's work as a source on other occasions, especially as the adoption of Sir William Hamilton's vase designs for the Wedgwood wares proved so popular. Hamilton's admiration for the work of the 'justly celebrated Angelica Kauffman' was well known. In his 'Observations' to the 1791 publication of the Vases, Hamilton unhesitatingly praises Kauffman's painting of 1782, *Penelope at Work*, based on plate 10: 'with little variation she painted a most pleasing picture from it.'[24]

An interesting George III commode, *c.* 1772, by the Swedish-born *ébéniste* to the Prince of Wales, Christopher Fuhrlohg, has decoration in his inimitable marquetry depicting *Erato and her Lyre* with the words 'ANGELICA KAUFFMAN R.A. PINXENT' scorched under the figure on the left-hand side (illus. 114), and his own signature on the right. Thus Fuhrlohg indicated the source of his inspiration. (Unfortunately, this commode was sold in April 1975 to a Lebanese dealer, and cannot at present be traced.) Its pair is in the Lady Lever Art Gallery, but the design is not attributed to Kauffman.

114 'Angelica Kauffman R.A. pinxent': legend scorched on the side of a commode designed by Christopher Fuhrlohg, *c.* 1772.

A further debt to Kauffman can be seen in Fuhrlohg's marquetry roundels on the supremely elegant commodes designed by Adam in the drawing-room at Osterley (O.P.H. 82–1949), depicting the goddess Diana on one, and on the other *Venus Explaining the Torch of Hymen to Cupid*.

PORCELAIN

Kauffman's repertory of engraved designs was widely used as decoration for porcelain. Surviving examples of these pieces are so often found only in museum cabinets and private collections that their function and purpose tends to be obscured. High-quality pieces were fashioned for ornament, but the entrepreneurial climate of the later eighteenth century created a buoyant market for relatively inexpensive products for everyday use (illus. 115). From mid century, English porcelain was available.

Directors of porcelain factories depended for their themes on the output of artists, and in particular artists whose work had been engraved. Prints were, therefore, the medium through which ideas were disseminated. The vogue for coffee and tea called for well-designed porcelain, a less costly material than silver. The design of silverware initially influenced the shape of porcelain coffee- and tea-pots, and was ideally suited to receive painted decoration. Engravings were adapted as necessary to fit not merely a variety of shapes, such as cups, saucers, vases, the rims and bases of plates, but, in order to sell the products, the design had to be placed on the objects in the most pleasing way possible. Kauffman's work clearly fitted these requirements, and the Worcester factory, which specialized in the production of 'useful wares', habitually sought her designs.

Cupid designs monopolized the field: Fanny Burney wrote to a friend, 'They who, in a short time, can make themselves known and admired now in London, must have their Cupids'.[25] One example of this craze was Kauffman's *Cupid's Struggle with the Graces to Recover his Arrows*. Engraved by Gabriel Scorodomoff in 1779, it appears, for example, on a vase of the Imperial Porcelain Factory, St Petersburg, in the early nineteenth century (Inv. no. 5304). Moreover, the reference to the vase draws attention to the practice of placing flowers on hearths, slabs or under tables, whereas urns and vases for display were a permanent feature of any interior scheme, designed to stand on chimneypieces, bookcases or bureaux.[26]

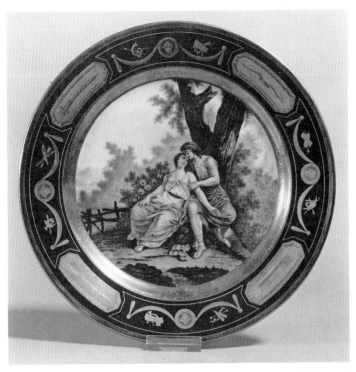

115 Plate in Paris porcelain, *c.* 1810, with a design after Kauffman: *Venus and Adonis*.

The Russian engraver Scorodomoff (Skorodumov) had arrived in England in 1773, and became Bartolozzi's pupil. His admiration for Kauffman is recorded in a letter of 1777 to the Imperial Academy of Arts: 'I have the honour to report that the best engravers are to be found in London namely F. Bartolozzi in the historical genre . . . In painting Mrs Angelica is an extremely skilled woman in the historical genre'.[27] Gerard notes in her biography of Kauffman that Scorodomoff was listed among 'the engravers who had a copyright of her designs'.[28] Complying with popular demand he made a speciality of engraving scenes involving the presence of Cupid.

A further example of this vogue is Kauffman's painting *Cupid Disarmed by Euphrosyne* (1784), which illustrates an episode from Metastasio's festal piece, 'Le grazie vendicate' (Revenge of the Graces).[29] The work of Metastasio, Vienna's court poet since 1730, enjoyed enormous popularity in England in the 1770s and '80s. Kauffman's painting was engraved by Thomas Burke in 1794, and the design

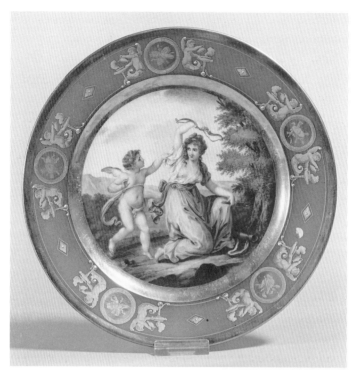

116 Plate of Paris porcelain, *c.* 1810, with design after Kauffman:
Cupid Disarmed by Euphrosyne.

can be seen in the centre of a plate (*c.* 1810) of Paris porcelain in the Bowes
Museum at Barnard Castle, County Durham (illus. 116). It also appears in reverse,
on a commode, attributed to Brookshaw, formerly at Piercefield Park, Mon-
mouthshire. The original painting, and its pair, *Cupid Binding Aglaia to a Laurel*,
also engraved by Burke, are now in the Rosenbach Museum, Philadelphia.

The large and splendid dinner-services, used perhaps only on state occasions,
provided opportunities for lavish decorative painting. At the Royal manufactory at
Sèvres, Kauffman's design *Beauty . . . Rewarded by Merit* engraved by J.-M. Delattre
in 1774, served as a model for the reserve on one of the plates of Louis XVI's
service, dated 1790.[30] The pair to this, *Beauty . . . Rejects with Scorn the Solicitations
of Folly* (illus. 108), was also engraved by Delattre in 1773, but it also appears in
more humble guise in England, in grisaille, on a Chamberlain Worcester beaker in
the Victoria and Albert Museum. Thus, in ceramics, as in other fields, the moral,

didactic tenor of much of Kauffman's work, so in tune with prevailing sentiment, appears in allegories illustrating the vexed question of choice.

The continuing appeal of Kauffman's designs can be instanced in the twentieth century. *Beauty . . . Rewarded by Merit* and its pair once again appear as decoration on a set of plates dated 1910 – the moment the Kauffman revival was gaining strength. Made for display rather than for use, they are marked 'AG' on the reverse, possibly indicating a small Austrian or Bohemian factory. Many porcelain manufacturers capitalized on the Neoclassical-cum-Kauffman revival. Even earlier evidence of this can be seen in the Bowes Museum. A Vienna plate, decorated in Hungary, that Mrs Bowes bought at the 1871 London Exhibition, has *Cupid Disarmed* as the central design (illus. 116).

The work of leading artists other than Kauffman was selected for the decoration of porcelain. Reynolds's portrait of her, probably from an engraving by Bartolozzi, by chance, decorates a late-eighteenth-century Meissen cup in the Victoria and Albert Museum.

One of the most comprehensive collections of English porcelain, amassed by Lady Charlotte Schreiber in the nineteenth century, is now displayed in the Victoria and Albert Museum, to which she bequeathed it. Curiously, no piece bears a Kauffman design, but a photograph of Lady Schreiber in her old age reveals the Kauffman print *Dormio innocuus . . .* (see illus. 121) framed on the wall behind her.[31] This particular design appeared on all manner of objects. It is, for example, the subject of a group from the Derby factory, in biscuit porcelain.

CONCLUSION

Every contemporary artistic development found in Kauffman a talent that could be employed with profit. To cater for the increased interest in poetry, John Bell of the Strand launched his pocket edition (1778–92) of 109 volumes, with frontispieces by prominent artists. Kauffman contributed, for instance, the frontispiece to volume 73 (illus. 139), the scene from David Mallet's 'Amyntor and Theodora', engraved by Bartolozzi. Moreover, it was reported in *The Oracle* for 11 July 1789 that she was engaged on a commission to illustrate *Evelina*, Fanny Burney's bestselling novel, for Catherine the Great. Kauffman's gifts were admirably suited to interpret with ease and elegance the whole range of decorative art. She was ready

to adapt her work either to the requirements of a mechanical process or, apparently, to the fashionable small-scale personal possessions or *objets de vertu*, characterized by the exquisite craftsmanship of the period.

Fanny Burney records in her diary how she spent 23 March 1781 at Reynolds's London house with his niece, Miss Palmer, who took her in the morning 'to see some beautiful fans, painted by Poggi, from designs by Sir Joshua Reynolds, Angelica, West and Cipriani on leather'.[32] Reynolds, in fact, urged the finest artists to design for such 'toys' in everyday use, citing the example of Cellini, who engraved fashionable ornaments. 'Such persons will infuse into those lower departments a style and elegance, which will raise them far above their natural rank'.[33] For this reason Angelica and other eminent artists agreed to provide designs for Anthony Poggi's fans to promote one of the 'inferior arts'. Kauffman's design for a fan in sepia and ink on paper depicting the *Three Fine Arts* (illus. 144) is preserved at Burghley House in a folio scrapbook compiled by Brownlow Cecil, 9th Earl of Exeter, one of Kauffman's earliest patrons. The design is a Neoclassical scene in line with the demand for fans to match Neoclassical interiors, and is the subject of a large painting by a second-rate artist that now hangs in a guest bedroom at Harewood House.

It could be argued that the designs of a woman artist were more frequently chosen for apartments set aside for the ladies of the house, for instance the 'glass' drawing-room at Northumberland House or the boudoir at Attingham Park, yet they also grace the severely Neoclassical saloon at Kedleston Hall. And they found a place in both town and country houses. To evaluate Kauffman's decorative painting purely in terms of Neoclassical design is, however, misleading. There were those who, like Dr Johnson, found that 'the attention naturally retires from a new tale of Venus, Diana and Minerva',[34] and Kauffman was well aware of this. Her greatest asset was her ability to range over the whole field of English history and literature. If her work as a decorative painter brought fewer rewards financially, it nevertheless made Kauffman more celebrated than any other field of her artistic endeavour could have done, for her ambition and initiative led her to be among the first artists to take advantage of the new mechanical processes and the mass markets they served.

Kauffman and the Print Market in Eighteenth-century England

DAVID ALEXANDER

In the last quarter of the eighteenth century there was a sudden fashion for 'furniture prints' – that is, decorative prints to be framed and put on the wall, rather than kept in a portfolio – engraved in the delicate new dotted technique of stipple. There were more singly issued stipples engraved in England after the work of Angelica Kauffman than after any other painter.[1] Between 1774 and 1781 – the second half of her stay in England – some 75 stipple engravings were published after her paintings and drawings, and nearly double that number appeared between her departure, in 1781, and 1800. This essay discusses this phenomenon, in particular her relationship with engravers and publishers and the extent to which the demand for prints influenced her art.

PAINTERS AND THE REPRODUCTIVE PRINT

From the earliest days of engraving, when Raphael worked with the engraver Marcantonio, prints played a vital role in promoting the reputation of painters.[2] Between the 1730s and the 1760s William Hogarth, who secured the Engravers' Copyright Act of 1735, showed how a painter could appeal directly to the public by skilful advertising and selling his prints by subscription. In the years before Kauffman's arrival in England in 1766 various painters had worked with engravers, in particular the engravers of mezzotints, the tonal technique so associated abroad with imported English prints that it was called *la manière anglaise*. This produced prints that were close in appearance to oil paintings; some, of fancy pictures, were bought as furniture prints, while others were bought by collectors of fine prints, or by those who wanted prints of Old Master pictures. James McArdell (1728/9–

1765) engraved several portraits, including, in 1754, *Lady Charlotte Fitzwilliam* after the young Joshua Reynolds, which the painters published to make themselves known. When, in 1760, exhibitions began with those of the Society of Artists, prints of contemporary pictures were shown, sometimes in the same year. Until then, most prints of English paintings had been portraits; now exhibitions broke the monopoly of the commissioned portrait and made it easier to paint on speculation, since if a painter exhibited, he could hope for sales and commissions. Thus, in the 1760s there was a greater variety of mezzotint, including historical pictures after Benjamin West, theatrical conversations after Johann Zoffany, *luministe* pictures – so suited to mezzotint – after Joseph Wright of Derby (1734–1797) and the animal pictures of George Stubbs (1724–1806).[3]

During the 1760s independent engraver-publishers became less important than large publishing firms, notably those of Robert Sayer (1725–1794) and John Boydell (1719–1804). Mezzotint was becoming less suitable for subject prints, especially those for which a large sale was expected; this was partly because it could be difficult to include the greater detail of history paintings, and partly because the plates wore more quickly than line engravings. In any case, line engraving, not mezzotint, was regarded as the appropriate medium for history painting; this was an important factor if overseas sales were hoped for. Since the 1730s there had been a market abroad for English line engravings, as witnessed by the number of prints with titles in English and French, but they tended to be of Old Master pictures. During the 1760s both Sayer and Boydell had success with the landscape prints of William Woollett (1735–1785); his prints after Richard Wilson, notably the *Niobe* published by Boydell in 1761, were – apart from Hogarth's – the first prints of contemporary English paintings to sell really well on the Continent.

THE FIRST MEZZOTINT PORTRAITS

Initially, it was Kauffman's powers as a portrait painter, allied with public interest in such an attractive and accomplished young woman, that made her known and led to her inclusion among the founder members of the Royal Academy in 1768. The first of her prints to be engraved was probably the full-length of Augusta, Duchess of Brunswick, and sister of George III. This commission in 1767 brought the aristocracy to her door. A large undated mezzotint by Jonathan Spilsbury (*c.* 1740–

1812) appeared with a dedication to the sitter's mother Augusta, Princess of Wales, for whom the picture was presumably painted, signed 'Angelica', an indication that the painter was involved in its publication. As no publisher's name is given, it is likely that she financed it, either issuing it by subscription or paying for the plate herself, with the aim of distributing some copies to her growing circle and selling others through print shops.

Thus the first major print of her English career may therefore have been initiated by Kauffman herself. Spilsbury also engraved Kauffman's *Thalia* in October 1770, on which he is given as the publisher. Publishers also began to take an interest in her pictures, and in October 1768 Richard Houston (1722–1775) presented to the visiting Christian VII of Denmark a copy of his mezzotint of Kauffman's portrait of him, published by Sayer.[4]

PRINTS OF HISTORY PAINTINGS

In the late 1760s Kauffman also became known for a new kind of Neoclassical history painting. She sent pictures of incidents from the story of the Trojan War to the exhibition arranged in 1768 by the Society of Artists in honour of King Christian and to the inaugural exhibition of the Academy in 1769. She showed *The Interview of Hector and Andromache* (illus. 25) on both occasions, and this was the first of her history paintings to be engraved; Sayer published a mezzotint of it by James Watson (1739–1790) in January 1772 as a pendant to *The Anger of Achilles* engraved by Robert Laurie (*c.* 1740–1804) after Antoine Coypel (1661–1722).

At the Academy a few months later a pair of drawings was exhibited of two pictures that Kauffman had shown there in 1770 and 1771 of scenes from British history, *Vortigern and Rowena* and *The Interview of Edgar and Elfrida after her Marriage with Athelwold*. These were the work of the line engraver William Wynne Ryland (1733–1783), and were a signal that he intended to engrave prints from them.

It was Ryland who was to be the engraver most responsible for spreading Kauffman's fame. He had trained as a line engraver in France and had engraved the coronation portraits of George III and Queen Charlotte after Allan Ramsay (1717–1784), becoming Engraver to the King in the early 1760s. Instead of continuing as an engraver, however, he went into business in 1766 with another engraver, Henry Bryer, as printsellers on Cornhill. They published some success-

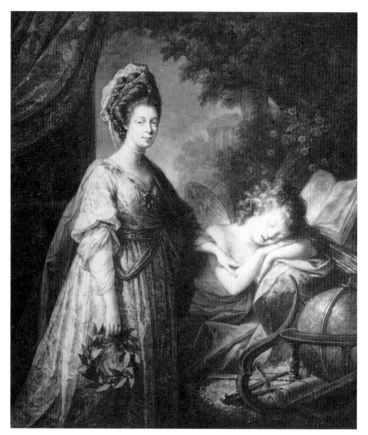

117 Thomas Burke after Kauffman, *Queen Charlotte Raising the Genius of the Fine Arts*, 1772, mezzotint.

ful prints, but went bankrupt in 1771. What was not generally known at the time was that the reason for their failure was not the Cornhill business, but a large consignment of pictures and prints sent to India on borrowed money that totally failed to sell.[5]

Ryland was soon trading again, this time in the Strand. He had recognized the potential appeal of Kauffman's subject pictures; he did not, however, make much progress with the line engravings. Such prints took a long time to engrave, and Ryland needed more immediate returns. Instead, he employed Thomas Burke (1749–1815) to engrave mezzotints after Kauffman's paintings. The first, an optimistic allegorical portrait, *Queen Charlotte Raising the Genius of the Fine Arts*

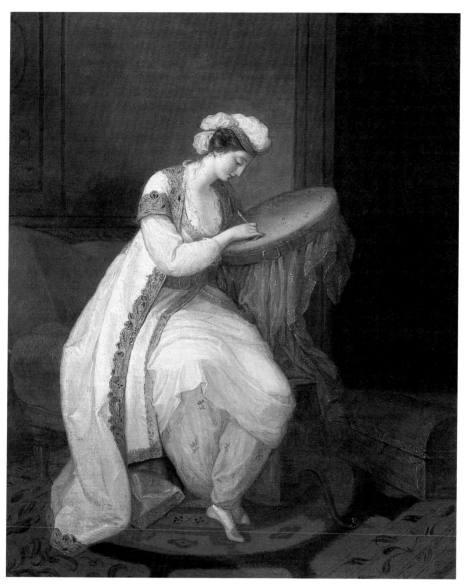

118 *Morning Amusement*, 1774–80, mechanical painting(?).

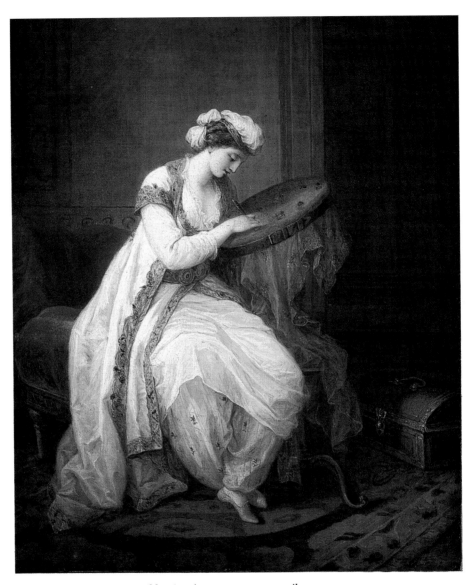

119 *Morning Amusement, c.* 1773, oil on canvas.

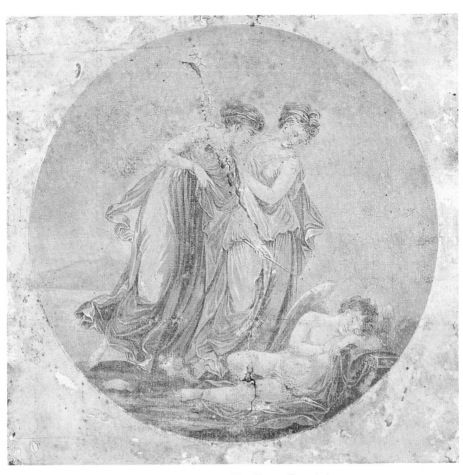

120 Francis Eginton after Kauffman, *Dormio innocuus*,
c. 1778, mechanical painting on laid paper.

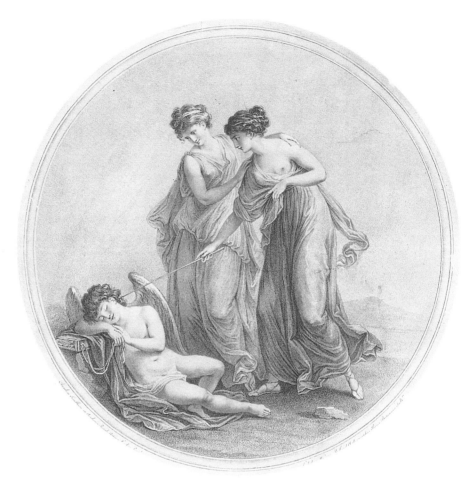

121 W. W. Ryland after Kauffman, *Dormio innocuus*,
1776, stipple engraving.

(illus. 117) appeared in May 1772. Two more appeared that September: *Cleopatra Adorning the Tomb of Mark Anthony* and *Samma the Demoniac*, inspired by Klopstock's *Messias*, a book that Count Bernsdorff had seen in her hand when he visited her studio – Pope's Homer was on her table – in September 1768.[6] These two affecting pictures, the former with the drooping female figures so associated with Kauffman and light effects that suggest the influence of Wright of Derby, had been exhibited at the Academy in 1770.

In 1773–4 Ryland published five more mezzotints after Kauffman – four from the Classics and one illustrating Ossian – while Sayer published two. Four of these seven prints were after paintings that had been seen at the Royal Academy. Whereas *Andromache* and *Samma* appeared more than two years after they were exhibited, prints soon began to be published quite quickly. Mezzotint plates could be engraved rapidly, so it is possible that Burke could have begun his *Cupid Finding Aglaia Asleep* after it was exhibited in April 1774; a proof – an impression aimed at collectors that was printed prior to the engraved lettering of the published state – is dated 21 July 1774. The following year *Renaldo Arresting the Arm of Armida*, engraved by Valentine Green (1739–1813), was published by Sayer on 20 April, while Kauffman's picture was on exhibition. A prior approach must clearly have been made. Publishers could ask owners of pictures for permission to engrave their pictures once they were in their possession without reference to the painter, but in the case of pictures still in the studio, whether sold or not, the approach would have to be to the painter. Ryland had a drawing of *Samma* that Kauffman may have done to assist the engraver, but this does not prove co-operation; he also had a proof which was said to have been 'touched', that is corrected, by Kauffman of the mezzotint of *Aristides* by William Dickinson (1746–1823), which suggests they were working together before he published it in May 1774.[7]

THE ACADEMY AND THE PRINT TRADE

Close relations between painters and print publishers was regarded with suspicion by the Royal Academy, especially if it seemed that the principal reason for a picture being exhibited was to promote the sale of a print. Although great numbers of prints were made from pictures by the President, Reynolds, who welcomed the publicity they brought, prints were almost invariably a by-product of his painting, not the

primary reason for the existence of the pictures. Reynolds was keen to raise the
social status of painters and to distance them from printselling. Whereas engravers
played an active part in the Society of Artists, they were excluded from membership
of the Academy on its foundation. By 1768 many of the leading engravers were
working for print publishers rather than issuing prints themselves; the Academy
did not wish to see its walls covered with prints issued by Sayer or Boydell. In
response, many engravers would have nothing to do with the Academy, and
resented those who accepted the position of Associate Engraver, a position that the
Academy had later conceded. It was still possible, however, for engravers to use the
Academy to a limited extent to promote themselves, as Ryland did in 1772 when he
showed his two drawings.

In contrast with the attitude of Reynolds, her friend and supporter, Kauffman's
interest in prints was not restricted to their publicity value. She had been making
small etchings since 1762, and she took the plates to London where she made
more.[8] At first these seem to have been intended simply for private distribution:

122 *Ego flos Campi* . . . (The Holy Family with an Angel),
1780, engraving by Kauffman after her own painting.

Count Bernsdorff wrote that she had given him some of her etchings that could not be bought in any printshop.[9] However, in 1774 she advertised that 'Twenty Etchings, Designed and Engraved by Angelica Kauffman' could be bought for a guinea at her house in Golden Square or 'at the Printsellers'.[10] It would, of course, have been a servant who took the money, and a guinea would have confined purchases to the wealthy.

Although Kauffman's prints are not masterpieces, their sale must have been encouraging enough for her to have produced further ones, and two years later to have advertised two for the increased price of ten shillings:

> TWO Prints from Original Pictures by
> GUIDO and ANGELICA KAUFFMAN:
> The one representing St Peter and St Paul, from
> the Zampieri Collection at Bologna, the other the
> Holy Family in the Collection of the Earl of Warwick.
> To be had at Angelica Kauffman's House in Gol-
> den Square, and at the Print-Shops.[11]

These were larger, and more finished, productions than the earlier prints. The *Holy Family* is found in an etched state (illus. 122), and then was made stronger with further working and issued with engraved lettering.[12] During 1776 she also published further engravings, which she produced with the help of her compatriot Giuseppe Zucchi (1721–1805): *Astronomy, Simplicity* and *Calypso Calling Heaven and Earth*.

STIPPLE SUPPLANTS MEZZOTINT

By 1776 the status of prints after Kauffman was being transformed. Instead of being confined to a few mezzotints of her subject prints and portraits, her work became the major inspiration for a new kind of decorative print – the stipple engraving. This used etched or engraved dots to build up areas of tone, the technique developed out of the French 'crayon manner' used to reproduce chalk drawings. The crayon manner, for which roulettes were used, was already known in England, having been used to reproduce Old Master drawings in *A Collection of Prints in Imitation of Drawings* engraved 1762–78 and published by the collector Charles Rogers (1711–1784). The main engraver for this work had been none

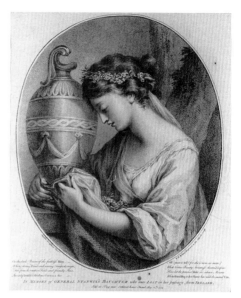

123 D. P. Pariset after Pierre Falconet,
W. W. Ryland, 1769,
crayon manner engraving.

124 W. W. Ryland, *In Memory of General
Stanwix's Daughter* (The Pensive Muse),
1774, stipple engraving.

other than Ryland, who, in 1768–9, had published a series of small crayon manner portraits by D. P. Pariset (1740–after 1780) after P. E. Falconet (1741–1791), which included one of himself (illus. 123). Both methods could translate the details of subject pictures more delicately and readably than mezzotint. Stipple plates could also print larger numbers than mezzotint plates, which was an advantage as the market increased.

In January 1774 Jonathan Spilsbury engraved and published a pair of stipples of *Phoenissa* and *Sophonisba*, which he advertised for eight shillings as 'in Imitation of Red Chalk Drawings . . . from original Paintings of Signora Angelica.'[13] These were the first prints after Kauffman in an oval form, indicating that they were aimed at those looking for prints to be framed in ovals for wall decoration. Given Kauffman's links with Spilsbury, it is possible that she may have been involved in this initiative; however, it was not Spilsbury who followed up the print with others, but Ryland. In May 1774 he engraved and published a large oval of a Pensive Muse, *In Memory of General Stanwix's Daughter, Who was Lost in her Passage from Ireland* (illus. 124). The publication line does not give Ryland as the publisher, but simply

as the seller, so it is not inconceivable that Kauffman had financed the plate. With its bold profile, oval format and the bright sanguine in which it was generally printed, this was a striking and novel object. Allied to such a tragic story it appealed in a way that many in the Age of Sensibility found irresistible. The print is unusual in using stipple in a bold way; henceforth, most stipples were smaller in scale.

Suddenly, mezzotint looked out of date, and after 1774 Ryland published no further mezzotints and only a handful – including James Watson's fine plate of the amateur artist Lady Bingham (illus. 125) – were brought out by others. Indeed, Chaloner Smith catalogues only seven mezzotint portrait plates after Kauffman. Stipple was obviously a technique that appealed both to those looking for furniture prints and to print collectors, many of whom – like Charles Rogers – treasured them as fine prints, and sought out proofs and fine impressions.[14] At the same time, there was a particularly feminine appeal about Kauffman's designs, and many of them were no doubt bought by fashionable women, who were then taking a more

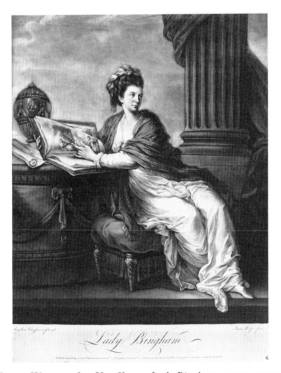

125 James Watson after Kauffman, *Lady Bingham*, 1775, mezzotint.

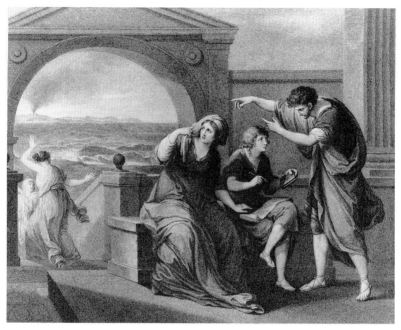

126 Thomas Burke after Kauffman, *The Younger Pliny Reproved*, 1794, stipple engraving.

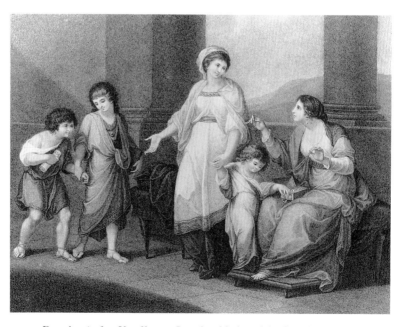

127 Francesco Bartolozzi after Kauffman, *Cornelia, Mother of the Gracchi*, 1788, stipple engraving.

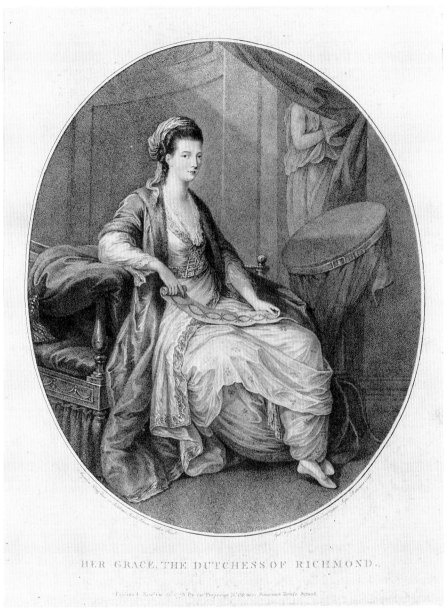

HER GRACE, THE DUTCHESS OF RICHMOND.

128. W. W. Ryland after Kauffman, *The Dutchess of Richmond*,
1775, stipple engraving.

active part in designing their own surroundings. Many of the designs were popular as motifs, for example in embroidery, and occasionally the prints were printed onto satin so that they could be directly used in needlework (illus. 100).

In February 1775 Ryland brought out a second stipple after Kauffman, a small circle entitled *Hope*. This print – related to a self-portrait in the Academy of St Luke – was based on a drawing, and could well have been a commission from Ryland; if so, it is the first of several drawings that she made specifically to be engraved. Prints could now be sold on Kauffman's name, without being based on actual pictures, let alone exhibited ones. As furniture prints sold better in pairs, because of their use in balanced wall arrangements of prints, Ryland engraved a pendant, *Faith*, dated April 1776. He brought out another pair: *A Lady in a Turkish Dress* was published in May 1775 after the picture then being exhibited at the Academy, and the *Dutchess of Richmond* (illus. 128) appeared the same December, showing how pictures painted as portraits could be turned into attractive furniture prints. In May 1776 he engraved a circular stipple of nymphs decorating a statue of Pan with a Latin title, *Olim truncus . . .* (illus. 129); this was the first print on which the owner of the picture, the Duke of Northumberland, is named; it is also the first of a series of circular prints of allegorical scenes of love that were all given Latin titles. Ryland no doubt thought that this was the right thing to do. Since they all had

129 W. W. Ryland after Kauffman,
Olim truncus eram ficulnus inutile lignum,
1776, stipple engraving.

130 Francis Eginton after Kauffman,
Olim truncus eram ficulnus inutile lignum,
c. 1778, mechanical painting.

131 Gabriel Scoromodoff after Kauffman, *Cupid's Revenge*,
1778, stipple engraving.

classical allusions, the Latin titles would somehow elevate the prints, but he had on one occasion at least to ask Charles Rogers for advice about the appropriate wording.[15] In all, ten out of the fourteen prints that he engraved between 1776 and 1779 had Latin titles; after that he reverted to English, or to English and French.

A RUSSIAN ENGRAVER, AND THOMAS BURKE

In July 1776 Sayer published four small ovals of female heads after Kauffman by a Russian, Gabriel Scorodomoff (1752–1792), who had come to London to improve his engraving. The following year Sayer published his Four Virtues after Kauffman, which the engraver dedicated as 'a most faithful subject' to Catherine II; in return he received a present of £200.[16] He also engraved three circles – *Cupid no More shall Hearts Betray*, *Cupid's Revenge* (illus. 131), and *The Triumph of Love* – with a dedication by Scorodomoff to the owner, the colourful Princess Dachkaw.

Ryland published these in 1777–8, the first stipples after Kauffman that he published signed by another hand.

Ryland undoubtedly needed engraving assistance. He was running a large and successful business; in 1775 he was one of the joint publishers of Woollett's plate after West of *The Death of General Wolfe*, which was to prove the most successful English line engraving of the century. His main source of help was doubtless Burke, who had ceased to engrave mezzotints in 1775; he must have been working on Ryland's stipple plates, unless he was working as a journeyman for another engraver, since he did not sign another print until 1779. As a leading mezzotint engraver, Burke had an independent reputation; Ryland was not known as a mezzotint engraver and it would have been foolish to have replaced Burke's well-known name by his own mezzotints, but, as a stipple engraver, who was presumably taught by Ryland, Burke's artistic identity could be suppressed by his employer.

COLOUR PRINTING

Ryland signed six plates after Kauffman in 1777, including a pendant to *Olim truncus* of Juno borrowing the Cestus, of which he had shown a drawing at the Academy in 1775, and one of Penelope at her loom, *Perseverance* (illus. 132).

He signed four in both 1778 and 1779, including Sterne's melancholy *Maria* (illus. 133). This print, which became one of Kauffman's best known images, was the first print of the few pictures she did of incidents in English literature. During 1779 Ryland also published *Conjugal Peace* (illus. 134), the first stipple plate Burke signed. As well as being published in black or sanguine, all these prints were printed in colours, such impressions usually being, like proofs, twice the price.

Colour printing was a relatively new art in England. In France it had been developed with great skill, often by using different plates for different colours, but this method was not often used in England, and only one such plate after Kauffman has been traced.[17] Instead, the colours were dabbed onto the plate *à la poupée*, prior to printing. This could produce extremely delicate effects, and soon became one of the main attractions of stipple. Ryland may not have been the first to publish such prints, but he was considered at the time 'the first artist who invented and brought to perfection the beautiful art of printing in colours'.[18] He is said to have brought a printer called Seigneur from Paris, but no confirmation of this has been found.[19]

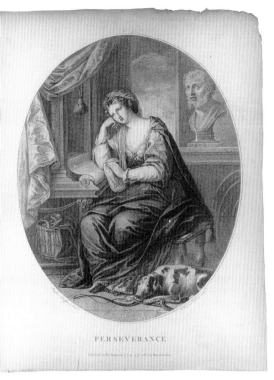

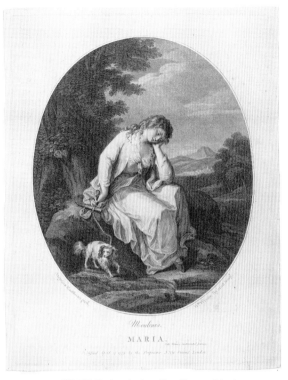

PERSEVERANCE

MARIA.

132 W. W. Ryland after Kauffman, *Perseverance*,
(Penelope at her Loom), 1777, stipple engraving.

133 W. W. Ryland after Kauffman, *Maria*,
1779, stipple engraving.

134 Thomas Burke after Kauffman, *Conjugal Peace*,
1779, stipple engraving.

135 *Cupid Bound by the Graces*, *c.* 1788, oil on paper/mechanical painting.

MECHANICAL PAINTINGS

One way, now little-known, in which many Kauffman paintings were reproduced in colour was as 'mechanical paintings'.[20] Aquatint plates were used to make transfers, being printed onto coated paper and then applied, as if printing a counterproof, onto canvas; vitreous colours were used and the prints were touched up by hand and varnished. The Birmingham inventor and manufacturer Matthew Boulton began to make these pictures between the mid 1770s and 1782. The idea was to produce batches of relatively inexpensive pictures that could pass as paintings; these were particularly suited for incorporation into decorative schemes, the best known being that of 22 Portman Square, the home of the noted literary and social figure Elizabeth Montagu, who was a cousin of Boulton. Boulton bought some pictures from Kauffman – a *Penelope with the Bow of Ulysses* at the end of 1776, and in 1778 a pendant *Calypso Mourning after the Departure of Ulysses*. How many pictures he bought is not clear, but it is a reflection of Kauffman's popularity and the suitability of her pictures for decorative schemes that a majority of the

mechanical paintings seems to have been her work. Fourteen reproductions of twelve subjects, out of 24 listed in his catalogue of 1780, were after Kauffman. These ranged in size and price from 10 × 8 inches at two guineas for the *Penelope* and *Calypso*, to 50 × 40 inches at twelve guineas for a version of *Rinaldo and Armida*; most cost between five and eight and a half guineas. The large mechanical paintings required several plates; the impressions printed onto several pieces of paper were then married together before transfer onto canvas. Boulton wrote to various owners of pictures, including Princess Dashkaw, who owned both *The Triumph of Love* and *Achilles Lamenting the Death of his Friend Patroclus* engraved by Ryland – which do not seem to have been reproduced, to ask permission to have their pictures copied for reproduction. In some cases the mechanical paintings were probably based on prints rather than paintings or copies. This is the case with the two small examples now in the Science Museum, London (illus. 120, 130), which probably are experimental transfers. These were after prints engraved in 1776 and 1777 by Ryland from pictures belonging to the Duke of Northumberland. Another of Ryland's circular prints, *Cupid Bound by the Graces*, also appears in Boulton's 1780 catalogue.

RIVAL PUBLISHERS

At the close of the 1770s Ryland was taking full advantage of the fashion for Kauffman's prints, but, inevitably, other publishers were trying to do the same. In 1777–8 Sayer published five stipples after Kauffman by Scorodomoff. Boydell had at first not taken much interest in prints after Kauffman: his main concern was to produce 'serious' line engravings, and he seems not to have considered her subject pictures to be of sufficient weight to be engraved in line for his ambitious series, *Prints of the Most Capital Paintings in England*, of which the first volume appeared in 1769. Although he published one early stipple in 1774 it was not until 1778–9, when he brought out three pairs by the German-born G. S. Facius and J. G. Facius, that he began to publish stipples after Kauffman in earnest. One of these pairs, published in November 1778, was of *Pheenisa* (sic) and *Sophonisba*. These are the same pictures as Spilsbury had engraved four years earlier, so Boydell must either have bought the pictures or have obtained permission from the owner of the earlier plates to copy them; otherwise he would have infringed copyright.

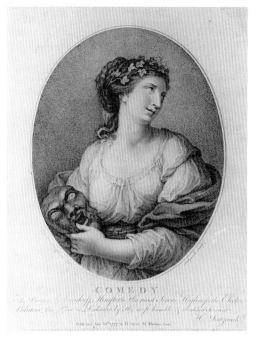

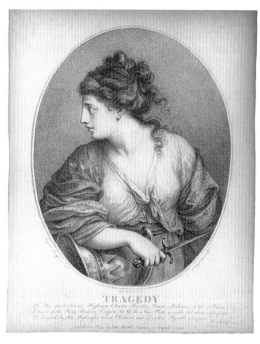

136 Heinrich Sintzenich after Kauffman, *Comedy*, 1777, stipple engraving.

137 Heinrich Sintzenich after Kauffman, *Tragedy*, 1777, stipple engraving.

In mid 1777 Henry Bryer issued a pair by the German engraver Heinrich Sintzenich (1752–1812): *Comedy* (illus. 136) and *Tragedy* (illus. 137). These plates, later acquired by Boydell, were based on drawings – a related drawing for the latter is in the Ashmolean Museum, Oxford – which may either have been commissioned or drawn by Kauffman on speculation to offer to a publisher looking for designs to have engraved.[21] One plate was dedicated by Sintzenich to the Count Palatine and the other to his Minister: Sintzenich, like Scorodomoff, planned to return home, and such gestures could do him no harm there. In 1778 Bryer published three more allegorical circles relating to love engraved by the Russian, of a size to be framed up as a set with the ones published by Ryland; two of these were from pictures belonging to Bryer, who died in 1778/9, upon which his business was taken over by his widow, Ann.

Other publishers issued isolated prints, but the only other important publisher was John Walker (*fl.* 1776–90). It was he who in 1778 published *Zoraida, the Beautiful Moor*, the first stipple after Kauffman engraved by Francesco Bartolozzi (1727–1815), the Italian who was a founder member of the Academy as a painter, but who worked almost entirely as an engraver (illus. 138). Significantly, Walker

was a carver and gilder, one of many to be drawn into printselling by the increased demand for framed prints. At his 'Sattin Print Manufactory' he sold 'sattin prints for muffs, screens, work-baskets and filigree work', and also prints for découpage.[22]

With all this interest, it is not surprising that nearly fifty stipples after Kauffman were published between 1774 and 1779. In November 1779 Kauffman herself published two more etchings, *La Penserosa* and *L'Allegra*, the latter related to a drawing in the Ashmolean that is incised for transfer.[23] She sold these through Anthony Torre, an Italian who ran the London branch of a Paris business and was a key figure in the Anglo-French print trade.

Given the great number of singly issued plates it is perhaps strange that Kauffman did not provide more drawings for book illustrations; this may partly be explained by the fact that she had left England by the time the demand for such drawings was really strong. She did, however, supply some for the elegant little volumes of *British Poets* launched by John Bell in 1778 (illus. 139); two of these, for James Hammond and for Charles Churchill, were engraved as a pair of singly issued circles in 1787.

138 Robert Marcuard after Joshua Reynolds, *F. Bartolozzi, R. A.*
& Engraver to his Britannic Majesty, 1784, stipple engraving.

139 Francesco Bartolozzi after Kauffman: scene from Mallet's
'Amyntor and Theodora', from *The Poets of Great Britain*, 1780.

RYLAND'S EXHIBITION

Perhaps in order to assert his leading position, in May 1780 Ryland mounted what
he called *Mr Ryland's exhibition consisting of original pictures, historical and emblemati-*
cal painted by Angelica Kauffman, on purpose for engravings in various manners exhibiting
with the above . . . [24] Of the 146 exhibits, eighteen were pictures by Kauffman;
prints had been published by Ryland of all these paintings, with the exception of

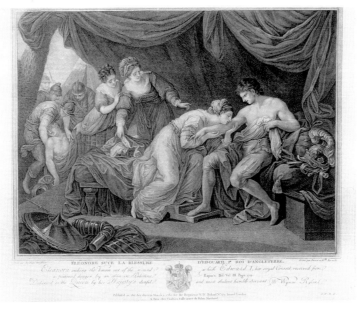

140 W. W. Ryland after Kauffman, *Eleanora Sucking the Venom from the Wound . . .*,
1780, stipple engraving.

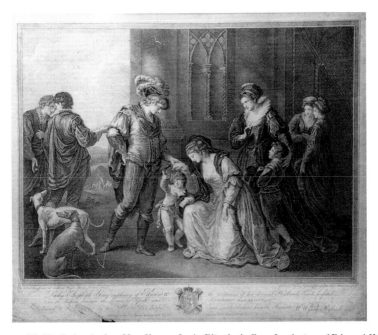

141 W. W. Ryland after Kauffman, *Lady Elizabeth Grey Imploring of Edward IV*
Resitution of her Deceased Husband's Lands . . .,
1780, stipple engraving.

four published by Bryer, including the two of pictures belonging to him. It is of course possible that many of the pictures were not the primary versions, and may be versions painted for the engraver to work from. It also helped for a publisher to show in his shop a painting that was being engraved. Even if this is so, it is still an impressive indication of the importance of the print market – and of Ryland in particular – to Kauffman. It is possible that the pictures may have belonged to Kauffman herself, and that they are either pictures painted on speculation that did not sell, or other versions. She obviously had a substantial number of pictures in her possession: in April 1779 she had for a time thought of returning to Italy and an auction sale was advertised by Christie, which, however, did not take place.[25]

There is no suggestion in the catalogue that the pictures, or indeed any of the prints, were for sale, and some of the items are described in terms that show that this was indeed an exhibition rather than a sale, though other impressions of the prints may of course have been available for purchase. The principal section was naturally the series of 23 stipples, predominantly of allegorical and classical subjects, which Ryland had himself signed. Most were shown printed in colours, with thirteen also in red. Interestingly, the catalogue gives the prints English titles rather than the Latin ones they bore. The stipples included two published in March 1780 of scenes from British history, the first to be produced: *Eleanora Sucking the Venom out of the Wound which Edward I Received . . .*, and *Lady Elizabeth Grey* (illus. 140, 141), after pictures shown at the Academy in 1776. These pictures, or versions, were shown in Ryland's exhibition. The print of *Lady Elizabeth* was dedicated by Ryland to the Queen, but no owner is given on the print or in the catalogue, which notes ownership of pictures in five cases where it had already been acknowledged on the prints. However, the most intriguing of the prints by Ryland in the exhibition is not a stipple but a line engraving: a proof of the plate of *Edgar and Elfrida*, of which Ryland had exhibited a drawing eight years previously. The great success of *The Death of General Wolfe* had no doubt stirred him into activity. Like many others he would have hoped to produce equally successful sequels, and he no doubt envisaged these as being sold as pendants. At that time West and Woollett were publishing further prints of British history to capitalize on their success. That he had Kauffman's support for the venture is shown by the existence of a proof of *Edgar and Elfrida* allegedly touched by her.[26]

142 Francesco Bartolozzi, *Adoration*, 1779,
stipple engraving.

PRINTS BY OTHERS

The exhibition also included some prints engraved by others, not all after Kauffman. As well as 33 of the pioneer aquatints made in the previous few years by Paul Sandby (1717–1809), there were also sixteen prints by Bartolozzi; these included five of only seven stipples he had at that time engraved after Kauffman, one of them being the finely modelled *Adoration*, which is shown here (illus. 142) framed with black and gold glass, or *verre églomisé*, which became a popular alternative to close framing; the black glass was like a mount, and enabled prints to be framed more impressively than their size might warrant. Although Bartolozzi

was to become the most famous of stipple engravers, he was in 1780 still primarily known as a line engraver. Ryland may not have seen him as a rival, indeed may have felt at an advantage in asking him to participate.

Ryland also showed stipples after Kauffman by other engravers, notably seven circular ones by Scorodomoff, published by Ryland or by Bryer; six of the pictures of Cupid's vicissitudes on which these were based were also included in the exhibition. These were, of course, popular subjects of which Kauffman probably painted several versions. At least one of the subjects, *Cupid's Struggle*, was made into a mechanical painting. Ryland also showed *Penelope* by J.-M. Delattre (1745–1840) – who was associated with Ann Bryer – and the Facius brothers; their prints were the only ones included that had been published by Boydell. One indication of the eclipse of mezzotint by stipple is that Ryland did not show any mezzotints, not even the nine he had published after Kauffman.

RYLAND'S RETIREMENT

Ryland's exhibition marked the height of his career. In January 1781 he published two of the plates exhibited as proofs, but by the October his shop was either taken over or shared by William Palmer. Kauffman left England after her marriage to Antonio Zucchi in July 1781. Ryland may have felt that he would no longer be able to rely on an automatic access given by Kauffman to the pictures most likely to sell as prints, and that his best hope of extricating himself from his long-standing debts was to concentrate once again on line engraving. As well as the two plates after Kauffman he also had a plate, which he never finished, of *King John Delivering Magna Carta* after J. H. Mortimer; these three plates presented an enormous amount of work. Ryland made a start on *Vortigern and Rowena*, which had not been shown in his exhibition, but he does not seem to have brought the pair on sufficiently to have launched a subscription, through which he might have sold such prints for a couple of guineas or more. In 1782 he published three more stipples of which he had exhibited proofs. On one, his circular *Cymon and Iphegenia*, published 15 January 1782, Ryland names himself for the first time as the owner of one of Kauffman's pictures; some copies of a pendant, Burke's *Death of Eloisa*, published on the same day, 'from an Original Painting in the Earl of Exeter's Collection at Burleigh', carried the imprint 'A Paris chez W. W. Ryland avec privilege du Roi'.[27]

THE CONTINENTAL MARKET

Although this is the only print of Ryland's that he published in Paris, his prints often had the address of the Torre's firm in Paris. Ryland's prints became very well known on the Continent, where the elegance and novelty of English stipples, particularly when printed in colours, were soon appreciated. Although English prints were known abroad it is clear that stipple transformed the attitude of overseas purchasers: suddenly there was a whole new genre of decorative print. These often received critiques in Continental periodicals of a kind totally absent in England.[28] Impressive collections of English prints were built up by collectors, both royal and private, for example the Leipzig banker Gottfried Winckler had some 85 English prints after Kauffman in his collection, sold in 1802.[29]

The copies of stipples that soon appeared, many done in Paris, is an indication of demand; some of these are by women, including Rose Le Noir, who signed herself 'aged 14 years 1782' on a copy of Ryland's *O Venus Regina*. Others distributed at a low price throughout Europe were the piracies produced by the Bassano firm of Remondini.[30] Stipples of a higher quality were made of Kauffman's later Continental pictures; their success both reflected and encouraged interest in similar English prints.[31]

THE EARLY 1780S

Despite Ryland's virtual retirement, other publishers were now so active that there were no fewer stipples after Kauffman: some eighteen in 1780, twenty-one in 1781 and twenty-two in 1782. The most prominent publishers were Boydell, and Ann Bryer, who brought out several prints by Delattre, including incidents from Sterne's *A Sentimental Journey*: *The Snuffbox* in 1781 and its pendant, *The Handkerchief*, in 1782. Torre began to publish prints after Kauffman, such as a set by Bartolozzi of the Seasons, for centuries a staple topic for decorative prints (illus. 143).

One new publisher was the Italian painter Anthony Poggi (*fl. c.* 1769–after 1803), who owned and probably commissioned drawings from Kauffman for engraved fans as well as singly issued prints. There were three drawings in his sale

in 1782: *The Three Fine Arts* (illus. 144), *The Bust of Pope Crowned by the Graces*, and
Venus Lending the Cestus to Juno.[32] He later published other prints after Kauffman,
including Bartolozzi's *Veillez amans si l'amour dort*. Another new publisher was the
carver and gilder James Birchall (*fl.* 1778–1794) of the Strand. His first stipples
after Kauffman were a pair of ovals, published in September 1781: *Harmony*, based

143 Francesco Bartolozzi after Kauffman, *Winter*, 1782, stipple engraving.

144 *The Three Fine Arts*
(drawing for a fan), *c.* 1780,
from a scrapbook.

on a drawing that Birchall owned, and *Painting*, a self-portrait of Kauffman; this first appeared without an engraver's name (illus. 145). 'T. B. sculpt' was later added, indicating that it was by Thomas Burke. The initial absence of his name may mean that his agreement with Ryland prohibited him from working for other publishers, though he must have been released by Ryland soon afterwards. The print was presumably after the Kauffman self-portrait that was in Birchall's posthumous sale.[33] When Sintzenich returned to Mannheim he engraved a copy of this print, which no doubt further spread awareness of Kauffman in Germany.

There was no lack of Kauffman designs to be engraved. She must have sold many paintings and drawings before she left England, some of which were bought by publishers such as Birchall. After her stay of fifteen years in London there was in any case a stock of unengraved pictures in private hands. She also sold the copper plates of her etchings, most of which were bought by Boydell, who reissued them, some with added aquatint, in 1780–1.

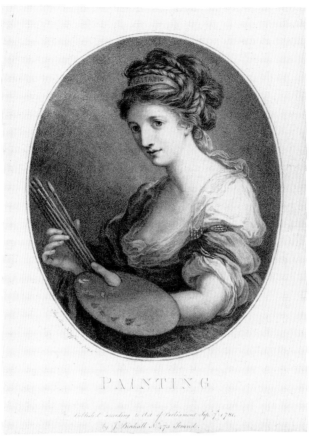

145 Thomas Burke after Kauffman, *Painting* (self-portrait),
1781, stipple engraving.

RYLAND'S DOWNFALL; BARTOLOZZI THE LEADING ENGRAVER

After Ryland's return from France in 1782 his financial troubles became too much for him and he forged two India bills. In his trial in July 1783 he argued that he had no need to do such a thing, having shares worth £7,000, a royal pension of £200 annually, and that 'My stock in trade is worth £10,000 and the net produce of my business falls little short of £2,000 a year'.[34] This implies that his withdrawal from publishing had been temporary.

Ryland was declared bankrupt before his execution in August 1783. In April 1784 there was a small auction of part of his stock, consisting of 82 lots of prints and

146 Thomas Burke after Kauffman, *Andromache Weeping over the Ashes of Hector*, 1772, mezzotint.

eighteen lots of 37 copper plates, thirteen of which were unfinished. Among the latter was the plate of *Vortigern*; this is the first mention of this plate, which does not appear to have been finished, though a line engraving (illus. 149) by Thomas Ryder was published in 1802 that is the same size as the *Wolfe*. There were no pictures in the sale: as Ryland seems to have disposed of most of his plates before his bankruptcy, he probably sold these as well. There were fourteen lots of prints, not named, unfortunately, which were sold as being 'touched and finished by A. Kauffman'.[35] *Edgar and Elfrida* was bought by a group of well-wishers and finished by William Sharp (1749–1824) for Ryland's widow, who set up as a printseller and reprinted at least eight of her husband's plates.[36]

Ryland's place as the leading engraver of Kauffman's pictures was taken by Bartolozzi. It was he who engraved the stipple of Reynolds's portrait of Kauffman (illus. 22) published in September 1780, which he sold to Boydell for 90 guineas.[37] Between 1778 and 1780 he engraved an average of only three stipples a year after Kauffman; between 1781 and 1784 he averaged ten a year. For Bartolozzi, unlike Ryland, these prints were only a small part of his production, since he had a very large studio of apprentices and assistants. Such was Bartolozzi's standing that his former pupils, such as Delattre, continued to sign many of their prints 'Late Pupil to F. Bartolozzi, R.A.'.[38]

MORE PICTURES FROM KAUFFMAN

Despite moving to Italy Kauffman did not give up her links with the London print publishers. In the ten years that followed her departure she sent at least 22 pictures back to printsellers, as is revealed by a list her husband drew up.[39] Five went to Ann Bryer – most of which were engraved by Delattre – between 1782 and 1789, six to Birchall between 1782 and 1788, three to Thomas Macklin between 1784 and 1790, six to John Matthews between 1789 and 1790, and two to Boydell in 1792. Most were small oils, in many cases little bigger than the prints made after them, costing between eight and thirty guineas. Presumably, the publishers preferred to be sent paintings rather than drawings because they could be shown in their shops, and then more easily re-sold.

Four of these pictures were more substantial commissions. Matthews, a printseller in the Strand, paid 100 guineas each for *The Death of Alcestis* and *Vergil*

Reading his Aeneid. He had these engraved by Bartolozzi but then died; his widow had some proofs printed in 1796 but did not formally publish the plates. When her husband's stock was auctioned in 1800 the pictures sold for 100 and 95 guineas, but the two plates and the proofs achieved 595 guineas.[40] Although this sum may be only slightly more than Bartolozzi charged, it is impressive that they sold as well as this at auction, and indicates that even in the depressed market conditions of wartime Britain, the combination of Kauffman and Bartolozzi could still make for a successful print. The two pictures painted for Boydell, scenes from Shakespeare's *Two Gentlemen of Verona* (illus. 29) and *Troilus and Cressida*, cost him 200 guineas each; they were displayed in his Shakespeare Gallery in Pall Mall, and engraved for his ambitious edition of the plays.[41]

Kauffman also sent back at least eighteen pictures to the collector George Bowles, who was a real enthusiast for her work. Most of these were engraved, several by Burke, who must have been on good terms with Bowles; some, for example, *Kauffman as Design* (illus. 147) – a gift to Bowles from the appreciative

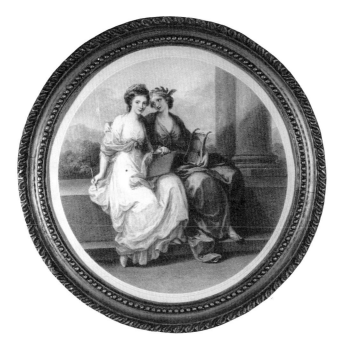

147 Thomas Burke after Kauffman, *The Portrait of Angelica Kauffman in the Character of Design, Listening to the Inspiration of Poetry*, 1787, stipple engraving.

artist – Burke published on his own account. Burke's name became so linked with that of Kauffman that he was obviously the preferred engraver for several publishers, and between 1781 and 1795 he engraved some 26 stipples after her work, an output second only to Bartolozzi. His later prints after Bowles's pictures were published by Thomas Macklin (1760–1800), the printseller who became known for the stipples of English literature issued from his Poets Gallery in Fleet Street. Macklin may have come to some arrangement with Bowles; it may not be coincidence that Bowles bought four small religious paintings that were engraved for Macklin's illustrated Bible.[42]

INTEREST DECLINES IN THE 1790S

Thus, even after she left England, Kauffman continued to be known to the British public through a steady flow of prints of her pictures. Other pictures already in England were also engraved. From 1784 a few of her paintings were turned into facsimiles of oil paintings by the Polygraphic Society, which used 'a chymical and mechanical process' that was probably the same as Boulton's. The Society held annual exhibitions in London at which the originals – either bought or borrowed – were shown with the facsimiles.[43] In contrast to Boulton's enterprise only a few of Kauffman's pictures were used. The catalogue of the 1790 exhibition lists three Kauffmans out of a total of 35 pictures: *Beauty Protected* and *Beauty Crowned*, a pair 30 × 30 inches at four guineas each which were borrowed from the French ambassador, Count d'Adhemar, who left England in 1788, and *Cupid Bound by the Graces* at eight guineas (illus. 135).[44] Polygraphs were cheaper than mechanical paintings, but the venture did not survive beyond the mid 1790s, despite extensive publicity and provincial agents who displayed examples.

Kauffman also remained to an extent in the public eye through the Royal Academy, which showed eight pictures sent from Italy. Further pictures were apparently rejected by the Academy; significantly, this was justified on the grounds that they were submitted not by her but by others: for example, two were sent in by a printseller in 1785.[45]

Nevertheless, given Kauffman's absence from England, it was inevitable that she should yield her place as the leading provider of images for stipples. The taste of the 1770s for allegorical and mythological scenes gave way to other subjects, for

example scenes from contemporary literature.[46] Painters based in England, such as Francis Wheatley (1747–1801), William Hamilton (1751–1801) and Thomas Stothard (1755–1834), were more readily able to respond to changes in the market.[47] Thus Birchall began to publish more stipples after Hamilton, both the increasingly popular small prints of playing children and larger plates for a series of *English History*. In the sale of Birchall's stock there were 35 copper plates after Hamilton, together with thirteen drawings and seventeen of his pictures, as opposed to 25 plates after Kauffman, with one drawing and four paintings.[48]

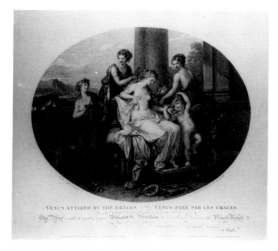

148 Francesco Bartolozzi after Kauffman, *Venus Attired by the Graces*, 1784, stipple engraving.

BARTOLOZZI'S POPULARITY

It is also worth emphasizing that many of the later prints after Kauffman would have sold regardless of the designer because they were engraved by Bartolozzi, whose prints were often bought on the strength of his name. Of the 150 or so plates after Kauffman engraved in the two decades after she left England, some 65 were signed by him. However, after 1784, the year which saw large plates such as *Venus Attired by the Graces* (illus. 148) – one of the few plates to carry the name of a copper-plate printer, J. Acoulon – Kauffman's pictures became less important in his *oeuvre*. Some widely known plates remained in the future, such as *Selim, or the Shepherd's*

149　Thomas Ryder after Kauffman, *Vortigern & Rowena*, 1803, line engraving.

Moral, engraved for the first number of Macklin's *British Poets*, but between 1785 and 1798, the year of his last plate after Kauffman, Bartolozzi produced an average of only two plates a year after her pictures. The last Kauffman prints he engraved for Boydell was a set published in 1787 of the four pictures, including *Design*, that she painted for the Academy, and which are now at Burlington House in Piccadilly.

CONCLUSION

In summing up the evidence, it is clear that Kauffman was more important than any other artist in providing designs for the initial period of stipple's popularity. It is also the case that for few artistic careers was the print market more important: it is likely that a higher proportion of her pictures were not only painted to be engraved but were also bought by printsellers than any other painter of standing in eighteenth-century England.

Chronological Checklist of Singly Issued English Prints after Angelica Kauffman

DAVID ALEXANDER

The prints are stipple engravings unless indicated; cited literary sources are given after the title, followed by the engraver's name. Owners of pictures, when named on the prints, are given in square brackets. Descriptions of untitled prints are given in round brackets; in the case of prints by Ryland with Latin titles, the English titles in the catalogue of his 1780 exhibition are given. The main date of publication is given; proofs often bear earlier dates. It should be emphasised that these are English singly issued prints, therefore book illustrations and French, Italian and Irish copies are excluded. Lack of space precludes fuller details or the inclusion of locations of impressions seen, but an expanded and indexed copy of this list has been deposited in the British Museum Print Room. The following abbreviations have been used:

B	*Angelika Kauffmann und ihre Zeit*, Neue Lagerliste 70, C. G. Boerner, Dusseldorf, 1979
BN	*Bibliothèque Nationale: Inventaire du fonds français, dix-huitieme siècle*, VI, 1949, pp. 219–32, catalogue of prints of J-M. Delattre
CS	J. Chaloner Smith, *British Mezzotinto Portraits*, 4 vols, London, 1878–83
G	G. Goodwin, *Thomas Watson, James Watson. . .* , London, 1904
O'D	F. O'Donoghue and H. M. Hake, *Catalogue of Engraved British Portraits . . . in the British Museum*, 6 vols, London, 1908–25
V&C	A. de. Vesme and A. Calabi, *Francesco Bartolozzi*, Milan, 1928
W	A. Whitman, *Valentine Green*, London, 1902

*c.*1767–8	[1]	*Princess Augusta*; mezzotint by Jonathan Spilsbury; no pub. line (CS.1).
Oct. 1768	[2]	*Christian VII of Denmark*; R. Houston; pub. Sayer (CS.33).

1770		
1 Oct	[3]	*Thalia*; mezzotint; Spilsbury; pub. Spilsbury (CS.39).

1772		
1 Jan	[4]	*The Parting of Hector and Andromache*; Homer; mezzotint; James Watson; pub. Sayer (G.177; B.101).
2 Jan	[5]	*Woman and Child*; R. Laurie; pub. Sayer, proof before title with this date; the title has been taken from Sayer & Bennett's catalogue for 1775, p.9.

19 May	[6]	*Queen Charlotte raising the Genius of the Fine Arts;* mezzotint; Thomas Burke; pub. Ryland (CS.1; B.78).
22 April	[7]	*Samma the Demoniac;* Klopstock's *Messias;* mezzotint; Burke; pub. Ryland (reissued 1786, B.159).
23 Sept	[8]	*Cleopatra, adorning the Tomb of Mark Anthony;* do (B.69).

1773
15 Feb	[9]	*Penelope awakened by Euryclea;* Homer; do (B.99).
15 Sept	[10]	*Telemachus at the Court of Sparta . . .;* Homer; do (B.110).
	[11]	*Inibaca discovering herself to Trenmor;* Ossian; do (B.147).

1774
1 Jan	[12]	*Phoenissa;* [13] *Sophinisba;* pair; Spilsbury; pub. Spilsbury and others.
10 May	[14]	*In Memory of General Stanwix's daughter . . .* (The Pensive Muse); Ryland; sold Ryland (B.88).
24 May	[15]	*Aristides requested by an illiterate Citizen of Athens . . . to sign the Ostracism for his Banishment;* Plutarch; mezzotint; William Dickinson; pub. Ryland (reissued 1786, B.66).
1 July	[16]	*Sappho;* John Pye; pub. Boydell (B.162).
15 Sept	[17]	*Cupid finding Aglaia asleep;* mezzotint; Burke; pub. Ryland; pendant to [9] *Penelope,* pub. 15 Feb 1773; reissued B. B. Evans 1786.
3 Dec	[18]	*Madona and Child;* mezzotint; Valentine Green; pub. Sayer & Bennett (W.84).
	[19]	*Paris and Helen directing Cupid to inflame each others Heart with Love . . . ;* mezzotint; Green; pub. Sayer (B.106); pendant to [23] *Renaldo,* 20 April 1775.
by 1775	[20]	(J. H. Hampe, M.D.); mezzotint; Burke; undated (CS.4).

1775
7 Feb	[21]	*Hope,* a self-portrait; Ryland; pub. Ryland (B.186); proof entitled *Spes* dated 12 Jan 1775, pendant to [26] *Faith,* 2 April 1776.
15 March	[22]	*Lady Bingham;* mezzotint; J. Watson; pub. Watson and B. Clowes; reissued 1 April 1776 by J. Bretherton (CS.10).
20 April	[23]	*Renaldo arresting the arm of Almida;* Tasso's *Gerusalemme;* mezzotint; Green; pub. Sayer & Bennett (W.186; B.115); pendant to [19] *Paris,* 1774.
10 May	[24]	*A Lady in a Turkish Dress,* Ryland; pub. Ryland.
21 Nov	[25]	*The Dutchess of Richmond;* do; pendant to above (O'D.2).

1776
2 April	[26]	*Faith,* engr. & pub. Ryland (B.186); pendant to following.
	[27]	*Hope;* said to be a portrait of Kauffman's ward, Rosa Bonomi (M-W, p.224).
1 May	[28]	*Olim Truncus . . .* (Bacchanalians adorning the statue of Pan); [Duke of Northumberland]; do (B.52); pendant to [38] *Juno cestum,* 1 Jan 1777.
16 May	[29]	*The Oath of Calypso,* Homer; mezzotint; Laurie, pub. Sayer & Bennett (B.96–7), pendant to following.
16 May	[30]	*Ulysses Conducted by Calypso . . . ;* mezzotint; P. Dawe (B.105).
21 May	[31]	*Dormio innocuus* (Nymphs awaking Love); engr. & pub. Ryland.
21 May	[32]	*Cleopatra;* G. Scorodomoff; pub. Sayer & Bennett (B.51); reissued Laurie & Whittle, 12 May 1794; pendant to 3 following.
2 July	[33]	*Lady Augusta Campbell;* do.

24 July	[34]	*Helen*; do (B.51). [35] *Artemisia*; do. [36] *Simplicity*; etching; Kauffman & Joseph Zucchi; pub. Kauffman; reissued Boydell 1 Jan 1781. [37] *Calypso calling Heaven and Earth . . .* ; do (B.98).
1777		
1 Jan	[38]	*Juno cestum a Venere postulat* (Juno borrowing the Cestus from Venus); [Duke of Northumberland]; engr. & pub. Ryland (B.52); pendant to [28] *Olim Truncus*, 1 May 1776.
10 Jan & 5 Feb	[39–42]	*Temperance; Justice; Fortitude; Prudence*; Scorodomoff; pub. Sayer & Bennett (set of 4, B.189).
12 March	[43]	(John Baker Holroyd); mezzotint; J. R. Smith; pub. Smith (CS.85); reissued with title *Lord Sheffield* by H. Humphrey 12 March 1779 (B.82).
18 March	[44]	*Etiam Amor . . .* (Cupid Punished); engr. & pub. Ryland (B.42).
31 March	[45]	'*Cupid no more . . .* ' (Nymphs Stealing the Arrows of Cupid); Scorodomoff; pub. Ryland (B.41); this is uniform with 4 other circular prints of Cupid published by Ryland and by Bryer, described below.
27 May	[46]	*Patience . . .* ; Mason's *Caractacus*; Ryland; 'Published for the Author . . . at No 159 Strand', Ryland's address (B.185).
30 May	[47]	*Comedy*; H. Sintzenich; pub. H. Bryer; pendant to [49] *Tragedy*, 14 July, both reissued by Boydell 1 Oct 1782.
9 July	[48]	*Perseverance*; (Penelope at her Loom); Homer; Ryland; pub. Ryland (proof 24 June 1777).
14 July	[49]	*Tragedy*; pendant to [47] *Comedy*, 30 May 1777.
20 Aug	[50]	*Cupid's struggle with the Graces*; Scorodomoff; pub. Bryer (B.41).
4 Sept	[51]	*Berenice*; J. K. Sherwin; pub. V-M. Picot (B.45).
8 Oct	[52]	*A Lady, Contemplating on her Lover's Picture*; Scorodomoff; pub. Sayer & Bennett as a pendant to *A Sultana* after de Loutherbourg.
4 Dec	[53]	*Achilles sese . . .* (Achilles Lamenting the Death of his Friend Patroclus), [Princess Daschkaw]; [54] *Telemachus redux . . .* ('Telemachus's Return to Penelope); [F. Barroneau]; pair engr. & pub. Ryland (B.94), pendants to [71] *Telemachus*, 7 Dec 1778.
1778		
13 Jan	[55]	*The Triumph of Love*; Scorodomoff; proof before the title with Bryer's name as publisher; published state has Ryland's address with a dedication by Scorodomoff to Princess Dashkaw (B.41).
10 March	[56]	*An Offering to Love*; [Bryer]; Scorodomoff; pub. Bryer (B.41).
25 March	[57]	*Cleopatra Marci Antonii . . .* (Cleopatra Adorning the Tomb of Mark Anthony); Ryland; pub. Ryland
2 March	[58]	*Cupid's Revenge*; Scorodomoff; pub. Ryland (B.41).
1 May	[59]	*Aglaia bound by Cupid*; [Bryer]; Scorodomoff; pub. Bryer (B.127), reissued Boydell, 1 Aug 1796.
	[60]	*Ariadne awakened from Sleep . . .* ; [61] *Sappho inspired by Love . . .* ; pair; G. S. & J. G. Facius; pub Boydell (B.44, 161).
17 June	[62]	*Porrigit hic veneri . . .* (The Judgment of Paris); Ryland; pub. Ryland (B.58).
10 Aug	[63]	*A Circassian Lady*; Scorodomoff; pub. Picot (B.210); this image is not positively identified on prints as being after Kauffman.
7 Sept	[64]	*O Venus Regina . . .* (Venus Triumphant); Ryland; pub. Ryland (B.172).
10 Oct	[65]	*The Graces Dancing*; [66] *Sacrifice to Ceres*; paired circles; Scorodomoff; pub. Sayer & Bennett (B.46, 49).

1 Nov	[67]	*Abelard and Eloisa, surprised by Falbert*; Scorodomoff; pub. Bryer; pendant to [97] *The Parting . . .*, 10 Aug 1780.
	[68]	*Zoraida*; Jarvis's *Don Quixote*; Bartolozzi; pub. J. Walker (V&C.1302; B.174–5); pendant to [81] *Fatima*, 14 Dec 1779.
2 Nov	[69]	*Pheenisa* (sic); [70] *Sophonisba*; pair; Facius; pub Boydell (B.75), related to [13, 14] Spilsbury's pair, 1 Jan 1774.
7 Dec	[71]	*Telemachus in aula . . .* (Telemachus, at the Court of Sparta, Discovered by his Grief on the Mention of his Father's Sufferings); engr. & pub. Ryland; pendant to pair pub. 4 Dec 1777.

1779
12 March	[72]	*Ludit Amabiliter* (A lady playing to her singing bird); [John Nightingale]; engr. & pub. Ryland.
25 March	[73]	*Industry, attended by Patience and assisted by Perseverance, is crowned by Honour and rewarded with Plenty*; Facius; pub. Boydell; used as the frontispiece of vol. IV of his *receuil*, the *Sculptura Britannica*; proofs have the title *Honour and Riches* (B.183).
12 April	[74]	*Maria*; Sterne; engr. & pub. Ryland (B.149); pendant to [80] *Eloisa*, 28 Nov.
April	[75]	*The Fair Alsacien*; Bartolozzi; pub. Bartolozzi (V&C.1278; B.205).
3 May	[76]	*Conjugal Peace*; Burke; pub. Ryland (B.182).
29 Sept	[77]	*Penelope weeping over the bow of Ulysses*; Delattre, 'F. Bartolozzi dirext'; pub. Ann Bryer (V&C.476), pendant to [95] *Dido*, 10 June 1780.
7 Oct	[78]	*Adoration*; [79] *Humility*; pair Bartolozzi; pub. F. Vivares (V&C.570, 634; B.199).
28 Nov	[80]	*Eloisa*; Pope; Ryland; pub. Ryland (B.143); pendant to [74] *Maria*, 12 April 1779.
14 Dec	[81]	*Fatima*; Bartolozzi; pub. Walker (V&C.1282); pendant to [68] *Zoraida*, 1 Nov 1778.

1780
3 Jan	[82]	*The Muse Erato*; etching; J. Zucchi; pub. Boydell (B.48).
1 Feb	[83–8]	*Moral Emblems*; set of 6: 1. *Instruction*; 2. *Prudence*; 3. *Wisdom*; 4. *Mercy and Truth*; 5. *Life*; 6. *Hope*; engr. & pub. C. Taylor (B.191).
	[89]	*Papirius Praetextatus entreated by his Mother . . .*; Burke; pub. Ryland; (B.71).
1 March	[90]	*Lady Elizabeth Grey imploring of Edward IV, the restitution of her deceased Husband's Lands . . .*; [91] *Eleanora sucking the Venom out of the wound which Edward I received . . . in Palestine*; Rapin; pair; engr. & pub. Ryland (B.67).
27 March	[92]	*Diana preparing for Hunting*; [Rev. Henry Bate]; Bartolozzi; pub. Walker (V&C.403).
1 May	[93]	(Jupiter's Throne); Delattre; pub. Diemar.
4 May	[94]	*Paris & Oenone*; Ovid; engr. & pub. Bartolozzi (V&C.472; B.154).
10 June	[95]	*Dido invoking the Gods . . .*; Delattre; pub. 'for the Proprietor' by A. Bryer (V&C.407); pendant to [77] *Penelope*, 29 Sept 1779.
10 July	[96]	*Madonna and child*; Ch. W. White; pub. Sayer & Bennett (B.36).
10 Aug	[97]	*The Parting of Abelard and Eloisa*; Scorodomoff; pub. 'for the Proprietor [Mrs Bryer] at No 7 Johnsons Court Fleet Street' (B.142); pendant to [67] *Abelard . . .*, 1 Nov 1778. Another version by Pariset has a French privilege; ?an authorised version for the French market.

10 Oct	[98]	*Damon and Delia*; Dodsley; Bartolozzi; pub. F. Vivares (v&c.1375; B.136).
	[99]	*Science resting in the Arms of Peace*; do; (v&c.702; B.201).

1781
1 Jan	[100]	*Venus presenting Helen to Paris*; [101] *The Flight of Paris & Helen*; pair; engr. & pub. Ryland (B.112, 153).
25 March	[102]	*Calais: The Snuff Box*, Sterne; Delattre; pub. A. Bryer, pendant to [125] *Moulines*, 1 March 1782.
20 Aug	[103]	*Erminia*; Tasso [Charles Boddam]; Sherwin; pendant to following.
27 Aug	[104]	*Paris and Helen*; C. White; pub. Sayer & Bennett (B.107); stipple version of [20].
1 Sept	[105]	'*Sacred to Fame immortal . . .*'; Ariosto (Nymph with swans); D. Jenkins (B.150); pair pub. T. Macklin.
7 Sept	[106]	*Hermione*, Shakespeare's *The Winter's Tale*; T. B. (?Burke); pub. J. Birchall (B.123), reissued Boydell, n.d., post.
	[107]	*Harmony;* [108] *Painting*, self-portrait; T. B. (?Burke); pair pub. Birchall (B.188, 83).
8 Sept	[109]	*Antiope*; Bartolozzi; pub. Walker (v&c.355; B.43).
15 Sept	[110]	*Louisa Hammond*, Pratt's *Emma Corbett*; do; pub. Vivares (v&c.1400).
1 Oct	[111]	*Sincerity*; [112] *Felicity*; pair; do; pub. W. Palmer (v&c.729, 615; B.178); pendants to 2 other pairs, 14 Feb 1782, 17 May 1782, after Cipriani.
1 Nov	[113]	*Leonora*; do; pub. Walker (v&c.1237).
30 Nov	[114]	*Rosalind*; [115] *Caelia*; do; pub. T. Watson (v&c.1857, 1858; B.125).
20 Dec	[116]	'*She found the body yet warm . . . Vide Emma Corbett*'; Pratt; P. W. Tomkins; pub. Palmer.
1781	[117]	*Harmony*; Bartolozzi; pub. Thane (B.187).
	[118]	*Palemon and Lavinia*; engr. & pub. C. Taylor; pendant to [130].

1782
15 Jan	[119]	*The Death of Eloisa*; Pope; Burke; [Earl of Exeter]; (B.144); [120] *Cymon and Iphegenia*, Boccaccio [Ryland], engr. Ryland (B.135); pair pub, Ryland.
1 Feb	[121]	*Innocence*; Marcuard; pub. Walker (B.197).
2 Feb	[122]	*The Birth of Shakespeare*; Wharton [Lady Rushout]; Bartolozzi; pub. A. Poggi (v&c.1819; B.163); pendant to [136] *Shakespeare's Tomb*, 1 Aug 1782.
	[123]	*Damon & Musidora*; [124] *Celadon & Amelia*; Bartolozzi; pair [Snelling]; pub. Birchall & by Durand (v&c.1376–7); *Damon* (B.138).
1 March	[125]	*Moulines: the Handkerchief*, Sterne; Delattre; pub. Bryer (v&c.1423); pendant to [102] *Calais*, 25 March 1781.
2 April	[126]	*Conjugal Peace*; engr. & pub. Ryland, small version of Burke's, pub. 3 May 1779.
	[127]	*Jupiter & Calista*; Burke; pub. Birchall (B.53) pendant to [131] *Orpheus*, 30 June 1782.
1 May	[128]	*Ulysses having by craft discover'd Achilles . . . among the Daughters of King Lycomedes . . .*; Homer; [Count de Panin]; Scorodomoff; pub. Boydell (B.104).
	[129]	*Mrs Fordyce, at the grave of Fingal*; mezzotint; Green; pub. (cs.44; w.112).
27 June	[130]	*Celadon and Amelia*; engr. & pub. C. Taylor; pendant to [118] *Palemon*.
30 June	[131]	*Orpheus and Eurydice*; Burke; pub. Birchall and by Durand (B.56); pendant to [127] *Jupiter . . .* ; 2 April 1782.

1 July	[132–5]	*Flora; Ceres; Pomona; Winter*; Bartolozzi; set pub. A. Torre (V&C.713–6); *Ceres* (B.132).
1 Aug	[136]	*Shakespeare's Tomb*; [Lady Rushout]; do; pub. Poggi (V&C.1820); first issued by Bartolozzi, 1781; pendant to [122] *The Birth . . .* , 2 Feb 1782.
11 Nov	[137–40]	*Mars Making Peace . . .* ; *Apollo Crowning Virtue; Tranquillity Restored by Love; The Dancing Nymphs*; Delattre; set pub. E. Hedges (BN.48–51; B.55).
20 Nov	[141]	*The Dutchess of Devonshire and Viscountess Duncannon*; engr. & pub. W. Dickinson.
1782	[142]	*Lyric Poetry*; Ryland (B.190).

1783

1 Jan	[143]	*Messalina's Sacrifice* [an alternative title appears on some impressions intended for the French market: *Desir Ardent pour la Pluralite des Maris*, but with the English subtitle: *The Empress Messalina, Sacrificing to Venus and Cupid before she obtained the Liberty for the Roman Ladies to have several Husbands*]; Burke; pub. A. Torre & J. Thane; this plate was cut down by 1½ inches in width and ¾ of an inch in height and the title and subtitle replaced by *A Cyprian Sacrifice*, with the address of Thane only and the same date.
	[144]	*The King Psammaticus of Egypt in Love with Rhodope*; [145] *The Beautiful Rhodope in love with Aesop* [pair: Charles Boddam Jnr]; pub. Diemar (V&C.1354–3; B.158); V&C give another state with the title *Psammeticus King of Egypt in love with Rhodope*.
28 Jan	[146]	*Beauty directed by Prudence . . .* ; Delattre; pub. Bryer (BN.53; B.194); pendant to [147] *Beauty governed by Reason*, 1784.
2 Feb	[148]	*Una*; Spenser; Burke; pub. Birchall (B.169); pendant to [160] *Abra*, 25 July 1783.
23 Feb	[149]	*The Liberal Fair*; Bartolozzi; pub. Palmer, (V&C.1320); reissued by R. Pollard, undated.
1 March	[150]	*The Muses crowning the Bust of Pope*; P. W. Tomkins; pub. S. Watts (B.155), proof entitled *The Muses crowning Pope*.
	[151]	*Friendship*; Marcuard; pub. Walker (B.184).
1 April	[152]	*Cleopatra and Meleager*; Plutarch; [153] *Paulus Aemelius*; pair pub. Torre (V&C.509, 507; B.72), reissued Molteno 1793.
20 May	[154]	*Cossuccia*; Winckelmann; Bartolozzi; pub. Dickinson (V&C.1280; B.204).
May	[155]	*Pomona*; P. W. Tomkins; pub. Walker (B.60).
1 July	[156]	*La Penserosa*; [157] *L'Allegra*; B. Pastorini, Bartolozzi dirext; pub. Torre (V&C.1289).
	[158]	*Music*; T. Ryder; pub. Watts (B.92); pendant to [193] *Poetry*, Oct 1784.
9 July	[159]	*Blind Mans Buff*; P. W. Tomkins; pub. Birchall (B.203).
15 July	[160]	*Abra*; Collins; Burke; pub. Birchall (B.126); pendant to [148] *Una*, 2 Feb 1783.
1 Oct	[161]	*Religion*; Bartolozzi; pub. Torre (V&C.701; B.193); reissued Molteno, 2 April 1793.
1 Nov	[162]	*Hebe* [Sir John Dick]; do; pub. Walker (V&C.423; B.50).
Nov	[163]	*Veillez amans si l'amour dort*; do; pub. Poggi (B.37); this plate was among several commissioned by Poggi as fan sheets; it was cut down and issued first as *Love Sleeps* and then as *Veillez . . .* (V&C.390).
10 Nov	[164]	*The Three Fine Arts*; Bartolozzi; pub. Poggi (V&C.2221; B.181).

11 Nov	[165]	*Cupid's Pastime*; Percy's *Reliques*; [Bowles]; Facius; pub. Boydell (B.134); pendant, [221] with the same title pub. 1 Dec 1785.
Nov	[166]	*Renaldo arresting the Arm of Almida*; Scorodomoff; pub. Sayer & Bennett (B.117), version of [24].
*c.*1783	[167]	*Venus lending the Cestus to Juno*; engr. & pub. Thomas Gaugain; between 1780 and 1783 Gaugain made some prints which were colour printed using several plates, and 4 plates for this print were in his sale in 1793, lot 36.

1784

1 Jan	[168]	*Cupid and Psyche*; [169] *Venus crown'd by Cupid*; Marcuard; pair pub. John Harris and by Durand (B.157).
	[170]	*A Flower painted by Verelst*; [171] *Cupid and Ganymede*; pair [Bowles] engr. & pub. Burke.
	[172]	*Cupid Reposeing*; Ogborne; pub. Thane.
	[173]	*The Death of Procris*; Ovid; [174] *Theseus finding his Father's sword and sandals*; Plutarch; T. Fielding; pair pub. Fielding and by Palmer (B.156, 168).
	[175]	*Rural Sports*; Bartolozzi; pub. Walker (V&C.1329; B.202).
4 Jan	[176]	*Bacchanalian Nymph*: [177] *Dancing Nymph*; Bartolozzi; pair pub. J. Matthews (V&C.364, 457).
10 Feb	[178]	[A Vestal, standing in profile, untitled]; pub. Wilkinson.
1 March	[179]	*Dido*; Delattre; pub. J. Gamble; small plate.
	[180]	*Morning Amusement*; [Henry Hoare]; Ryland; pub. 'for the Proprietor by W. Palmer'.
12 March	[181]	*Abra*; [182] *Una*; R. Read; pub. Birchall; small version of Burke's prints, see 2 Feb 1783.
25 March	[183]	*Griselda*; Chaucer; Bartolozzi; pub. S. Vivares (V&C.1369).
	[184]	*Meditation*; J. B. Michel; pub. Boydell.
1 April	[185]	*Rinaldo and Armida*; [186] *Ermina*, Tasso; J. Hogg; pair pub. A. Torre.
1 May	[187]	*Venus Attired by the Graces*; Bartolozzi; pub. Watts (V&C.499; B.61).
1 June	[188]	(Miss Harrop, singer); [Earl of Exeter]; Delattre; pub. Walker (O'D.1).
27 July	[189]	*Lady Rushout & Daughter*; Burke; pub. Dickinson (O'D.1).
7 Sept	[190]	*Cleone*; Dodsley; [191] *Cordelia*, Shakespeare's *King Lear*; Bartolozzi; pair pub. Birchall (V&C.1378, 1859; B.133, 121).
1 Oct	[192]	*Elizabeth Vernon, Countess Harcourt*; engr. & pub. L. C. Ruotte (B,90–91).
	[193]	*Poetry*; Ryder; pub. Watts (B.192) pendant to [158] *Music*, 1 July 1783.
2 Oct	[194]	*Apollo and Daphne*; anon; pub. W. Turner.
16 Oct	[195]	*Pericles and Aspasia*; Plutarch; [196] *Catullus and Lesbia*, Catullus; Sherwin; pair pub. T. Watson (B.131).
21 Nov	[197]	*Cupid disarm'd by Euphrosine*; [198] *Cupid binding Aglaia to a Laurel*; pair [Bowles] engr. & pub. Burke (B.128); reissued S & J. Fuller, 1 Sept 1816.
1 Dec	[199]	*Tancred and Clorinda*; Bartolozzi; pub. Palmer (V&C.1366; B.118); pendant to *Tancred and Ermina* after Cipriani (V&C.1367).
10 Dec	[200]	*Tragedy and Comedy*; engr. & pub. Picot (B.196).
	[201]	*'Till lively gesture . . .*'; [202] *'With pliant arm . . .*'; etchings A. Albanesi; pair pub. J. Harris.

1785

10 Feb	[203]	*Ariadne*; Dryden; Delattre; pub. Macklin (BN.54; B. 130).
20 Feb	[204]	*The Shepherdess of the Alps*; [205] *Gualtherus and Griselda*; Bartolozzi; pair, Marmontel [Bowles], pub. W. Dickinson (V&C.1412, 1368).
21 Feb	[206]	*Diana and Nymphs* [Isaac Martell]; Marcuard; pub. Durand and by Harris.
23 Feb	[207]	*The Death of Mark Anthony*; Delattre; pub. A. Bryer, (B.70); pendant to [226] *Posthumio*, pub. 5 April 1786.
March	[208]	*Samma the Demoniac*; Ryland; pub. Birchall (B.160); stipple version of Burke's mezzotint, pub. 22 April 1772.
25 March	[209]	*Abelard offering Hymen to Eloisa*; Ogborne; pub. Thane; same size as [119] *The Death of Eloisa*, pub. 15 Jan 1782.
1 May	[210]	*The Flower Girl*; Spilsbury; pub. Boydell.
9 May	[211]	*Nymphs sacrificing to Love*; [212] *Nymphs sacrificing to Mercury*; Marcuard; pair pub. Birchall (V&C.459–60; B.54).
12 May	[213]	*Penelope awakened . . .* ; Ryland, & [finished by] Michel; pub. Boydell; stipple version of Burke's mezzotint [10] 15 Feb 1773.
15 May	[214]	*A Nymph sacrificing*; [215] *Harmony*; Bettelini; pub. Torre.
20 May	[216]	*Andromache weeping over the ashes of Hector*; engr. & pub. Dickinson (B.95); pendant to [267] *The Last Interview of Hector . . .* , c. 1790.
1 July	[217]	*Zeuxis composing the picture of Juno*; Bartolozzi; pub. Palmer (V&C.1355; B.64), reissued by Molteno, 4 May 1803.
2 July	[218]	*Rinaldo and Armida*; Tasso; [219] *Death of Clorinda*; Bartolozzi; pair pub. Poggi; (V&C.1365, 1364; B.115).
3 Nov	[220]	*Coriolanus*, Shakespeare [George Shepherd]; do; pub. Birchall (V&C.1842; B.122).
1 Dec	[221]	*Cupid's Pastime*, Percy's *Reliques* [Bowles]; Facius; pub. Boydell (B.134), pendant to [165], pub. 11 Nov 1783.

1786

1 Jan	[222]	*Brotherly Affection*; S. Sedgwick; pub. Boydell (B.207).
1 Feb	[223]	*The Interview between Edgar and Elfrida after her Marriage with Athelwold*; [Lord Boringdon]; line; Ryland, completed by W. Sharp; pub. Mrs Ryland (B.68).
2 Feb	[224]	*Alexander resigning his Mistress Campaspe to Apelles who was in Love with her*, Pliny; [225] *Cleopatra throwing herself at the Feet of Augustus, after the Death of Marc-Antony*, Plutarch; Burke; pair [Bowles] pub. Burke and by S. Vivares (B.65).
5 April	[226]	*Posthumio Consul of Rome . . .* , Rollin; Delattre; pub. A. Bryer; reissued Molteno 15 Jan 1805; pendant to [207] *The Death of Mark Anthony*, 23 Feb 1785.
20 April	[227]	*Electra and Chrysothemis*; Franklin's Sophocles' *Electra* [Sir Edward Vernon]; S. Harding 'delt'; pub. T. Macklin; pendant to [231] *Peleus*, 20 June 1786.
1 June	[228]	*The Power of Music*, engr. J. Hogg; [229] *The Power of Love*, engr. Ogborne; pub. Thane.
7 June	[230]	*Telemachus and Mentor in the Island of Calypso* [Bowles]; Bartolozzi; pub. M. Ryland (V&C.484; B.167), reissued Colnaghi 2 Sep 1799; pendant to [217] *Zeuxis*.
20 June	[231]	*Peleus and Thetis* [Vernon]; anon; pub. Macklin (B.59); pendant to [227] *Electra . . .* , 20 April.

21 July	[232]	*Bacchanalians*; [233] *Nymphs after Bathing*; Bartolozzi; pair [Charles Boddam]; pub. Diemar (v&c.363, 468).
1 Sept	[234]	*Miranda and Ferdinand*; Shakespeare's *Tempest*; P. W. Tomkins; pub. Birchall (B.124).
5 Sept	[235]	*Cupid finding Aglaia asleep, binds her to a Laurel*, Metastasio [Robert Hellen]; Burke; pub. B. B. Evans.
1 Nov	[236]	*Achilles discover'd by Ulysses* [Bowles]; Facius; pub. Boydell (B.103); proof entitled *Hector Discovered*; pendant to [251] *Hector . . .*, 1 Jan 1788.
1786	[237]	*Acontius & Cidippe*; engr. J. F. Martin.

1787

1 Jan	[238–41]	*Colouring; Composition; Design; Invention*; Bartolozzi; set [Royal Academy] pub. Boydell (v&c.583, 588, 597, 640; *Design*: B.200).
	[242]	*Sylvia overseen by Daphne who endeavour'd to persuade her to love Aminta*; Tasso; P. W. Tomkins; pub. S. Vivares (B.120).
5 Jan	[243]	*The Portrait of Angelica Kauffman in the Character of Design, listening to the Inspiration of Poetry* [Bowles]; engr. & pub. Burke (B.86).
March	[244]	*Hammond's Love Elegies*, Hammond; [245] *Churchill's Gotham*, Churchill; Delattre; pair [drawings: John Bell]; pub. A. Bryer 10 & 30 March (Hammond: B.80; Churchill: BN.57).
April	[246]	*Virtue weeping at the Tomb of Emma Corbett*; Pratt; C. G. Player; pub. Wilkinson.
16 June	[247]	*Pictoresque Amusement*; [248] *Practical Excersise* (sic); Bettellini; pair pub. Torre (B.38, 39).
10 Oct	[249]	*The Mirror of Venus* [Robert Sayer]; T. Trotter; pub. Sayer.
1 Dec	[250]	*Damon and Musidora*; C. Knight; pub. Dickinson, pendant to [254] *Palemon . . .*, 10 April 1788.

1788

1 Jan	[251]	*Hector reproaching Paris* [Bowles]; Facius; Boydell (B.102); early state entitled *Hector rebuking Paris*, pendant to [236] *Achilles*, 1 Nov 1786.
18 Jan	[252]	*Chevalier D'Eon*; engr. & pub. F. Haward (O'D.9).
4 April	[253]	*Selim or the Shepherd's Moral*; Bartolozzi; pub. Macklin in No.1 of *The British Poets* (v&c.1428).
10 April	[254]	*Palemon and Lavinia*; Knight; pub. Dickinson, pendant to [250] *Damon*. 1 Dec 1787.
30 July	[255]	*The Judgment of Paris*: started by Knight, signed by Bartolozzi; pub. Watts (v&c.475).
Oct	[256]	*Dormant Love*; Ogborne; pub. Thane on the same plate as *Active Love*, Strutt after Stothard.
Nov	[257]	*Cornelia Mother of the Gracchi* [Bowles]; Bartolozzi; pub. M. Ryland; (v&c.506).

1789

1 Feb	[258]	*Cupid and Cephisa*, 'Cephisa says . . . ' [Bowles]; engr. & pub. Burke; pendant, [262], pub. 10 July 1789.
2 March	[259]	*Cupid and Bacchanals* [Robert Sayer]; Robert Thew; pub. Sayer, pendant to [260] *The Nursing of Bacchus*, by Thew, ?same date.
24 April	[261]	*Beauty and Prudence*, Lord Exeter; Ryder; pub. Watts (BM).
10 July	[262]	*Cupid and Cephisa*, 'One Day . . . ' [Bowles]; engr. & pub. Burke.

1790

2 Feb	[263]	*Eurydice* [Mathew Michell]; Bartolozzi; pub. Birchall (V&C.413).
1 Oct	[264]	*Shakespeare's Tomb*; do; pub. Poggi (V&C. 1821), small version of [136].
18 Dec	[265]	*Ferdinand IV Re delle due Sicilie e . . . Maria Carolina . . .* ; engr. & pub. M. Bovi.
1790	[266]	*Rinaldo and Armida*; mezzotint; Dickinson (B.113 as 1790); the plate was in Dickinson's sale in 1794 (18 Feb, lot 64), described as 'unfinished'.
c. 1790	[267]	*The Last Interview of Hector and Andromache* [William Dickinson]; Schiavonetti, pub. Dickinson, New Bond St. This print is the same size as Dickinson's *Andromache*, pub. 20 May 1785; the copper plate for this was in his sale, but neither the picture nor the print for this later plate were.

1791

1 March	[268]	*Una*; Bartolozzi; small circle pub. Birchall.
1 July	[269]	*Venus shows Aeneas the road to Carthage*; [270] *Penelope taking down the Bow of Ulysses*; Ryder; pair [Lord Boringdon]; pub. B. B. Evans (B.111).
	[271]	*Diana reposing after the Chace*; [272] *Venus explaining to Cupid the Torch of Hymen*; Dumee; pub. Read.

1792

1 Jan	[273]	*The Sun Setting*; J. Kirk; pub. 'the Proprietor' (reissued as *Evening*. 1 Jan 1794, pair, B.177); pendant to *The Sun Rising*; T. Kirk after Reni; this is one of the earliest of a series of small stipples in elaborate engraved frames published by Poggi, probably for *découpage*; see 3 Feb 1794, 1 Jan 1794.
2 Jan	[274]	*Henry and Emma*, Prior; [275] *Angelica and Sacriponte*; Ariosto; Burke; pair [Bowles] pub. Boydell (B.129).
1 Feb	[276]	*Honble Anne Damer* [Gen. Conway]; Ryder; Watts (O'D.5).
20 Feb	[277]	*Venus and Adonis*: [278] *Sylvia & the Dog*; Sherwin; pub. Read.
16 March	[279]	*Horace*; [280] *Virgil*; Bartolozzi; pair [Bowles] pub. 'for the Proprietor' by Ryder, Colnaghi, & Bovi (V&C.1358-9); [279] is dated 1797 by V&C but the year could read 1792; an unrecorded proof before title with a scratched has the line 'Publish'd . . . Feb 1 1791 by S. Watts', which indicates that the proprietor was Watts and suggests that the prints appeared in 1792.
16 May	[281]	*The Marchioness of Townshend*; Cheesman; pub. Peter Borgnis (V&C.1214; O'D.5*; B.89).
1 Aug	[282]	*Two Gentlemen of Verona*; L. Schiavonetti; Boydell's *Shakespeare*.

1793

4 Jan	[283]	*Veneration*; 'Demee' (i.e. Dumee); pub. J. Read; pendant to *Adoration* after Cipriani.
3 Feb	[284]	*Servius Tullius*; T. Kirk; pub. Poggi (B.74).
April	[285]	*Modesty*; [286] *Vanity*; Bartolozzi; pair pub. Matthews (V&C.660, 735; B.180).
18 May	[287]	*History*; do; pub. T. Tomkins.

1794

1 Jan	[288]	*Love Sleeps*; [289] *'Blest as the Immortal Gods . . .* '; J. Kirk; pub. Poggi; circles, see 1 Jan 1792; an unsigned circle, [290] *Cupid Wounded*, published on the same day by Poggi may be after Kauffman.

Jan	[291]	*Atalanta*; S. Close (Close was a Dublin engraver, but this is inscribed 'London Pub Jany 1794').
Jan	[292]	*Penelope and her Web*; [293] *Venus attired by the Graces*; Dumee; pair pub. J. Read (B.108, 62).
20 Jan	[294]	*The Younger Pliny Reproved*, Melmoth's *Pliny* [Bowles]; Burke; pub. T. Macklin.
1 April	[295]	*Sappho*; Burke; Poggi; see 3 Feb 1793; 1 Jan 1794.
12 May	[296]	*Christ appearing to the Marys* [Bowles]; Bartolozzi; Macklin's *Bible* (V&C.53).

1795

1 Jan	[297]	*Troilus and Cressida*; L. Schiavonetti; Boydell's *Shakespeare*.
	[298]	*Renaldo and Armida*; Tasso [Bowles]; Burke; pub. Macklin.
25 Nov	[299]	*Ahijah foretelling the Death of Abijah*; Bartolozzi; Macklin's *Bible* (V&C.48).

1796

| 4 May | [300] | *Joseph Sold by his Bretheren*; [301] *Joseph telling his Dream*; mezzotints; pair engr. & pub. John Murphy, see 26 Jan 1798. |

1798

| 10 Jan | [302] | *Lady Jane Gray giving her Table Book to Sir John Gaze . . .* ; [303] *Queen Margaret and the Robber*; Bartolozzi; pair [Bowles] pub. Macklin (V&C.529, 523). |
| 26 Jan | [304] | *Joseph sold by his Bretheren*; [305] *Joseph telling his Dream to his father*; Godby; pair pub. J. Murphy (B.35), see 4 May 1796. |

1800

| 4 June | [306] | *The Death of Sylvia's Stag*, Virgil [H. Wm Downes]; Bartolozzi; pub. Macklin (V&C.1351). |

1801

| 1 Jan | [307] | *Bacchus amidst solitary rocks teaching the Nymphs to make verses*, Horace; Bartolozzi; pub. Miss Bryer (V&C.373). |

1802

| 1 Jan | [308] | *The Death of Alcestis*; [309] *Virgil reading his Aenead*; Bartolozzi; pair, of which proofs had been issued by Jane Matthews on 5 May 1796, pub. 'for the Proprietor' by Colnaghi (V&C.352, 1360). |

1803

| 1 Nov | [310] | *Vortigern & Rowena*; line; Ryder; pub. B. B. Evans (B.76); this plate is possibly one started by Ryland as a pendant to [223] *Edgar . . .* , 1 Feb 1786. |

1809

| 29 June | [311] | *Ulysses in the Island of Circe*; [312] *Ulysses discovers Achilles disguised as a Virgin among the Daughters of King Lycomedes*; W. Bond; pair [Bowles] pub. James Daniell. |

Chronology

1741 Angelica Kauffman born 30 October in Chur (Coire), Switzerland, to Johann Josef and Cleofa Lucin Kauffman; christened Maria Anne Angelica Catherine.

1742 September: family moves to Morbegno in Lombardy.

1752 Family living in Como; she paints the portrait of the local Bishop, and various other notables.

1754 In Milan, where she paints portraits of the Duchess of Modena, the Archbishop of Milan, and the Austrian Governor.

1757 1 March: death of her mother. Travels to Bregenz, her father's birthplace. There she assists her father in painting frescoes of the Twelve Apostles in the parish church at Schwarzenburg.

1759 Travels with her father to Milan, Modena and Parma in order to study and to copy works of art.

1762 June: arrives in Florence, where she produces her first etchings. While there she meets Benjamin West. On 1 October she is elected to the Florentine Accademia del Disegno.

1763 January: arrives in Rome, where she meets the antiquarian J. J. Winckelmann, and makes drawings after Antique sculptures. July: in Naples, where she copies paintings at the Palace of Capodimonte. Paints portraits of Lord Exeter, David Garrick, John Parker, John Byng, Dr John Morgan and others.

1764 12 April: returns to Rome, following which she paints her first classical history paintings.

1765 18 February: visited by John Boswell and Nathaniel Dance. Sends her portrait of David Garrick to London to be exhibited at the Society of Artists. 5 June: elected to the Accademia di San Luca, Rome. 1 July: arrives in Bologna. October: in Venice, where she is joined by Nathaniel Dance. Leaves for England, visiting Paris en route.

1766 Arrives in London, with Lady Wentworth, on 22 June. Visits Joshua Reynolds in his studio on 30 June.

1767 Sets up her home and studio in Golden Square, London. January: paints a portrait of the Duchess of Brunswick. The Princess of Wales visits her studio. Her father joins her in London in the summer. 22 November: marries 'Count de Horn'.

1768 10 February: the marriage is annulled. In the autumn she exhibits three history paintings at the Society of Artists' special exhibition held in London for the visiting King Christian VII of Denmark. December: foundation in London of the Royal Academy of Arts.

1769 May: exhibits at the first exhibition held by the Royal Academy.

1770 Begins her collaborations with the engraver W. W. Ryland.

1771 Spends six months in Ireland, during which time she paints portraits of the Viceroy of Ireland, Lord Townshend, and his family and others. This year she exhibits the first painting of British history ever to be seen at a Royal Academy exhibition: *Vortigern Enamoured with Rowena*.

1773 Along with Reynolds, Dance, James Barry and G. B. Cipriani, she is chosen to decorate the interior of St Paul's Cathedral in London with large historical paintings; the project is never carried out.

1774 She and other artists are invited, but decline, to paint scenes of British history for the Society of Arts in the Great Room at the Adelphi, London. Advertises a set of 20 etchings for sale.

1775 Nathaniel Hone mocks Reynolds and her in *The Conjuror*; she expresses her objections to the Council of the Royal Academy and Hone's painting is withdrawn.

1780 Completes allegories of *Invention, Composition, Design* and *Colour* for the ceiling of Somerset House, the Royal Academy's new home. In May, Ryland exhibits 146 engravings after her, and numerous paintings by her hand.

1781 14 July: marries the painter Antonio Zucchi. Five days later she leaves England with her husband, her father, Joseph Bonomi and her cousin. En route to Italy she visits Flanders, as well as her father's home in Schwarzenburg, and Verona. Arrives in Venice on 4 October. Zucchi begins keeping a 'Memorandum of Paintings'. The Grand Duke and Grand Duchess of Russia visit her studio and purchase paintings.

1782 11 January: death of her father in Venice. In April she and Zucchi travel to Rome, where they set up home and a studio. In June she travels to Naples, where, in September, Queen Caroline and King Ferdinand of Naples commission a painting of the royal family. She executes life-size heads on separate canvases to be incorporated into a large canvas. November: returns to Rome.

1783 Exhibits three paintings (sent from Naples) at the Society of Artists in London. In August in London Ryland is declared bankrupt, and executed for forgery.

1784 24 March: she completes the portrait of the royal family of Naples. In London, some of her works are reproduced as 'mechanical paintings' by the Polygraphic Society.

1785 January: leaves Naples and returns to Rome. February: paints a large history painting of *Servius Tullis* for Catherine the Great, Empress of Russia. Her paintings are rejected by the Royal Academy in London because they are submitted by a printseller. 20 July: back in Naples, where she paints subjects from Roman history (*Cornelia, the Mother of the Gracchi* and *Tullia, Wife of Pompey*) and portraits for Queen Caroline, as well as a Roman subject (*Ovid at Pontus*) for Prince Youssouppoff of Russia. In October she paints three scenes from Roman history for George Bowles (*Cornelia, the Mother of the Gracchi, The Younger Pliny, with his Mother at Misænum* and *Vergil on his Deathbed*). November: returns to Rome.

1786 Exhibits three paintings of Roman history (painted for George Bowles the previous year) at the Royal Academy in London. Attends her first meetings of the Academy of Arcadians, a Roman society of poets. The German poet Goethe is named a member this year. September: paints a large pair of history paintings, *Defeat of Quintilius Varus by Hermann* and *The Death of Palantis*, for the Emperor Josef II of Austria.

1787 Begins her close friendship with Goethe and his fellow poet Johann Gottfried von Herder. Paints a self-portrait for the Grand Duke of Tuscany's collection in Florence of artists' self-portraits.

1788 January: paints *Cornelia, Mother of the Gracchi* and *The Sentence of Brutus on his Sons* for Prince Poniatowsky of Poland. August: paints *Augustus, Octavia and Vergil* for the King of Poland.

1789 At the beginning of the year, the Duchess of Saxe-Weimer, Anna Amelia, arrives in Rome and becomes her close friend. February: paints scenes from *Two Gentlemen of Verona* and *Troilus and Cressida* for Boydell's Shakespeare Library in London. May: sends paintings of *Queen Margaret of Anjou* and *Lady Jane Grey* to George Bowles in England. October: paints a *Holy Family* for the chapel of Bartholomew Colleoni at Bergamo for Cardinal Carrara. December: paints *Achilles Among the Maidens* for Catherine the Great.

1790 May: paints *A Scene in Arcady*, after a poem by her friend George Keate.

1791 February: paints the *Self-portrait: Hesitating Between the Arts of Music and Painting* for Princess Holstein-Beck of Russia. December: paints a portrait of Emma, Lady Hamilton. For the next four years she continues to live in Rome, painting a variety of subjects and portraits for a wide circle of international patrons.

1795 November: paints portrait of Prince Augustus Frederick in the military uniform of a Scotch Highlander. 26 December: death of her husband, Antonio Zucchi.

1796 Paints a large allegory of *Religion* for a Mr Forbes.

1797 Exhibits her *Portrait of a Lady* at the Royal Academy, the last picture she submits for showing there.

1798 French armies occupy Rome, but she is allowed to continue working in her studio. 17 February: paints a portrait of Citizen-General L'Espinasse. 22 June: her bankers in London, Messrs Kuliff and Grellet, send interest on £5000 on deposit with them to Donat Orsi and Sons, bankers in Florence, for her use. 30 August: paints the portrait of Citizen-Countess Thierry. 16 November: last entry by her in the 'Memorandum of Paintings'.

1799 12 October: in a letter she expresses her distress and tremendous losses, which meant working harder than ever at a time when she had expected to enjoy comfort and ease.

1800 Her health is in decline, but she continues to paint, and to lead an active social life.

1805 Trip to Florence, Bologna, Como and Venice, returning via Padua and Perugia.

1807 5 November: dies in Rome, and is buried in the Church of San Andrea delle Fratte. 23 December: at a General Assembly of the Royal Academy, Benjamin West reads out the letter from Joseph Bonomi (then in Rome) informing him of her death.

References

The Art of Painting in England

1 Kauffman (and not Kauffmann) is the preferred spelling of her name; this is the form she used most often in her correspondence, for documents, and when signing her paintings.

2 W. S. Sparrow, *Women Painters of the World* (London, 1905), pp. 58–9.

3 This *Memorandum* is now in the Royal Academy of Arts, London. An English translation (from the Italian) is in V. Manners and G. C. Williamson, *Angelica Kauffman, R.A.: Her Life and Works* (London, 1924), pp. 141–74. See W. W. Roworth, 'Angelica Kauffman's "Memorandum of Paintings"', *The Burlington Magazine*, CXXVI (1984), pp. 629–30.

4 G. G. De Rossi, *Vita di Angelica Kauffman* (Florence, 1810). The introduction to the facsimile edition (London, 1970) by R. Lightbown provides information on De Rossi and his relationship with Kauffman.

5 See *The Diary of Joseph Farington*, 16 vols [I–VI ed. K. Garlick and A. Macintyre, VII–XVI ed. K. Cave] (London, 1978–84).

6 A. Thackeray, *Miss Angel* (London, 1875).

7 De Rossi, *op. cit.*, pp. 33–47, tells the entire story, but he makes sure to add in a note (p. 46), undoubtedly to protect her posthumous reputation, that he found it odd that this man who so schemed to marry Angelica was actually incapable, due to a wound, of becoming 'physically married'.

8 W. W. Roworth, 'Biography, Criticism, Art History: Angelica Kauffman in Context', in *Eighteenth-century Women and the Arts*, ed. F. M. Keener and S. E. Lorsch (London, 1988), pp. 209–23. See also E. Kris and O. Kurz, *Legend, Myth, and Magic in the Image of the Artist* (New Haven, 1979), pp. 13–38.

9 De Rossi, *op. cit.*, pp. 16–18.

10 *Memorandum*, Rome, 1791, p. 33; Manners and Williamson, *op. cit.*, p. 160. De Rossi (p. 17, n.5), states that two replicas were made, including one for an Academy in Rome. For further discussion of the self-portrait see Roworth, in Keener and Lorsch, *op. cit.*, pp. 217–21; *Genial Company: The Theme of Genius in Eighteenth-century British Portraiture*, exhibition catalogue by D. Shawe-Taylor, University Art Gallery, Nottingham (1987), pp. 21–2; and A. Rosenthal, 'Angelica Kauffman Mas(k)ing Claims', *Art History*, XV (1992), pp. 38–59.

11 H. von Erffa and A. Staley, *The Paintings of Benjamin West* (London, 1986), pp. 36–8, 239.

12 See *Reynolds*, exhibition catalogue ed. N. Penny, Royal Academy of Arts, London (1986), pp. 205–7; D. Mannings, 'Reynolds, Garrick, and the Choice of Hercules', *Eighteenth Century Studies*, XVII (1984), pp. 259–83; M. Postle, 'Reynolds, Shaftesbury, van Dyck and Dobson: Sources for "Garrick Between Tragedy and Comedy"', *Apollo* (1990), pp. 306–11.

13 *Women Artists: 1550–1950*, exhibition catalogue ed. A. S. Harris and L. Nochlin, Los Angeles County Museum of Art (1976), pp. 107–8.

14 De Rossi, pp. 2–3; and Roworth in Keener and Lorsch, *op. cit.*, on his biography as a masculine model.

15 R. Parker and G. Pollock, *Old Mistresses: Women, Art and Ideology* (London, 1981), p. 91.

16 This work, *Geschichte der Kunst der Altertums*, was published in Dresden.

17 See F. Haskell and N. Penny, *Taste and the Antique: The Lure of Classical Sculpture, 1500–1900* (London, 1981).

18 A. S. Marks, 'Angelica Kauffman and some Americans on the Grand Tour', *American Art Journal*, XII/2 (1980), pp. 5–24.

19 This sketchbook is now in the Victoria and Albert Museum, London; it was acquired from Kauffman in 1800 by Giuseppi Vallardi, a Milanese print dealer. See P. S. Walch, 'An Early Neoclassical Sketchbook by Angelica Kauffman', *The Burlington Magazine*, CXIX (1977), pp. 98–111.

20 James Martin, manuscript journal of Grand Tour, II, 8 January 1764. Noted in Sir Brinsley Ford's Grand Tour Archives, Paul Mellon Centre for British Art, London.

21 *Antichità de Ercolano: Le Pitture Antiche d'Ercolano e contorni incise con qualche spiegazione*, Accademia Ercolenese, I–VIII (Naples, 1757–92).

22 *Ibid*, II, p. 52.

23 See *Angelika Kauffmann und ihre Zeitgenossen*, ed. O. Sandner, Vorarlberger Landesmuseum (Bregenz, 1968), p. 65. This painting was formerly in an English collection. A. Clark noted a striking compositional similarity to the same subject exhibited by Batoni in 1773; see Clark, *Pompeo Batoni* (New York, 1985), pp. 325–6.

24 See M. D. Garrard, *Artemisia Gentileschi: The Image of the Female Hero in Italian Baroque Art* (Princeton, 1989), and W. Chadwick, *Women, Art and Society* (London, 1990), pp. 87–103.

25 L. Nochlin, 'Why Have There Been No Great Women Artists?' (1971), reprinted in *Women, Art and Power, and Other Essays* (New York, 1988), pp. 158–64; see also *The Artist's Model: Its Role in British Art from Lely to Etty*, exhibition catalogue by I. Bignamini and M. Postle, University Art Gallery, Nottingham, and The Iveagh Bequest, Kenwood (1991).

26 *The Artist's Model*, pp. 41–2; the peculiar positioning of Kauffman's portrait was first commented on by Nochlin, *op. cit.*, p. 161, although she did not note the additional presence of the other female founder member, Mary Moser.

27 De Rossi, *op. cit.*, p. 14.

28 See *The Painted Word: British History Painting, 1750–1830*, exhibition catalogue ed. P. Cannon-Brookes, Heim Gallery, London (1991), and the review by B. Allen, 'Conspicuous by its Absence: British History Painting,' *Apollo* (1991), pp. 412–4.

29 In the 1630s the Gentileschis painted the ceiling panels for the Great Hall of the Queen's House, Greenwich, London, a neo-Palladian building by Inigo Jones (these panels were later removed and are now to be seen at Marlborough House in London); Rubens's ceiling paintings for the Banqueting House at Whitehall, London, also built to designs by Jones, date from the same decade; among the works contributed by the Riccis is the early eighteenth-century *Resurrection* in the Chapel of the Royal Hospital, Chelsea, London. For a comprehensive account of these, and

other, works see E. Croft-Murray, *Decorative Painting in England, 1537–1837*, 2 vols (London, 1962, 1970).

30 J.-A. Rouquet, *The Present State of the Arts in England* (London, 1755), p. 22.

31 See J. Barrell, *The Political Theory of Painting from Reynolds to Hazlitt: 'The Body of the Public'* (London, 1986).

32 See S. Hutchison, *The History of the Royal Academy, 1768–1968* (London, 1968); and N. Pevsner, *Academies of Art, Past and Present* (Cambridge, 1940, reprinted New York, 1973).

33 *The Public Advertiser* (2 May 1775), p. 2.

34 Recorded in Manners and Williamson, *op. cit.*, in the collection of the Earl of Strafford, Wrotham Park, Hertfordshire, as 'two classical scenes representing Coriolanus', p. 211; the records at Wrotham also list them in this way.

35 The story is in Plutarch, Livy and other sources. Valerius Maximus, *Illustrious Act of the Ancients*, V. 4, 1 (1567), p. 119.

36 A. M. Clark, 'Agostino Masucci: A Conclusion and a Reformation of the Roman Baroque', in *Essays in the History of Art presented to Rudolf Wittkower*, ed. D. Fraser, H. Hibbard and M. Lewine (London, 1967), pp. 259–64.

37 D. Macmillan, 'The Epic Style', in *Painting in Scotland: The Golden Age* (Oxford, 1986), pp. 31–42; A. U. Abrams, *The Valiant Hero: Benjamin West and Grand-Style History Paintings* (Washington, DC, 1985), pp. 121–60.

38 See J. Newman, 'Reynolds and Hone: "The Conjuror" Unmasked', in *Reynolds*, exhibition catalogue edited by N. Penny, Royal Academy of Arts, London (1986), pp. 344–54.

39 *Reynolds*, pp. 339–40; *Genial Company*, pp. 28–31.

40 De Rossi, *op. cit.*, mentions a letter (10 October 1766) from Kauffman to her father telling him that Reynolds had asked her to paint his portrait (p. 24). Manners and Williamson, *op. cit.*, claim, without proof, that Reynolds, in return, portrayed Kauffman (p. 20).

41 *Eirene and the Child Ploutos*, by Kephisodotos, early 4th century BC; see B. S. Ridgway, *Roman Copies of Greek Sculpture: The Problem of the Originals* (Ann Arbor, 1984), p. 67.

42 It reads: 'Carol. ILLE de Bruns. & Prin. Hered./A: MDCCLX M. Jul. apud Emsdorff VICTORIA / et A. MDCCLXIV M. Jan. apud Britannos AMORE / Coronatus'. See O. Millar, *The Later Georgian Pictures in the Collection of Her Majesty the Queen* (London, 1969), I, p. 59.

43 De Rossi, *op. cit.*, p. 27. The letter is dated 10 February 1767.

44 W. T. Whitley, *Artists and Their Friends in England, 1700–1799* (London, 1928), I, p. 223.

45 Von Erffa and Staley, *op. cit.*, pp. 179–80.

46 See the National Trust guidebook, *Saltram, Devon* (1990), pp. 50–58, and E. Waterhouse, 'Reynolds, Angelica Kauffmann and Lord Boringdon,' *Apollo* (1985), pp. 270–4.

47 *Lloyd's Evening Post* (1 May 1769), p. 427.

48 Comte de Caylus, *Tableaux tirés de l'Iliade, de l'Odyssée d'Homère et de l'Enéide de Virgile* (Paris, 1757), p. 9, 50, 160, 291.

49 *Ibid.*, p. 15.

50 *Ibid.*, pp. 50–1.

51 Noted in P. S. Walch, 'Angelica Kauffman', unpubd doctoral dissertation (Princeton University, 1968), p. 264.

52 Shaftesbury, *op. cit.*, pp. 10–11, 42–3.

53 Philostratus the Younger, *Imagines*, I, 'Achilles on Scyros'. In 1818 Kauffman's friend Goethe published an essay on the paintings described by Philostratus, and translated several of them into German.

54 Adam's 'Section of the Great Drawing Room', wall elevation, 1768 (I, 68), is in Sir John Soane's Museum, London; see also the National Trust guidebook, *Saltram, Devon*, p. 17.

55 Adam's 'Design of a chimney piece for the Great Drawing Room at Saltram', 1768 (XXII, 250), is in Soane's Museum; see also *Saltram, Devon*, p. 21, and R. Fletcher, *The Parkers at Saltram, 1769–89* (London, 1970), p. 75.

56 British Museum, London, Morley Papers., Add. MSS. 48219.

57 *Ibid.*, vol. II, letter no. 194. Lord Boringdon's account book is at Saltram.

58 On Turkish dress see A. Ribeiro, 'Turquerie: Turkish Dress and English Fashion in the Eighteenth Century', *Connoisseur* (May 1979), pp. 16–23.

59 Letter from T. Parker to her brother Thomas, Lord Grantham, (24 August 1775); British Museum, Morley Papers, vol. II.

60 See D. Alexander, 'Patriotism and Contemporary History, 1770–1830', in *The Painted Word*, pp. 31–5; R. Strong, *'And when did you last see your father?': The Victorian Painter and British History* (London, 1978), pp. 13–29.

61 Metastasio, 'Le grazie vendicate' (1735), in *Tutte le opere di Pietro Metastasio*, ed. B. Brunelli (1954), pp. 219ff.

62 Noted in Manners and Williamson, *op. cit.*, p. 185; Croft-Murray, *op. cit.*, II, p. 229.

63 Comte de Caylus, *op. cit.*, II, p. 368, III, p. 317.

64 A. Boime, *Art in the Age of Revolution, 1750–1800: A Social History of Modern Art*, I (Chicago, 1987), p. 112 ff., suggests that the aristocracy of the period, many of whom had recently returned from service in the Seven Years War, identified with these basic heroic subjects, such as those at Saltram.

65 See E. Croft-Murray, 'Decorative Painting for Lord Burlington and the Royal Academy,' *Apollo*, LXXXIX (1969), pp. 125–38. The best contemporary description is G. Baretti, *A Guide Through the Royal Academy* (London, 1781).

66 R. R. Wark is the editor of the standard edition of Reynolds's *Discourses on Art* (London, 1975).

67 C. Ripa, *Iconologia* (Padua, 1611), p. 242. See the examination of Artemisia Gentileschi's self-portrait as the 'Allegory of Painting' in Garrard, *op. cit.*, pp. 337–70, for a full explanation of this iconography.

68 *Painters by Painters* (Uffizi), exhibition catalogue by C. Caneva and A. Natali, National Academy of Design, New York, & the Museum of Fine Arts, Houston (Wisbech, 1988), cat. no. 26.

69 See, for example, R. Lee, *Ut Pictura Poesis: The Humanistic Theory of Painting* (New York, 1967).

70 As quoted in Manners and Williamson, *op. cit.*, p. 38.

71 *The Middlesex Journal* (25 April 1772), p. 4.

72 For example, John Wolcot, *The Works of Peter Pindar, Esq.* (London, 1809), I, p. 28:

'Angelica my plaudits gains –
Her art so sweetly canvass stains!
Her dames so Grecian! give me such delight!

But, were she married to such gentle males

As figure in her painted tales,

I fear she'd find a stupid wedding night.'

73 See E. Spickernagel, 'Helden wie zarte Knaben . . . bei Johann Joachim Winckelmann und Angelika Kauffmann', in *Frauen–Weiblichkeit–Schrift*, ed. R. Berger *et al.* (Berlin, 1985), pp. 99–118; T. Pelzel, 'Winckelmann, Mengs, and Casanova: A Reappraisal of a Famous Eighteenth-century Forgery', *Art Bulletin*, LIV (1972), p. 304–15.

74 These were all painted for George Bowles: see W. W. Roworth, 'The Gentle Art of Persuasion: Angelica Kauffman's "Praxiteles and Phryne"', *Art Bulletin*, LXV (1983), pp. 488–92; Rosenthal, *op. cit.*, pp. 49–55.

75 Haskell and Penny, *op. cit.*, pp. 144–6. The *Endymion* in the Capitoline Museum, Rome, is also identified as 'Adonis'.

76 *The London Chronicle* (3 May 1774).

77 *The Morning Chronicle* (27 April 1772), p. 2.

78 *The London Chronicle* (29 April 1777), p. 413.

79 *The London Chronicle* (24 April 1779), p. 400.

80 *Memorandum*, Venice, December 1781, p. 1; Manners and Williamson, *op. cit.*, p. 141.

81 *Memorandum*, Rome, 1790, p. 31; Manners and Williamson, p. 158. See B. Ford, 'Thomas Jenkins: Banker, Dealer and Unofficial English Agent', *Apollo* (June, 1974), pp. 416–25.

82 *Memorandum*, Naples, 1785, p. 17; Manners and Williamson, *op. cit.*, p. 149.

83 B. Ford, 'The Earl-Bishop: An Eccentric and Capricious Patron of the Arts', *Apollo* (June, 1974), pp. 426–39.

84 *Memorandum*, Rome, 1793, p. 40; Manners and Williamson, *op. cit.*, p. 91, 164; *Genial Company*, p. 19.

85 Horace, *Odes*, II, 19; *Memorandum*, Rome, August 1787, for Mrs Bryer, London, p. 23 and, added on loose sheet, described as a pendant to *Telemachus on the Island of Calypso . . . assisted by Nymphs singing Ulysses' praises*, Manners and Williamson, *op. cit.*, p. 153, 171.

86 *Memorandum*, Naples, 20 October 1785, p. 15; Manners and Williamson, *op. cit.*, p. 148.

87 See P. Walch, in *Women Artists: 1550–1950*, p. 50; Roworth, in Keener and Lorsch, *op. cit.*, p. 212.

88 De Rossi, *Memorie delle belli arti*, I, Rome, April 1785, pp. li–liv; September 1785, pp. cxxxv–cxli.

89 *The General Evening Post* (29 April 1786), p. 4; *The Morning Chronicle* (3 May 1786), p. 3.

90 *The Morning Post* (9 May 1786).

91 *The Public Advertiser* (22 May 1786), p. 2.

92 *Memorandum*, Rome, 1793, pp. 40, 44; Manners and Williamson, *op. cit.*, p. 164–5. See the National Trust guidebook *Attingham Park, Shropshire* (1987), pp. 30–33.

93 Metastasio, 'Le grazie vendicate', in *Opere*, p. 221.

94 The last, in 1797, was a portrait of 'A lady of quality'.

95 *Memorandum*, 17 February 1798, p. 7 of loose sheets: Manners and Williamson, *op. cit.*, pp. 169, 101; reported by Cornelia Knight, *Personal Reminiscences* (London, 1874).

96 Manners and Williamson, *op. cit.*, p. 108.

97 *Ibid.*, p. 110.

98 De Rossi, *op. cit.*, pp. 104–5.

Portraiture

Note: Questions concerning the ideological position of Kauffman's portraiture are addressed in greater detail in my PhD thesis (Trier University), in progress.

1 J. Moore, *A View of Society and Manners in Italy* (London, 1781), II, p. 71.

2 According to E. P. Bowron, of the approximately 300 portraits, including autograph replicas by Batoni known today, 193 depict individually named sitters, of which 154 (80%) are British, and 116 (60%) English (*Pompeo Batoni and his British Patrons*, exhibition catalogue; The Iveagh Bequest, Kenwood, London: 1982, p. 7).

3 Quoted in A. S. Marks, 'Angelica Kauffmann and some Americans on the Grand Tour', *The American Art Journal*, XXI/2 (1980), p. 23.

4 The portrait of West, which is signed and dated, is a black chalk drawing, 41.9 × 31.7 cm (National Portrait Gallery, London, inv. no. 1649); see A. M. Clark, 'Roma mi è sempre in pensiero', *Studies in Roman Eighteenth-century Painting* (Washington DC, 1981), pp. 125–38.

5 Morgan's portrait (135 × 100 cm) is in the National Portrait Gallery, Washington DC. See *Angelika Kauffmann (1741–1807)/Marie Ellenrieder (1791–1863)*, exhibition catalogue by E. von Gleichenstein & K. Stober; Städtische Museen Konstanz, Rosengartenmuseum, 1992, fig. 2.

6 See *Reynolds*, exhibition catalogue by Nicholas Penny, Royal Academy of Arts, London, 1986, no. 78.

7 See P. S. Walch, 'An Early Neoclassical Sketchbook by Angelica Kauffmann', *Burlington Magazine*, CXIX (1977), pp. 98–111.

8 The commercial nature of portraiture in London at this time is discussed in M. Pointon, 'Portrait Painting as a Business Enterprise in London in the 1780s', *Art History*, VII (1984), pp. 187–205, and in D. Mannings, 'Notes on some Eighteenth-century Portrait Prices in Britain', *British Journal for Eighteenth Century Studies*, VI (1983), pp. 185–96.

9 Letter quoted in W. Schram, *Die Malerin Angelica Kauffmann* (Brünn, 1890), pp. 45–7, here translated; compare Manners and Williamson, *op. cit.*, pp. 24–5.

10 *Ibid.*

11 Rouquet, *op. cit.*, p. 43.

12 Rouquet, *op. cit.*, pp. 123–4 and p. 43.

13 Whereas Kauffman's portrait measures 270.5 × 187.3 cm, Ramsay's portrait of the King measures 248.9 × 162.6 cm while Cotes's portrait is 265.7 × 186.7 cm. See O. Millar, *The Later Georgian Pictures in the Collection of Her Majesty the Queen* (London, 1969), II, no. 869. In 1769 Kauffman's painting was take out of its frame in order to be copied, possibly by the artist herself. A copy is now in Braunschweig's Herzog Anton Ullrich-Museum.

14 G. C. Zucchi, *Memorie storiche di Angelica Kauffmann-Zucchi*, MSS in Bregenz, Vorarlberger Landesmuseum (translated into German by H. Gabel), p. 18.

15 For examples of Kauffman's role-playing in her self-portraits see A. Rosenthal, 'Angelica Kauffman Ma(s)king Claims', *Art History*, XV (1992), pp. 38–59.

16 See, for example, *Elizabeth Berkeley, Countess of Craven and Margravine of Anspach as Hebe* (Christie's London, 19 Sept 1973, no. 1008, or *A Lady as a Sibyl* (Dresden, Staatliche Kunstsammlung, inv. no. 2181), or *Dorothy Holroyd* (Sotheby's, London, 6 Nov 1963, no. 85) after Guercino's *Sibylla*

Persica of 1647. See G. Kraut, 'Weibliche Masken: Zum allegorischen Frauenbild des späten 18. Jahrhunderts', *Sklavin oder Bürgerin? Französische Revolution und Neue Weiblichkeit, 1760–1830*, exhibition catalogue by Victoria Schmidt-Linsenhoff, Historiches Museum, Frankfurt-am-Main 1989, pp. 340–57, and B. Baumgärtel, *Angelika Kauffmann (1741–1807): Bedingungen weiblicher Kreativität in der Malerei des 18. Jahrhunderts* (Weinheim and Basle, 1990), pp. 119–21; and the 1992 Konstanz exhibition catalogue, figs. 9 and 10.

17 These are *The Earl of Ely, with his Wife and Two Nieces*, signed and dated 1771, 243 × 287 cm, National Portrait Gallery of Ireland, Dublin, inv. no. 200; *The Townsend Family*, National Portrait Gallery of Ireland; *Philip and Mary Tisdall, with their Daughters and Grand-daughter*, 1771 (154.3 × 190.5 cm), private collection, Ireland. For an interesting variation on the type, painted after her return from Ireland, see *The Family of the Earl of Gower*, 1772, (150.5 × 208.3 cm), The Holladay Collection, National Museum of Women in the Arts, Washington DC. (See the catalogue, by M. B. Rennolds, of the *National Museum of Women in the Arts*, New York, 1987, pp. 40–41).

18 See P. S. Walch, 'Angelica Kauffman', unpubd diss. (Princeton University 1968), p. 73. The painter George Romney received £15, £30 and £60 in 1775, and £20, £40 and £60 in 1781; see Pointon, *op. cit.*, p. 200; D. Mannings, *op. cit.*, p. 194, n. 25.

19 Klopstock to Gleim, 2 September 1769, quoted in Schram, *op. cit.*, p. 14, here translated. Klopstock is probably referring here to half-length portraits.

20 British Museum London, Prints and Drawings, Whitley Papers, 'Notes on Artists', VII, J-L, p. 840.

21 Some ideas can be gleaned from the letters and diaries written by her clients, chiefly of travellers in Italy, such as the Countess of Stolberg or Herder. For some examples, see A. Rosenthal, 'Die Zeichnungen der Angelika Kauffmann im Vorarlberger Landesmuseum, Bregenz', *Jahrbuch der Vorarlberger Landesmuseumsvereins, 1990; Bregenz* (1990): pp. 139–81.

22 *Memorandum of Paintings*, ed. and trans. in Manners and Williamson, *op. cit.*, p. 163.

23 Letter of 9 September 1777, quoted in *Reynolds, op. cit.*, p. 60.

24 Quoted in Bowron, *op. cit.*, p. 15.

25 For Kauffman's use of drawings, see A. Rosenthal, 'Die Zeichnungen . . . ' (1990).

Decorative Work

1 V. Manners and G. C. Williamson, *Angelica Kauffmann* (London, 1924), p. 208.

2 *The Early Diary of Fanny Burney* ed. A. R. Ellis (London, 1889), II, p. 223.

3 See J. Fowler and J. Cornforth, *English Decoration in the Eighteenth Century* (London, 1974), pp. 15–18.

4 Frances Gerard, *Angelica Kauffmann* (London, 1892).

5 Accession no. 635–1870 (U/11).

6 For this, see Manners and Williamson, *op. cit.*, p. 131; J. Lees-Milne, *The Age of Adam* (London, 1947), p. 121; M. Jourdain, *English Interior Decoration, 1500–1830* (London, 1950), p. 61; and D. Stillman, *The Decorative Work of Robert Adam* (London, 1966), p. 45.

7 G. Beard, *Georgian Craftsmen and Their Work* (London, 1966), p. 85.

8 Manners and Williamson were not alone in their attributions: *The Daily Graphic* (23 February 1921) has an entry relating to 20 St James's Square, which 'contains decorative paintings by

Angelica Kauffman', while *The Daily Chronicle* (28 February 1921) noted that the same house 'has ceiling paintings by Angelica Kauffman'. Both these cuttings are in the Print Room of the Victoria and Albert Museum in Kauffman folios.

9 A. Hartcup, *Angelica: The Portrait of an Eighteenth-century Artist* (London, 1954), pp. 118–19.

10 P. S. Walch, 'Angelica Kauffman' unpubd doctoral dissertation (Princeton University, 1968).

11 B. Chancellor, *The Private Palaces of London* (London, 1908), p. 328; J. Swarbrick, *The Lives and Work of Robert and James Adam* (London, 1915), p. 282. The Burney MSS are in the British Museum, Egerton MSS, 3690, 3696.

12 See C. R. Leslie and T. Taylor, *The Life of Sir Joshua Reynolds*, II (London, 1865), p. 487; C. Simon Sykes, *Private Palaces* (London, 1985), p. 223.

13 See R. W. Symonds, 'Adam and Chippendale: A Myth Exploded', *Country Life Annual* (1958), pp. 53–6.

14 A description used by Mrs Montagu in a letter (20 July 1779) to the Duchess of Portland; see Beard, *op. cit.*, p. 69, n.7.

15 M. Bevington, *Stowe – A Guide to the House* (1990), p. 29; 1921 sale catalogue of Messrs Jackson-Stops to *The Ducal Palace of Stowe*, p. 130, lot 1692. Our thanks to Michael Bevington for drawing our attention to the sale catalogue for the following year, in which the wording has been changed to read 'after or by Angelica Kauffman'.

16 Beard, *op. cit.*, p. 69, n.7.

17 E. Hargrove, *History of the Castle, Town and Forest of Knaresborough*, 4th edn (Leeds, 1789).

18 Stillman, *op. cit.*, p. 71.

19 An article by M. Forbes Adam, 'A Choice Question: Angelica Kauffman and Newby Hall', is in preparation. It is believed that the roundels came to Newby in the 1930s. They do not appear in the inventory of Newby Hall paintings dated 25 May 1794 now in the Leeds Archives, NH.2801/2, in which Zucchi is stated to have executed the dining-room paintings. Our thanks to Wendy Wassyng Roworth for confirming the attribution.

20 See L. Wood, 'George Brookshaw, "Peintre Ébéniste par Extraordinaire"', *Apollo* (June 1991) part 2, pp. 383–97.

21 At Christie's, London, in 1772 Guercino's painting of *Tancred and Erminia*, other characters from Tasso's epic, was sold for a record 500 guineas to the Earl of Carlisle.

22 See M. Forbes Adam and M. Mauchline, '"Ut Pictura Poesis": Decorative Designs illustrating Angelica Kauffman's use of English Sources', *Apollo* (June, 1992), pp. 345–9.

23 C. M. Gordon, *British Paintings of Subjects from the English Novel, 1740–1870* (New York, 1988), pp. 74–6, quoting J. Moser, 'Memoir of the Late Angelica Kauffman', in *The European Magazine* (April 1809), p. 254.

24 Sir William Hamilton, *Collection of Engravings from Ancient Vases* (Naples, 1791). I, p. 68, 70.

25 *The Diaries and Letters of Madame d'Arblay*, ed. C. Barrett (1892), IV, p. 219.

26 A. Kelly, *Decorative Wedgwood in Architecture and Furniture* (London, 1965), p. 114.

27 A. G. Cross, *By the Banks of The Thames: Russians in Eighteenth-century Britain* (Newtonville, MA, 1980), p. 213.

28 Gerard, *op. cit.*, n.5.

29 Wendy Wassyng Roworth traced the subject to 'Le grazie vendicate'; our grateful thanks to her.

30 G. de Bellaigue, 'Sèvres Artists and their Sources – 11,' *The Burlington Magazine*, CXXII (1980), pp. 748–59.

31 *Lady Charlotte Schreiber: Extracts from her Journal, 1853–91*, ed. the Earl of Bessborough (London, 1952).

32 In *The Diaries and Letters of Madame d'Arblay*, I, pp. 328–9.

33 See Hartcup, *op. cit.*, n.9.

34 S. Johnson, *The Lives of the English Poets*, ed. G. B. Hill (Oxford, 1905), II, p. 283.

The Print Market in Eighteenth-century England

1 As there is no catalogue of prints after Kauffman, it has been necessary as part of this study to compile a checklist, which is included in this book. The catalogue *Angelika Kauffmann und ihre Zeit* issued by the distinguished firm of Boerner in 1979 (compiled by C. Helbok) has been most helpful, especially as it illustrates some 190 out of the 280 or so singly issued English prints published before 1810. The major collections that have been consulted, and where the staffs have been uniformly helpful, are those of the British Museum, the Victoria and Albert Museum, the National Gallery of Scotland, the Hunterian Museum, University of Glasgow, the Metropolitan Museum of Art, the New York Public Library, the Yale Center for British Art, New Haven, the Cottonian Collection, Plymouth Art Gallery, and Rob Dixon.

2 The most useful study of the reproductive print is *The Image Multiplied*, exhibition catalogue by S. Lambert, Victoria and Albert Museum, London (1987). Eighteenth-century England is covered in more detail in *Painters and Engraving: The Reproductive Print from Hogarth to Wilkie*, exhibition catalogue by D. Alexander and R. T. Godfrey, Yale Center for British Art, New Haven (1980), and in *The Painted Word: British History Painting, 1750–1830*, exhibition catalogue ed. P. Cannon-Brookes, Heim Gallery, London (1991).

3 T. Clayton, 'The Engraving and Publication of Prints of Joseph Wright's Paintings', in *Wright of Derby*, exhibition catalogue by J. Egerton, Tate Gallery, London (1990); C. Lennox-Boyd, R. Dixon and T. Clayton, *George Stubbs: The Complete Engraved Work* (Abingdon, 1989).

4 *The Public Advertiser* (10 October 1768). The print appeared first without a publisher's name (Chaloner Smith 33. I), and it is possible that it was initiated by Kauffman and the plate then sold to Sayer, who is advertised as the publisher by 10 October.

5 For this venture see H. Hayward and P. Kirkham, *William and John Linnell* (London, 1980), I, p. 6.

6 F. A. Gerard, *Angelica Kauffmann: A Biography* (London, 1892), p. 106.

7 *Catalogue . . . Prints . . . of a late Celebrated Artist, deceased* (i.e. Ryland), Christie and Ansell, 7 April 1784, lot 88: 'One drawing of Samma the Demoniac and 1 touch'd print of Aristides by Angelica'.

8 Her plates are catalogued by Andresen.

9 Gerard, *op. cit.*, p. 142.

10 *The Public Advertiser* (25 and 26 March 1774).

11 *The Public Advertiser* (23 February 1776). The small painting of *The Holy Family* remained at Warwick Castle until the 1970s.

12 An impression of the later state in the Victoria and Albert Museum is illustrated in A. Rosenthal's article in *Jahrbuch der Vorarlberger Landesmuseumsvereins* (Bregenz, 1990), p. 171.

13 *The Daily Advertiser* (27 January 1774).

14 Rogers's collection of prints in their original albums is now in the Cottonian Collection, Plymouth Art Gallery.

15 A proof of *O Venus* (Venus Triumphant), now in the Cottonian Collection, was sent by Ryland to Rogers, who returned it with his suggestion for the appropriate Latin quotation.

16 A. G. Cross, *By the Banks of the Thames: Russians in Eighteenth-century Britain* (Newtonville, MA, 1980), p. 215.

17 The plates for 'Venus lending the Cestus to Juno . . . printed with 4 plates', and 'A drawing of ditto by Angelica Kauffman', appeared in lots 35 and 36 in the sale of the engraver Thomas Gaugain: Gerard, 17 December 1793. Wendy Wassyng Roworth informs me that there is a drawing of this title by Kauffman in the Ringling Museum, Sarasota. I have not located an impression of the print.

18 Newspaper of August 1783, quoted in F. W. Hilles and P. B. Daghlian, eds, *Anecdotes of Painting in England . . . collected by Horace Walpole . . . Volume the Fifth*, (New Haven, 1937), p. 222.

19 J. Frankau, *Eighteenth-century English Colour Prints* (London, 1900), p. 53, on the authority of the engraver Henry Minasi (1776–1865), whom Frankau knew in his old age.

20 E. Robinson and K. R. Thompson, 'Matthew Boulton's Mechanical Paintings', *The Burlington Magazine*, CXII, no. 802 (August 1970), pp. 497–505; this remains the best account of the venture, upon which this paragraph is based, and discusses previous writings on the subject. Antony Griffiths has been working further on the topic; I am grateful to him for help with this part of my essay.

21 D. B. Brown, *Ashmolean Museum, Oxford: Catalogue of the Collection of Drawings, IV: Early English Drawings* (Oxford, 1982), no. 872. These two heads seem to have been reproduced as mechanical paintings; see Robinson and Thompson, p. 507.

22 Victoria and Albert Museum Library, Press Cuttings, p. 300, advertisement dated in pen 1786.

23 D. B. Brown, *op. cit.*, no. 87.

24 There is a copy of this catalogue in the Cottonian Collection, Plymouth; I am grateful to the curator for drawing this to my attention.

25 *The Public Advertiser* (April 1779). I am grateful to Jeremy Rex-Parkes of Christie's Archive for confirming that no sale took place.

26 *Catalogue of . . . part of the . . . stock . . . of Mrs Ryland, Printseller, of New Bond Street*, Christie, 9 March 1799, lot 49, proof 'retouched by Angelica'.

27 This imprint is found on an impression in the British Museum (1873–8–9–276), but was soon erased.

28 Work on criticism of English prints in German periodicals is currently being undertaken by Tim Clayton.

29 M. Huber, *Catalogue raisonné du Cabinet d'estampes de feu Monsieur Winckler*, I (Leipzig 1802), pp. 466–7, 926–32.

30 Some 50 copies of English prints after Kauffman by Regona, Bonato, dall'Acqua, Gabrielli and others are listed in the Remondini Catalogue for 1803 (reprinted Bassano, 1990). These prints have no publication lines. Other copies were published by A. Suntach. For a selection of copies after Kauffman see *Donne Artiste nelle Collezioni del Museo di Bassano*, exhibition catalogue (Bassano, 1986).

31 Several of these are included in the catalogue *Angelika Kauffmann* by C. Helbok (1979).

32 Poggi sale, Christie, 19–21 June 1782, lots 106, 109, 111.

33 *Catalogue of. . . engraved copper plates . . . late the property of Mr James Birchall*, Mrs Hutchins, 20–24 May 1795: 23 May, lot 46, 'The portrait of Angelica, by herself'. Lot 8 was a drawing in black chalk by Angelica of *Harmony*.

34 Quoted by A. G. B. Russell, 'The Tragedy of Ryland', *Connoisseur*, XXVIII, no. 109 (September 1910), p. 26.

35 *Catalogue . . . Prints . . . of a late Celebrated Artist, deceased*, Christie and Ansell, 7 April 1784, lots 46–59 (lot 52 'one touch'd print and 1 drawing of Telemachus'); see also reference 7 above.

36 The plate of *Edgar* was sold in her sale in 1799, lot 45 (see reference 25 above), where it was remarked 'This favourite subject has been ever considered the very finest engraving of the late Mr Ryland'.

37 Bartolozzi published this print himself on 3 September (V & C. 1086; see the following reference for this); he then sold the plate to Boydell for 90 guineas (receipt dated 1 November 1780 in the Anderton R.A. catalogues, British Museum Print Room).

38 Bartolozzi's prints are catalogued by Vesme and Calabi (V & C); this lists some 70 prints after Kauffman by Bartolozzi and a number of others by his pupils.

39 This list is printed by V. Manners and G. C. Williamson, *Angelica Kauffmann* (London, 1924), pp. 141–74. See also W. W. Roworth, 'Angelica Kauffman's "Memorandum of Paintings"', *The Burlington Magazine*, CXXVI (1984), pp. 629–30. Manners and Williamson, *op. cit.*, also cite (p. 240) two letters of 1784 from Kauffman to the printseller John Thane, but these have not been traced.

40 *Stock of Copper Plate . . . of late Mr Matthews*, Christie, 7 June 1800, lots 118–19.

41 A. E. Santannello, ed., *The Boydell Shakespeare Prints* (New York, 1979). A letter from Kauffman to Boydell, dated 29 December 1787, suggests that she took the decision about the choice of subjects (perhaps from a shortlist sent to her by Boydell): Anderton R. A. catalogues, 1289, British Museum Print Room.

42 T. S. R. Boase, 'Macklin and Bowyer', *Journal of the Warburg and Courtauld Institutes*, X (1947).

43 W. T. Whitley, *Artists and their Friends in England, 1700–1799* (London, 1928), II, pp. 25–9.

44 *A Catalogue of Pictures copied for Sale by chymical and mechanical process . . . By the Polygraphic Society, At their Rooms in the Strand . . . being their fifth exhibition: opened in November, 1790*. Copy in the British Museum Print Room.

45 Whitley, *Artists and their Friends in England*, II, p. 38.

46 See *Affecting Moments: Prints of English Literature made in the Age of Sensibility, 1775–1800*, exhibition catalogue by D. Alexander (York, 1986, revd edn 1992).

47 The only catalogue of prints after any of these painters is in M. Webster, *Francis Wheatley* (London, 1970); about 70 stipples were engraved after Wheatley's work between 1786 and 1804.

48 See reference 33 above.

Bibliography

Affecting Moments: Prints of English Literature made in the Age of Sensibility, 1775–1800, exhibition catalogue by D. Alexander; City Art Gallery, York: 1986, revd edn 1992.

The Age of Neoclassicism, exhibition catalogue; Royal Academy of Arts, London, and Victoria & Albert Museum, London: 1972.

R. D. Altick, *Paintings from Books: Art and Literature in Britain, 1760–1900*, Columbus, 1985.

A. Andresen, *Der Deutsche Peintre-Graveur*, V, 1878, pp. 373–98 [lists 36 etchings by Kauffman].

Angelica Kauffmann, exhibition catalogue; The Iveagh Bequest, Kenwood, London: 1955.

Angelika Kauffmann (1741–1807)/Marie Ellenrieder (1791–1863), exhibition catalogue by E. von Gleichenstein & K. Stober; Rosengartenmuseum, Städtische Museen Konstanz: 1992.

Angelika Kauffmann und ihre Zeitgenossen, exhibition catalogue ed. O. Sandner; Bregenz and Vienna: 1968.

Angelika Kauffmann und ihre Zeit: Graphik und Zeichnungen von 1760–1810, Neue Lagerliste 70, C. G. Boerner, catalogue by C. Helbok; Dusseldorf: 1979.

The Artist's Model: Its Role in British Art from Lely to Etty, exhibition catalogue by I. Bignamini & M. Postle; University Art Gallery, Nottingham, and The Iveagh Bequest, Kenwood, London: 1991.

G. Baretti, *A Guide Through the Royal Academy*, London, 1781.

J. Barrell, *The Political Theory of Painting from Reynolds to Hazlitt: 'The Body of the Public'*, London, 1986.

B. Baumgärtel, *Angelika Kauffmann (1741–1807): Bedingungen weiblicher Kreativität in der Malerei des 18. Jahrhunderts*, Weinheim & Basle, 1990.

——, 'Freiheit-Gleichkeit-Schwesterkeit: Der Freundschaftskult der Malerin Angelika Kauffmann', *Sklavin oder Bürgerin Französische Revolution und Neue Weiblichkeit, 1760–1838*, exhibition catalogue; Historisches Museum, Frankfurt am Main: 1989, pp. 325–39.

A. Boime, *Art in the Age of Revolution, 1750–1800*, Chicago, 1987.

W. H. Bowles, *Records of the Bowles Family*, London, 1918.

F. den Broeder, 'A Weeping Heroine and a Mourning Enchantress by Angelika Kauffmann', *Bulletin of the William Benton Museum of Art* [University of Connecticut], (1974), pp. 19–28.

M. Butlin, 'An Eighteenth-century Art Scandal: Nathaniel Hone's "The Conjuror"', *Connoisseur*, CLXXIV (1970), pp. 1–9.

Comte de Caylus [Anne-Claude-Philippe de Tubières], *Tableaux tirés de l'Iliade, de l'Odyssée d'Homère et de l'Enéide de Virgile*, Paris, 1757.

W. Chadwick, *Women, Art and Society*, London, 1990.

J. Chaloner Smith, *British Mezzotinto Portraits*, 4 vols, London, 1878–83.

A. M. Clark, '"Roma mi è sempre in pensiero"', *Studies in Roman Eighteenth-century Painting*, ed. E. P. Bowron, Washington DC, 1981, pp. 125–38.

E. Croft-Murray, 'Decorative Painting for Lord Burlington and the Royal Academy', *Apollo*, LXXXIX (1969), pp. 11–21.

——, *Decorative Painting in England, 1537–1837*, 2 vols, London, 1962, 1970.

G. G. De Rossi, *Vita di Angelica Kauffmann, pittrice*, Florence, 1810.

A. De Vesme & A. Calabi, *Francesco Bartolozzi*, Milan, 1928.

J. Farington, *The Diary*, ed. K. Garlick & A. MacIntyre [I–VI], & K. Cave [VII–XVI], 16 vols, London, 1978–84.

R. Fletcher, *The Parkers at Saltram, 1769–89: Everyday Life in an English Country House*, London, 1970.

M. Forbes Adam & M. Mauchline, 'Attingham Park, Shropshire', *Country Life* (2 July 1992), pp. 88–91.

——, '"Ut Pictura Poesis": Decorative Designs illustrating Angelica Kauffman's use of English Sources', *Apollo*, CXXXII (1992), pp. 345–9.

B. Ford, 'Thomas Jenkins: Banker, Dealer and Unofficial English Agent', *Apollo*, XCIX (1974), pp. 416–25.

J. Fowler & J. Cornforth, *English Decoration in the Eighteenth Century*, London, 1974.

J. Frankau, *Eighteenth-century English Colour Prints*, London, 1900, revd edn 1906.

Genial Company: The Theme of Genius in Eighteenth-century British Portraiture, exhibition catalogue by D. Shawe-Taylor; University Art Gallery, Nottingham, & Scottish National Portrait Gallery, Edinburgh: 1987.

F. A. Gerard, *Angelica Kauffmann – A Biography*, London, 1892.

C. M. Gordon, *British Painting of Subjects from the English Novel, 1740–1870*, New York, 1988.

——, '"More than One Handle": The Development of Sterne Illustration, 1760–1820', *Words: Wai-te-ata Studies in Literature* [Wellington, NZ], IV (1974).

S. Hammer, *Angelica Kauffman*, Vaduz, 1987.

A. Hartcup, *Angelica: The Portrait of an Eighteenth-century Artist*, London, 1954.

C. Helbok, *Miss Angel: Angelika Kauffmann – Eine Biographie*, Vienna, 1968.

S. Hutchinson, *The History of the Royal Academy, 1768–1968*, London, 1968.

The Image Multiplied, exhibition catalogue by S. Lambert; Victoria & Albert Museum, London: 1987.

D. Irwin, *English Neoclassical Art: Studies in Inspiration and Taste*, London, 1966.

G. Keate, *An Epistle to Angelica Kauffman*, London, 1781.

Lady V. Manners & G. C. Williamson, *Angelica Kauffmann, R.A.: Her Life and Works*, London, 1924.

D. Mannings, 'Notes on some Eighteenth-century Portrait Prices in Britain', *British Journal for Eighteenth-century Studies*, VI (1983), pp. 185–96.

A. S. Marks, 'Angelica Kauffman and some Americans on the Grand Tour', *American Art Journal*, XII/2 (1980), pp. 5–24.

D. M. Mayer, *Angelica Kauffmann R.A., 1741–1807*, Gerrards Cross, Bucks, 1972.

Memorie per le Belle Arti, ed. G. G. De Rossi & O. Boni, Rome, 1785–8.

O. Millar, *The Later Georgian Pictures in the Collection of Her Majesty the Queen*, 2 vols, London, 1969.

J. Moser, 'Memoir of the Late Angelica Kauffman, R.A.', *The European Magazine and London Review* (April 1809), pp. 251–62.

The Painted Word: British History Painting, 1750–1830, exhibition catalogue ed. P. Cannon-Brookes; Heim Gallery, London: 1991.

Painters and Engraving: The Reproductive Print from Hogarth to Wilkie, exhibition catalogue by D. Alexander & R. T. Godfrey; Yale Center for British Art, New Haven: 1980.

Painters by Painters, exhibition catalogue by C. Caneva & A. Natali; National Academy of Design, New York: 1988.

R. Parker & G. Pollock, *Old Mistresses: Women, Art and Ideology*, London, 1981.

M. Pointon, *Milton and English Art*, Manchester, 1970.

——, 'Portrait Painting as a Business Enterprise in London in the 1780s', *Art History*, VII (1984), pp. 187–205.

Reynolds, exhibition catalogue ed. N. Penny; Royal Academy of Arts, London: 1986.

A. Ribiero, 'Turquerie: Turkish Dress and English Fashion in the Eighteenth Century', *Connoisseur* (May 1979), pp. 16–23.

E. Robinson & K. R. Thompson, 'Matthew Boulton's Mechanical Paintings', *Burlington Magazine*, CXII (1970), pp. 497–507.

R. Rosenblum, *Transformations in Late Eighteenth-century Art*, Princeton, 1968.

A. Rosenthal, 'Angelika Kauffman Ma(s)king Claims', *Art History*, XV (1992), pp. 38–59.

——, 'Die Zeichnungen der Angelika Kauffmann im Vorarlberger Landesmuseum, Bregenz', *Jahrbuch der Vorarlberger Landesmuseumsvereins: 1990*, Bregenz, 1990, pp. 139–81.

J.-A. Rouquet, *The Present State of the Arts in England*, London, 1755.

W. W. Roworth, 'Angelica Kauffman's "Memorandum of Paintings"', *Burlington Magazine*, CXXVI (1984), pp. 629–30.

——, 'Artist/Model/Patron in Antiquity: Interpreting Ansiaux's "Alexander, Apelles and Campaspe"', *Muse*, XXII (1988), 92–106.

——, 'Biography, Criticism, Art History: Angelica Kauffman in Context; *Eighteenth-century Women and the Arts*, ed. F. M. Keener & S. E. Lorsch, London, 1988. pp. 209–23.

——, 'The Gentle Art of Persuasion: Angelica Kauffman's "Praxiteles and Phryne"', *Art Bulletin*, LXV (1983), pp. 488–92.

Saltram, Devon, National Trust guidebook, London, 1990.

A. E. Santannello, ed., *The Boydell Shakespeare Prints*, New York, 1979.

Shaftesbury, A. A. Cooper, Earl of, *Notion of the Historical Draught, or Tablature, of the Judgement of Hercules*, London, 1713.

J. T. Smith, *Nollekens and his Times*, London, 1828.

D. H. Solkin, 'Great Pictures of Great Men?: Reynolds, Male Portraiture and the Power of Art', *Oxford Art Journal*, IX/2 (1986), pp. 42–9.

W. S. Sparrow, *Women Painters of the World from the Time of Caterina Vigri to Rosa Bonheur and the Present Day*, London, 1905.

E. Spickernagel, '"Helden wie zarte Knaben oder verkleidete Mädchen": Zum Begriff der Androgynität bei Johann Joachim Winckelmann und Angelika Kauffmann', *Frauen-Weiblichkeit-Schrift: Literatur im historischen Prozess*, n.s. XIV ed. R. Berger *et. al.*, Berlin, 1985, pp. 99–118.

D. Stillman, *The Decorative Work of Robert Adam*, London, 1966.

R. Strong, *'And when did you last see your father?': The Victorian Painter and British History*, London, 1978; pubd New York as *Recreating the Past: British History and the Victorian Painter*, 1978.

D. Sutton, 'Aspects of British Collecting – II', *Apollo* (December 1982), pp. 405–20.

E. Thurnher, *Angelika Kauffmann und die deutsche Dichtung*, Bregenz, 1966.

P. Tomory, 'Angelika Kauffmann's "Costanza"', *Burlington Magazine*, CXXIX (1987), pp. 668–9.

——, 'Angelika Kauffmann – Sappho', *Burlington Magazine*, CXIII (1971), pp. 275–6.

A. W. Tuer, *Bartolozzi and his Works*, 2 vols, London, 1881.

P. S. Walch, 'Angelica Kauffman', unpubd doctoral dissertation: Princeton University, 1968.

——, 'An Early Neoclassical Sketchbook by Angelica Kauffmann', *Burlington Magazine*, CXIX (1977), pp. 98–111.

——, 'Foreign Artists at Naples, 1750–1790'. *Burlington Magazine*, CXXI (1979), pp. 247–52.

E. K. Waterhouse, *Painting in Britain, 1530–1790*, London 1953, revd edn 1978.

——, 'Reynolds, Angelica Kauffmann and Lord Boringdon', *Apollo* (1985), pp. 270–4.

W. T. Whitley, *Artists and their Friends in England, 1700–1799*, 2 vols, London, 1928.

D. Wiebenson, 'Subjects from Homer's "Iliad" in Neoclassical Art', *Art Bulletin*, XLVI (1964), pp. 29–37.

J. J. Winckelmann, *Geschichte der Kunst des Altertums*, Dresden, 1764.

Women Artists: 1550–1950, exhibition catalogue ed. A. S. Harris & L. Nochlin; Los Angeles County Museum of Art: 1976.

L. Wood, 'George Brookshaw, "Peintre ébéniste par extraordinaire", and the Case of the Vanishing Cabinet Maker – II', *Apollo*, CXXXI (1991), pp. 383–97.

List of Illustrations

Notes on the Contributors

DAVID ALEXANDER is a former holder of the Bromberg Fellowship for the study of prints at Worcester College, Oxford, and a founder member of *Print Quarterly*, the international journal for the study of the history of prints. In addition to his current work on a biographical dictionary of British engravers, 1700–1830, he is researching the development of the print market and cataloguing stipple engravings.

MALISE FORBES ADAM is co-founder of two London-based art appreciation societies, 'Art Circle' and 'Art Experience'. She has lectured extensively on art-historical subjects in Britain and the USA, and is the author, with Mary Mauchline, of articles on Angelica Kauffman published recently in *Apollo* and in *Country Life*.

MARY MAUCHLINE retired in 1975 from the headship of the History Department of Ripon College (now the University College of Ripon and York), North Yorkshire, in order to become a freelance lecturer and writer. A revised edition of her book *Harewood House* appeared in May 1992. She is the author, with Malise Forbes Adam, of articles on Angelica Kauffman published recently in *Apollo* and in *Country Life*.

ANGELA ROSENTHAL is currently researching her PhD thesis on Angelica Kauffman at Trier University. In addition to articles published in Germany, she has contributed to a recent issue of *Art History*.

WENDY WASSYNG ROWORTH is Professor of Art History at the University of Rhode Island. An authority on Angelica Kauffman, she has published articles on her in *The Burlington Magazine*, *Art Bulletin* and various other journals and books. She has also published a book on the seventeenth-century Italian artist Salvator Rosa.

Index

This index does not list illustrations, except when a person is also the author or subject of a picture. In such cases the illustration (rather than page) number is given, *in italics*.